WILDLIFE PHOTOGRAPHY

STORIES FROM THE FIELD

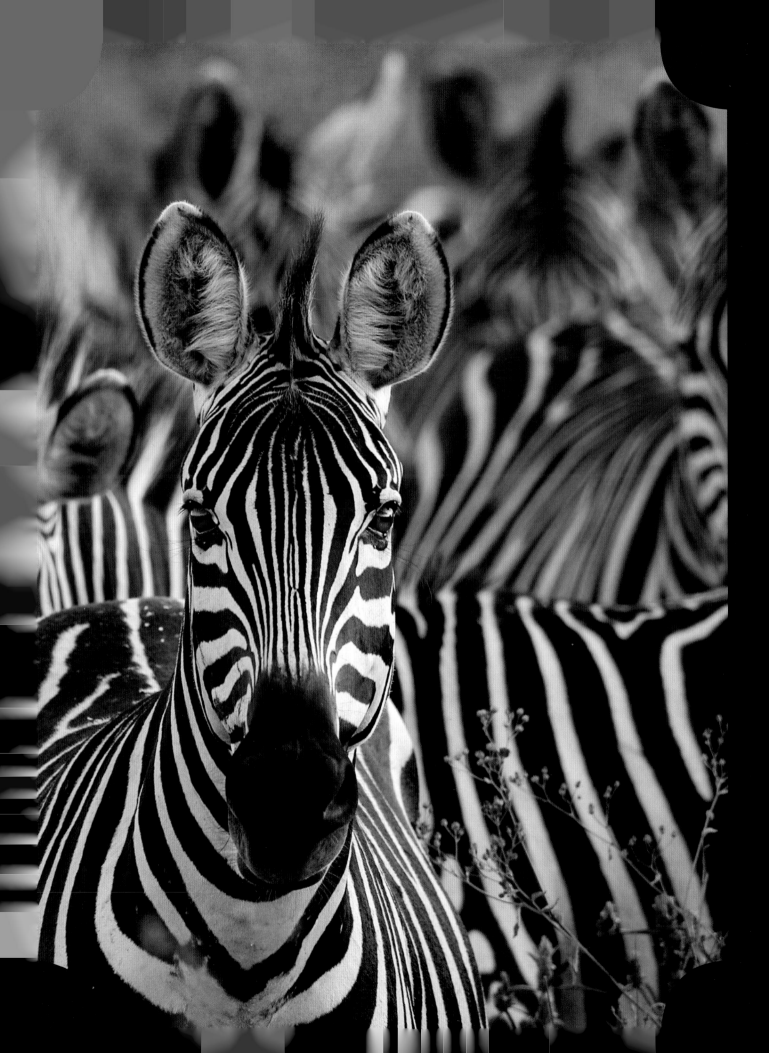

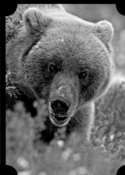
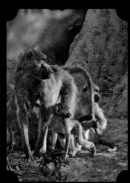
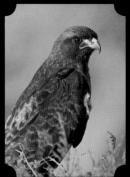

GEORGE
LEPP

AND KATHRYN VINCENT LEPP

WILDLIFE PHOTOGRAPHY

STORIES FROM THE FIELD

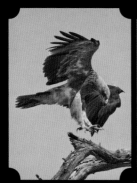

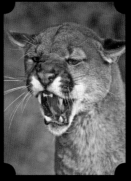

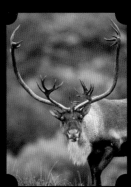

LARK
PHOTOGRAPHY
BOOKS

A Division of Sterling Publishing Co., Inc.
New York / London

Editor: Haley Pritchard
Book Design: Sandy Knight
Cover Design: Thom Gaines

Library of Congress Cataloging-in-Publication Data
Lepp, George D., 1944-
 Wildlife photography : stories from the field / George Lepp and Kathryn Vincent Lepp. -- 1st ed.
 p. cm.
 ISBN 978-1-60059-632-2
 1. Wildlife photography. I. Lepp, Kathryn Vincent, 1948- II. Title.
 TR729.W54L47 2010
 779'.32--dc22

 2010008045

10 9 8 7 6 5 4 3 2 1

First Edition

Published by Lark Photography Books, A Division of
Sterling Publishing Co., Inc.
387 Park Avenue South, New York, N.Y. 10016

Text © 2010 George Lepp and Kathryn Vincent Lepp
Photography © 2010 George Lepp unless otherwise specified

Distributed in Canada by Sterling Publishing,
c/o Canadian Manda Group, 165 Dufferin Street
Toronto, Ontario, Canada M6K 3H6

Distributed in the United Kingdom by GMC Distribution Services,
Castle Place, 166 High Street, Lewes, East Sussex, England BN7 1XU

Distributed in Australia by Capricorn Link (Australia) Pty Ltd.,
P.O. Box 704, Windsor, NSW 2756 Australia

This book is sponsored by Canon U.S.A., Inc. The Canon and Explorers of Light logos are
used with permission of Canon U.S.A., Inc. Canon, EOS, Speedlite, and other Canon product names
are registered trademarks of Canon, Inc. All other product names are trademarks of their
respective manufacturers.

If you have questions or comments about this book, please contact:
Lark Books
67 Broadway
Asheville, NC 28801
(828) 253-0467

Manufactured in China

ISBN 13: 978-1-60059-632-2

For information about custom editions, special sales, premium and corporate purchases, please contact
Sterling Special Sales Department at 800-805-5489 or specialsales@sterlingpub.com.

For information about desk and examination copies available to college and university professors,
requests must be submitted to academic@larkbooks.com. Our complete policy can be found at
www.larkbooks.com.

To learn more about digital photography, visit www.pixiq.com.

FOR ELLY LEPP

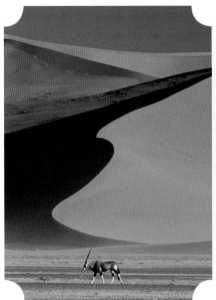 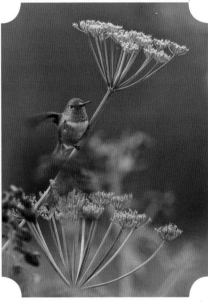 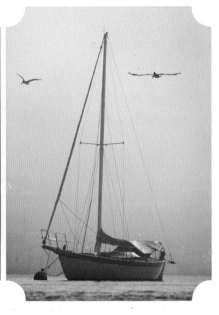

IN GRATITUDE

As Kathy and I have learned in our separate careers, one does not build a philosophy, a creative approach, or a body of work, alone. This book represents the cumulative experience and philosophies of its two authors, but every career is influenced by others who have knowledge and passions to share. We gratefully acknowledge the particular contributions of the following friends, mentors, and colleagues who have so generously shared with us their knowledge and commitment to intellectual and artistic pursuits. These individuals and many others have contributed directly and indirectly to this book, but we alone are responsible for any errors or omissions.

In the world of academia, we thank Professor Lincoln Brower of Sweetbriar College; Professor Arturo Gómez-Pompa of the University of California, Riverside and University of Veracruz, Mexico; Dr. Andrea Kaus of the University of California Institute for Mexico and the United States; Professor Jaime E. Rodríguez O. of the University of California, Irvine; Professor Paul Sherman of Cornell University; and Professor Lee Waian of Saddleback College.

For their friendship and encouragement throughout my photographic career, I am grateful to Steven Werner and Debra Levine of Werner Publications, and to my colleague Dave Metz. Additionally, without the support of the superb staff at Canon USA's New York headquarters and the help of Canon's outstanding field technicians, this book would not have been possible. Thank you for a successful 23-year association, and we look forward to many more cooperative endeavors.

Thanks also to those organizers of great outdoor photography workshops who've been instrumental in getting me together with some of the wildlife you've seen in this book: Joe van Os of Joe van Os Photo Safaris; Randy Green of International Wildlife Adventures; Art Taylor and Celia Condit of Searcher Natural History Tours; Steve and Brennan Rimer of Journeys Unforgettable and Wilderness Safaris; and Wally and Jerryne Cole of the incomparable Camp Denali/North Face Lodge.

This book celebrates a new relationship, too. We are grateful to Marti Saltzman and Haley Pritchard, our editors at Lark Books, for their enthusiasm about our project and their dedication to producing a beautiful book.

And not least, we lovingly remember The Honorable Bobby Ray Vincent, whose passion for wilderness inspired all who knew him.

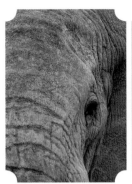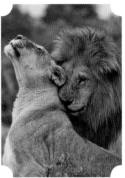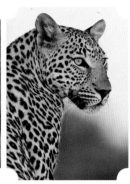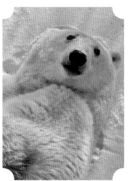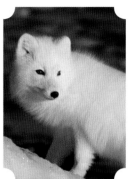

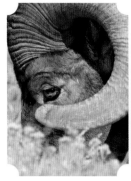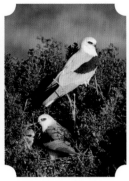

FOREWORD

Those who can, *do* teach. Perhaps more than with any other discipline, outdoor photographers are selfless teachers of their art, and George Lepp is one of the most gifted of these. Since the inception of *Outdoor Photographer* magazine in 1985, George has authored the popular "Tech Tips" column and countless articles. For readers, he has come to be the foremost guru on blending equipment and technique to achieve the best possible results. I will always remember our first meeting when, having heard about our new magazine launch, he was the first to offer his assistance as a regular contributor. In the ensuing years, George has helped to influence the direction of the magazine and to elevate its stature.

Technology does improve art, there's no mistake about it. To be a great photographer and teacher, George Lepp has had to be one of nature photography's outstanding students. He began his career in the simpler days of film, but has learned and adapted throughout photography's technical advancements, which have brought a wealth of tools to those who must cope with the challenges of the outdoors. He has been among the very earliest adopters of all that is digital.

At the outset, when many photographers were skeptical and even fearful of the onslaught of electronic imaging, George embraced each subsequent breakthrough as an opportunity. Photography is absolutely a mechanical art, and there is no sense in being a purist when the ends justify the means. During George's career, photographic and software companies have introduced such game-changers as autofocus, image stabilization, digital capture, computer-controlled image manipulation, and inkjet output. No one can bring to bear all the advantages of modern photography on one serendipitous moment in nature the way George can, handholding 700mm from a floating kayak, then stitching together a gloriously sharp panorama of shore birds enlarged to a wall-sized print.

With this book, George has collaborated again with his wife Kathryn, who in her 30-year career with the University of California wrote and edited many scholarly works on the subject of environmental issues. George and Kathryn have put their skills together over the years to co-author two *Beyond the Basics* books and many published articles for photographers. Their truly symbiotic partnership is, in my experience as an editor of *Outdoor Photographer*, not atypical. I can count many such relationships in professional photography. Privately, I call them swans for obvious reasons.

As any photography lecturer knows, it is difficult to sway many amateur photographers from the impression that some magic filter, film, pixel count, or enhancement secret is the alchemy behind professional images. In this book, George and Kathryn make it clear with their stories behind the photographs that there is no substitute for being in the right place at the right time equipped with the right gear, sufficient knowledge about the subject matter, and bountiful enthusiasm for the pursuit of the shot. Some professionals are deliberate in saying "make" a photograph, as that implies the full creative process of capturing an image, and as differentiation from the "take" which seems to insinuate a snapshot, or "capture" which is clichéd poetry. In the retelling by George and Kathryn, it is clear that the process involves all of these verbs, for a photograph is something that has to be found and caught before it can be crafted, personalized, and possessed.

Then there are the not-to-be discounted life lessons that we learn from our participation in photography. It's not only a hobby, an art, and a gadget fetish, but also a process that causes us to pause and contemplate, to look closer and longer. One line in particular from this book stands out in my mind: *When you encounter an animal in the wild, you represent all of that individual's cumulative experiences with humans, and you are adding to that experience with your own actions.*

What a great bit of wisdom, so complete and concise. It should be a National Park sign, or maybe something we could apply to our human relations.

STEVE WERNER | Publisher/Editor in Chief
Outdoor Photographer Magazine, Digital Photo Pro Magazine

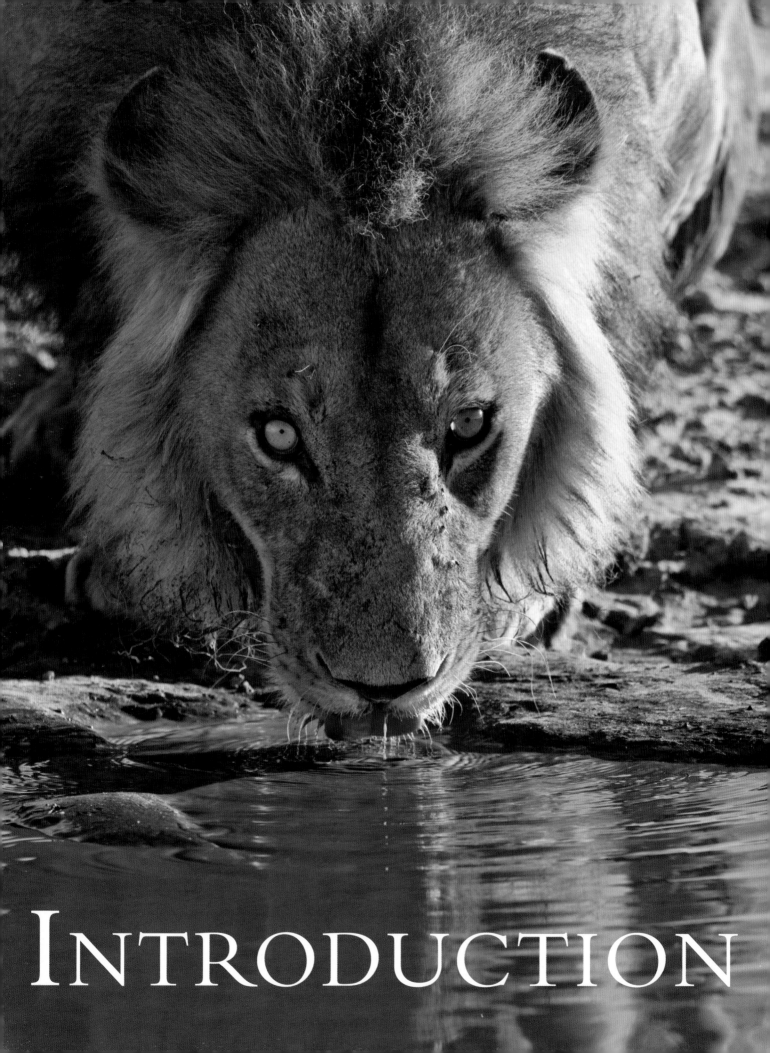

INTRODUCTION

On many occasions, Kathy and I have written about the consciousness of nature photographers, which we'll define here as a keen awareness of—and curiosity about—the natural world. And then there's the nature photographer's conscience, that indefinable aspect of character that dictates a thoughtful, protective approach toward wild creatures. That conscience also demands an honest portrayal of nature's subjects and respect for their spirits, their fears, their behavior, and their habitats. In our experience, combining the best aspects of consciousness and conscience yields a photographer who finds unending joy in the pursuit of wildlife photography.

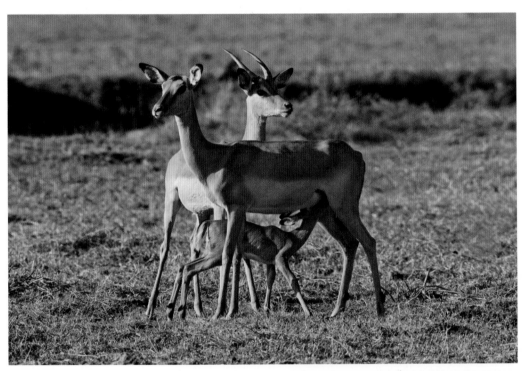

Canon EOS-1D Mark III, 500mm f/4L lens, EF 2X tele-extender (1300mm), ISO 400

Above

I photographed this family of impala near Mombo Camp in Botswana's Okavango Delta. The parents are on alert due to the presence of a lion at the perimeter of the plain where the herd is feeding, but the photography occurred at an unthreatening distance. It's especially satisfying to capture an intimate portrait of parents and newborns demonstrating natural behavior in their own environment.

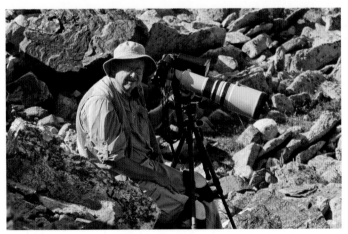

© Kathryn Vincent Lepp

Above

George, deep in the thrall of field work, is equipped for photographing marmots at an elevation of 12,000 feet in Rocky Mountain National Park. He's hauling a Canon EOS-1Ds Mark III camera with an EF 500mm f/4L lens, an EF 1.4X tele-extender, and a projected flash, all mounted on a Gitzo Explorer tripod and a Really Right Stuff BH 55 pro ballhead.

WHERE DO WILDLIFE PHOTOGRAPHERS COME FROM?

Why are some people so fascinated by wild animals? What draws us to find them, identify them, watch them, and capture them in our photographs? Why are some photographers compelled to leave the comfort of the couch, drive or fly for hours, hike for days into backcountry, haul tripods and big lenses and mosquito repellant and tents, and even risk their own lives just to take a picture?

Below

I photographed this California valley quail at a wildlife sanctuary. No bird was harmed during this shooting.

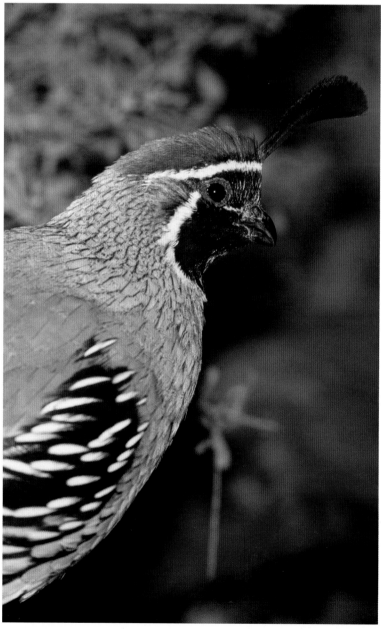

Canon T90, 500mm f/4.5 lens with extension tubes

Some would say it's about the physical journey: getting outside into new environments, discovering places, the thrill of the chase, overcoming physical obstacles. Others would say it's about the personal journey: challenging yourself, discovering your strengths, experiencing the sensory overload of natural places and their inhabitants, learning about them, taking the experience into your everyday life and sharing it with others. And for a very few, these physical and personal journeys take on the status of a profession and a life's work.

Most professional wildlife photographers I know didn't start out planning to be wildlife photographers. For one thing, their parents wanted them to grow up and get "real jobs," like being a doctor or a teacher or a firefighter. Some of the best-known wildlife photographers started out doing something very different as a profession, and many will tell you that their first interactions with wildlife were associated with childhood hunting trips, where they developed a fascination with wild places and learned the naturalist's skills of patience and observation. An obsession with wildlife became a part of their being, but not a likely source of future financial support. My story is not much different.

I come from a long line of hard-working German farmers, and those who work the land generally see wildlife as a pestilence, a food source, or both. I grew up under the influence of several uncles who were only slightly older than I was, and we spent many afternoons on my grandfather's farm blasting away at rabbits, ground squirrels, and game birds. The birds were shot for sport, but always made it to the table; to kill and abandon potential food was wasteful, and thus discouraged.

This was all great fun for a competitive gang of boys. A squirrel a hundred yards out was viewed through a rifle scope. If you were a good shot, you knocked him off a rock, then you moved on. It was nothing personal (except to the squirrel), but one day I was

hunting with my Uncle George, and I shot a valley quail out of the air with a shotgun. When I went to collect the trophy, I found that it was only wounded. The bird was absolutely beautiful; it looked me in the eye with bright intelligence, and I was obligated to end its innocent life with my own shaking hands. I became a non-hunter that day, and more than fifty years later, I am still haunted by that valley quail.

It was a classic revelation, a stereotypical rite of passage, a moment in which one recognizes another's life spirit and assigns to it a value that is greater than the urge to act out of habitual custom, or the pursuit of personal pleasure or power. Only when you can get close enough to the unknown to look it in the eye can you begin to know it.

And now, as I look back, I understand that my short experience with the doomed quail generated in me a profound desire to be accepted by wild creatures, to know and to understand them, to deserve their trust, and to communicate, somehow, my respect. But even now I am not sure whether I simply found my true, unique nature that day with the quail, or if this longing to connect with wild things can be taught to any child.

Not long after this incident, a teacher introduced me to photography by handing me a Crown Graphic 4x5 camera and an assignment to take pictures for the school. I didn't make the personal connection between my growing fascination with photography and animals then, however, because the cameras to which I had access, such as the Crown Graphic and a twin-lens reflex, weren't suited for photographing wildlife. But I was aware of the kinds of wildlife photography that could be done; Disney features, such as *Bear Country* and *The Living Desert*, fascinated me. The photographs in *Life Magazine* and *National Geographic* intrigued me, and to this day some of them still stick in my mind's eye. I wanted to be a wildlife photographer the way some kids wanted to be rock stars or pro basketball players—a nice dream, but not very realistic.

Into adulthood, I continued my outdoor explorations, and my appreciation for the natural world grew. I looked for a

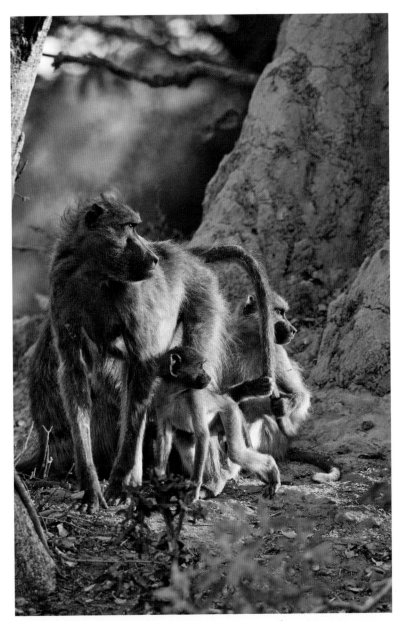

Canon EOS-1D Mark III, EF 500mm f/4L lens, ISO 400

way to make my living in it, so my major in college became wildlife management, and my summers were spent working for either the U.S. Forest Service or the U.S. Fish and Wildlife Service. One aspect of this direction in my life troubled me as much as the experience with the valley quail: No matter what my personal priorities were, the agencies' goals—and thus the outcome of my own education and summer service— were to "harvest" either the woods or the wildlife. What bothered me most was that I was headed for a professional career as an enabler of sport hunting, a kind of wildlife interaction I personally rejected.

Above

This baboon family was captured unaware in early morning light near Mombo Camp, Botswana.

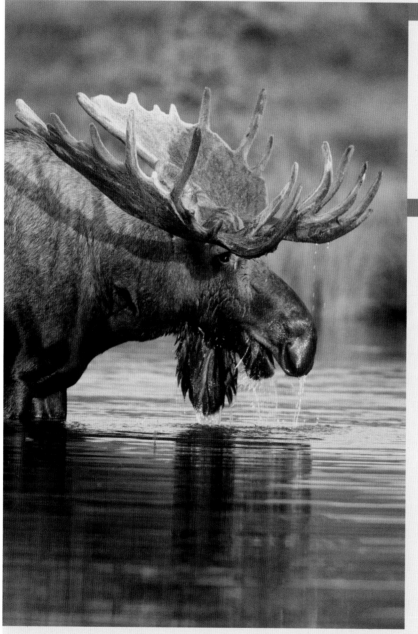

Canon EOS-1V, 500mm f/4L lens

Above

I photographed this trophy bull moose in Alaska. After his encounter with me, I hope that he lived a long reproductive life, and that he was "captured" by other photographers.

> IF YOU HUNT, I WISH YOU WOULD USE A CAMERA INSTEAD OF A GUN.

Wildlife photography supplies all the primeval satisfaction of the hunt, from the stalk, to the strategy, to the trophy shot. You don't need a license; you don't need a gun, a butcher knife, or a taxidermist. And if you shoot another photographer with your 500mm lens, no harm done! You can go back again tomorrow and get another chance to shoot great subjects, and others can do the same. Instead of removing the best examples of the species from the population, you've simply photographed them and left them to fulfill their role in nature, and perhaps to reproduce. You can return in the spring to photograph your trophy's offspring. You can show their pictures and tell their stories, and your own, to other people who love wildlife, knowing that you didn't take anything away from any living creature in the doing.

Becoming a Photographer

My college education was interrupted, as were so many in the sixties, by the military draft. It's ironic that, thanks to my uncles, I was a sharpshooter. However, I extended my obligation for two years for the privilege of choosing a non-combat occupation, and I served my time as an illustrator and graphic artist in Hawaii and Vietnam. By the time I left the service, I knew I wanted to be a photographer.

I entered Brooks Institute of Photography on the G.I. bill and confounded my instructors by redefining all their assignments to include wild subjects. No one, they said, can really make a living photographing nature. So after graduation I worked as a scientific and commercial photographer, and for *Car and Driver* magazine, with nature photography as a sideline until a market developed for the work I really wanted to do. In the meantime, I approached my *Car and Driver* assignments from a nature photographer's perspective, using long lenses for compression, pans to heighten the speed and action, and macro techniques for details.

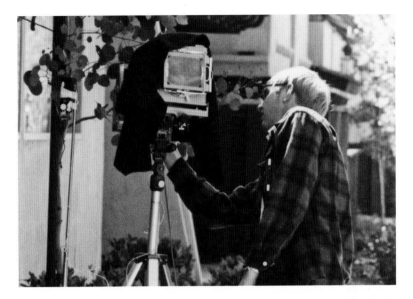

The sixties and seventies ushered in a new sense of discovery about the lives, experiences, and rights of individuals and species different from ourselves. That newfound understanding coincided with a rise in environmental activism, from "tree huggers" to whale watchers, demands for dolphin-free tuna and pesticide-free waterways, and opposition to wolf traps and harp seal hunts. As environmental consciousness hit the mainstream, it helped

Above

For a photography school portrait assignment in the late sixties, I set up a 4x5 studio camera on a hummingbird's nest. Note the sophisticated lighting, provided by a flash taped to a stand!

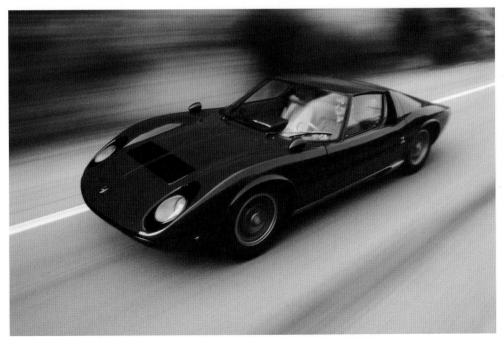

Canon EOS-1N, 28-135mm zoom lens

Left

The nature photography technique I applied on an assignment for *Car and Driver* magazine demonstrated that a classic Lamborghini Miura is as fleet as a deer. Careening down a 4-lane highway in the hills above Los Angeles, I photographed the Lamborghini through the sunroof of a vehicle running at equal speed; a long exposure rendered the foliage alongside the road as just a blur, suggesting the Lamborghini was moving even faster than it was.

me to move forward in pursuit of my own photographic agenda. I saw wildlife photography as a tool to preserve and protect every species, be they a continent's prized "Big Five" or the despised ground squirrel.

I began my own "trophy hunting" in earnest. I sought out magnificent and interesting animals, I watched their behavior, I captured their images, and I hung them on my wall; I sold them to others, I wrote about them, and I used them in my lectures and books. I live to get close to a wild creature, watch it, photograph it, and back away without it ever changing its behavior in response to my presence. I especially love it when the animal knows I'm there and accepts me, and I am particularly grateful when I'm allowed to look into the eyes of a beautiful, free being and capture its very spirit for all to see. I want everyone who views my wildlife photographs to fall in love with the subjects, because we humans don't work to save what we don't know, what we don't understand, what we don't love.

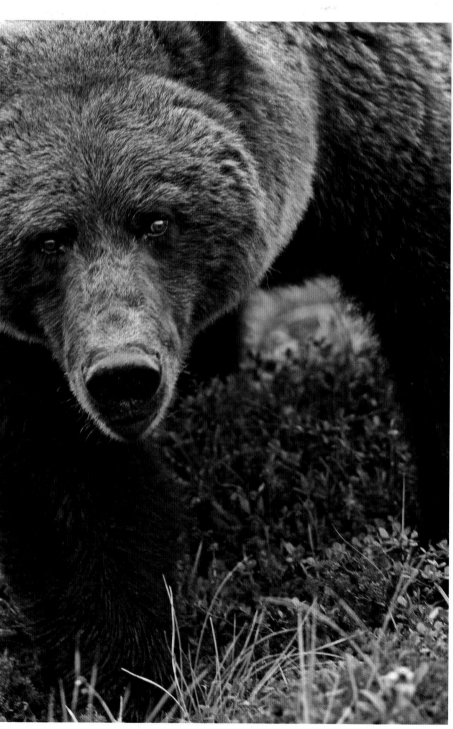

Canon EOS-20D, EF 500mm f/4L lens with EF 1.4x tele-extender

Left

Through my lens, I'm eye to eye with this curious grizzly bear in Denali National Park. I caught the bear eating blueberries; after our encounter he moved past me to another patch of berries across the road.

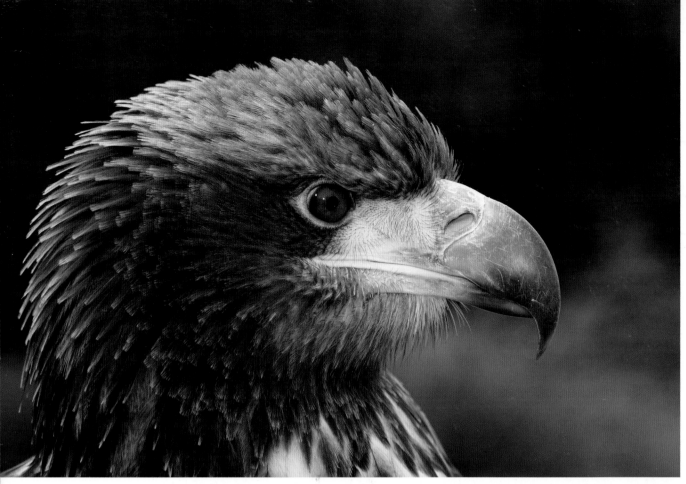

Canon EOS-1Ds Mark II, EF 100-400mm f/4.5-5.6L lens at 310mm

SIZE DOESN'T REALLY MATTER

In this book, you'll find plenty of images of "trophy" animals—the biggest bear, the ram with the largest curl, the smallest hummingbird jewel—but you'll also find the rest of the story. You'll see the behavior, the female, the juvenile, the small mammals, birds, fish, and insects. These days, it seems there's only room for the "beauty shot" in most publications, and supposedly lesser subjects are disdained. There's no money in it; there's no glory in it. As natural science photographers have been replaced by the wildlife paparazzi, we've lost much of the opportunity to appreciate a wide variety of wildlife species. If you love wildlife and wildlife photography, I urge you to spend time with less popular subjects. It's good for your photography and good for your soul.

Some photographers get their trophy shots at game farms, where animals are kept in small enclosures but brought into larger, more natural looking areas for use by photographers. I do not frequent these facilities, and I discourage others from doing so. I especially deplore the breeding practices of many of these facilities. Every spring, new babies are cute subjects for hordes of high-paying photographers. And the next spring, they're replaced by a new batch. Where do the gawky adolescents go?

Nonetheless, you will see in these pages a few images of controlled animals. I've photographed in first-rate zoos and have worked with trained animals (well-treated subjects that could not have been photographed safely in the wild) as well as with animals in rehabilitation facilities. These individuals have become ambassadors for their wild counterparts, and I believe they help us to know and inspire us to protect animal species. Still, I have mixed emotions about photographing captive animals. I always prefer to photograph in the wild.

Above

Photographing at wildlife rehabilitation centers offers opportunities for images that shouldn't be attempted in the wild. I photographed this injured golden eagle from a distance of about five feet (about 1.5 meters) with a combination of ambient light and fill flash.

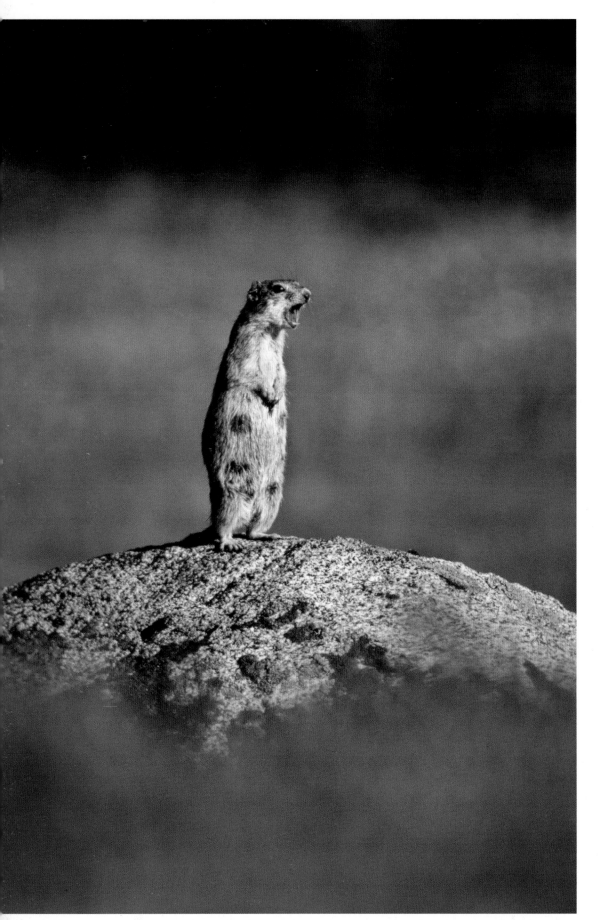

Left

On assignment for *Natural History* magazine, I worked with biologist Paul Sherman to document the behavior of Belding's ground squirrels just outside Yosemite National Park. This female is sounding an alarm call at a coyote coming into the colony's territory.

Nikon FE2, 600mm f/4 lens

UNENDING REWARDS

I now live in Colorado at the edge of the national forest in a neighborhood where most of the human residents understand that wildlife has equal priority. By common agreement there are no fences to mark the boundaries of each property, and deer, foxes, raccoons, cougars, bears, and skunks move freely among our homes with their young. Abundant bird species nest in the stands of pine and oak, and many stay for the winter. I feel a close, personal connection with the wildlife I see outside my studio every day.

Below

This is a typical winter scene outside my studio in Colorado Springs. Each day is filled with opportunities to reconnect with the wildlife in our neighborhood.

Canon EOS 5D Mark II, EF 24-105mm f/4L lens at 73mm, ISO 400, 1/90 second at f/8

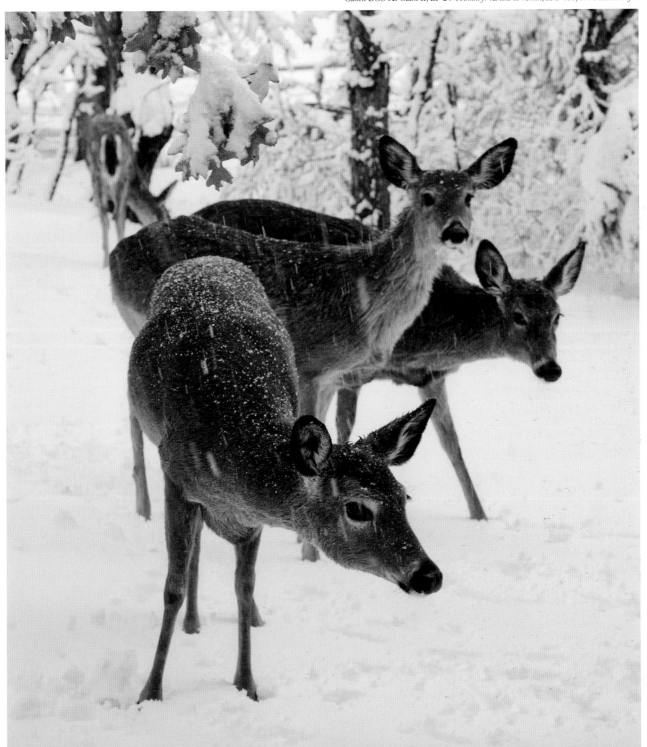

When I am away to teach or photograph elsewhere, I feel that I've somehow abandoned my responsibility to witness the progression of the extended animal families at home. I wonder what has happened to that skinny fox that could catch, but never hold onto, a scolding squirrel. Did the doe with the broken foreleg escape the mountain lion? I think of the tiny, wide-eyed newborn spotted fawn we found hidden under a shrub in the yard early one June. I remember the big red mother bear, gracefully balanced on the deck rail, sipping from the hummingbird feeder while her eager cub bounced about in a nearby tree. Did I miss the grosbeak fledging?

I have been seriously pursuing wildlife and wildlife photography for over forty years now and have developed a pretty large body of work featuring large and small mammals, insects, birds, and fish. For decades, others have been using my wildlife photographs to tell their own stories—to illustrate their natural science books, sell their products, or convey particular sentiments on a calendar—but the market for stock photography is changing. Images of just about every thing and every place can be purchased for literally pennies over the Internet. So I don't really need to

keep taking more wildlife shots, but I just can't stop taking those pictures.

I still get a thrill when I come across a colony of tiny pikas and have an afternoon to spend with them as they run about, gathering grasses and wildflowers, calling to each other, sitting up to take my measure. Watching them engage in their busy lives is more compelling to me than trying to capture another ultimate pika shot, but still I

Below

A visit to our deck from a big cinnamon black bear is an undesired outcome of feeding wild birds. Even worse, this sow's cub was watching (and learning) the dangerous behavior from a nearby tree. Nonetheless, the encounter was exciting; I photographed the adult walking the deck rail like a balance beam, fifteen feet (4.57 meters) above the ground.

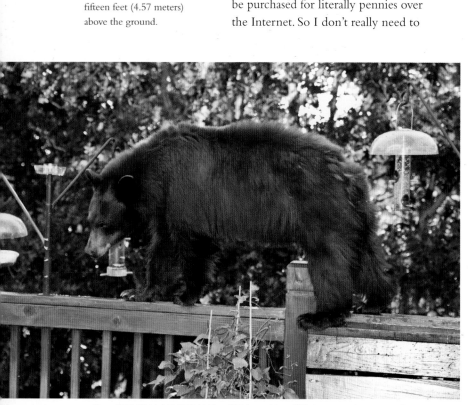

Canon EOS 5D Mark II, EF 24-105mm f/4L lens at 80mm, fill flash, exposure of 1/60 second @ f/5.6, ISO 200

put on the 500mm lens and the 2x extender and set it all up on a sturdy tripod.

These days, I'm as likely to take video as stills, but either way there's probably no financial reward for the afternoon's work with the pikas. So why bother? I do it because their habitat is so threatened, and because it's increasingly rare to find them. I do it because I want to see their bright eyes and hear their sharp calls. I want to understand what they do and why they do it. I want to know them, every one of them. And I want you to know them too.

In this book, Kathy and I have gathered up my favorite wildlife images—my personal trophies—and Kathy has coupled these images with the stories of how they came to be. She writes in three voices: mine, her own, and the subject's. To ignore the greater context of the subject's story

Below

I photographed this American pika in the San Juan Mountains of Colorado, near Telluride, at about 12,000 feet (approximately 3,658 meters). Because of loss of suitable habitat, pika populations are disappearing from lower elevations in the Rockies.

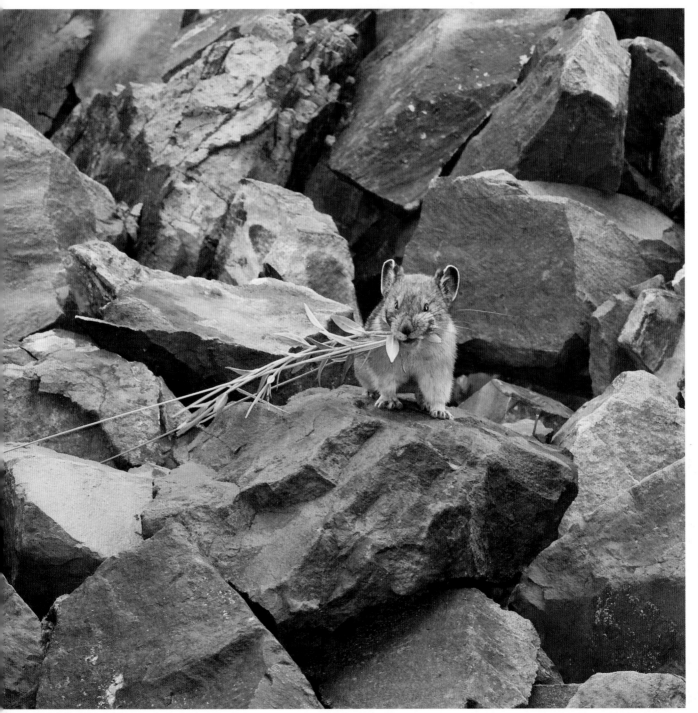

Canon EOS 5D Mark II, EF 500mm f/4L lens and EF 1.4X tele-extender, ISO 400

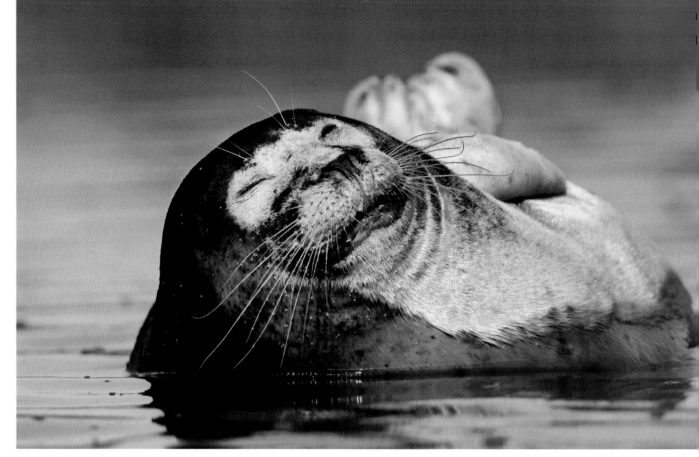

Canon EOS-1V, EF 100-400mm f/4.5-5.6L lens at 400mm

Above

Everything about this Morro Bay harbor seal says, "Life is good!" He looked glad to see me, seemingly welcoming my kayak, my camera, and me into his environment. It's hard to resist attributing human emotions to an animal that looks as happy as this guy.

Opposite, top

A small group of elephant seals established a rookery on the central California coast near the Piedras Blancas lighthouse in 1990. As their numbers grew and breeding began, their location became a popular destination for nature photographers and tourists driving along scenic California Highway 1. With the increasing numbers of visitors, volunteer organizations and wildlife managers imposed controls that manage access for photography in a quest to protect both the seals and the public.

would be disrespectful; to construct that narrative, we drew on our own observations and experiences as well as the knowledge of others. The reality of environmental change and the effects of human-generated stress on wild creatures and their habitats cannot, in our opinion, be separated from the subjects and the photographs.

You'll find many instances in this volume where, in our attempts to express the look, attitude, or behavior of an animal, we draw a comparison to human experience. In doing so, we are trying to convey to you, our human reader, the special characteristics of a particular subject in terms you can recognize. We attribute intelligence and feeling—and inter-species communication—to wild things. Thus, we trust that you will indulge us when we encourage you to imagine delicate chulengos (baby guanacos) performing ballet in pink leg warmers! But this book is certainly not just about emotion; it's about the obstacles, the questions, the answers, the mysteries involved in capturing these images; it's about the equipment, the techniques, the magic that creates powerful photographs. In short, the remainder of this book contains the when, where, and how of

my wildlife photography. And if you've read this far, then you already know the why.

When I started my journey to becoming a nature photographer some forty years ago, there were few competitors. Now, the natural landscape is a very crowded playing field, and it's harder than ever to capture a unique image. In my more cynical moments, I see us all on the same circuit, moving through parks and mountain passes, along the coasts and through the river valleys, seeking the same subjects. When one photographer stops suddenly, the line behind him crashes; I imagine tripods and bodies in photo vests, all piled up like pick-up sticks.

Over the months that Kathy and I worked to put this book together, we had many discussions about what lies in store for young nature photographers in the years ahead. I feel very fortunate to have entered the field of nature photography at a time when subjects, and opportunities to photograph them, were abundant. But am I done now? No way! I want to go back to every place depicted on these pages and do it all over again. With all the technical and creative power offered by today's digital cameras, image-stabilized lenses, and capture

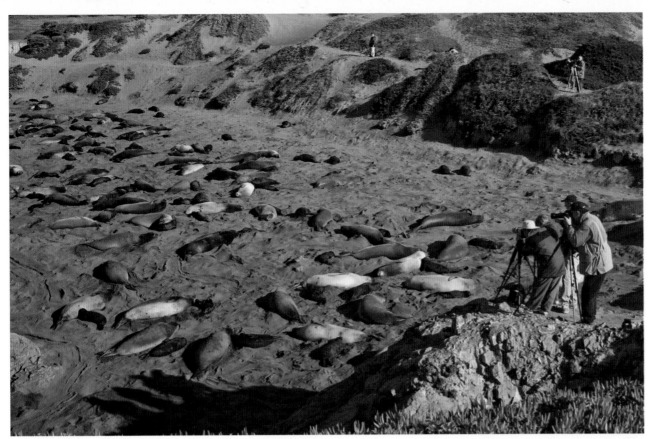

Canon EOS-D30, 28-135mm f/3.5-4.5 lens at 28mm

and composite techniques, I have a renewed urgency to document the wildlife I love, and I hope that talented younger photographers will find the impetus, inspiration, and resources to do the same.

To the next generation of nature photographers, I say please do it better than I did. Please focus on the challenges faced by our environment and shout them to the world. Please seek out the grace, beauty, and purpose of each creature that calls to you, and document that life for posterity. Please join the line of nature photographers who've gone before you, put your tripods where theirs stood, and contribute your vision to the field of wildlife photography. And please, as long as I'm standing, save me a place in the queue.

Right

Colorado nature photographers love the approachable mountain goats that live at the summit of Mount Evans, but apparently the feeling isn't always mutual. Or maybe this is just a goat's way of saying "hi."

Canon EOS-1D Mark II, EF 100-400mm f/4.5-5.6L lens at 400mm, fill flash

MAMMALS

GEORGE AND KATHRYN LEPP

WAITING FOR ELEPHANTS

The extra-large, free-roaming elephants of Kenya's Amboseli National Park are, like the park itself, treasures of disputed ownership. The park, its residents, and the indigenous African Maasai people who live around it and across the border in Tanzania, are elements of the ever-changing political and economic environment in the African nations that profit from eco-tourism. But the Amboseli elephants know no borders. On a photographic safari in Tanzania, our Maasai guides positioned us at the border with Kenya, where we waited in open vehicles for the usually gentle behemoths to wander over in their incessant search for food.

FACE TO FACE

This big bull elephant walked directly towards our vehicle and allowed a full-frame face shot at the zoom lens' maximum range of 400mm.

Canon EOS-1N

There's something very eerie about being surrounded by a herd of huge elephants; we in our tiny vehicles actually became one of the group and moved along with them to reposition ourselves for photography. Amazingly, they allowed it. Long lenses were completely unnecessary. Everywhere we looked, there was nothing but the sight, sound, and smell of elephants. There were no trumpeting displays, but rather gentle, heavy breathing, chewing, and the sounds of thorny acacia bushes being torn from the parched earth.

Another strategy for photographing elephants is to wait where they drink. At the end of the dry season, the animals predictably

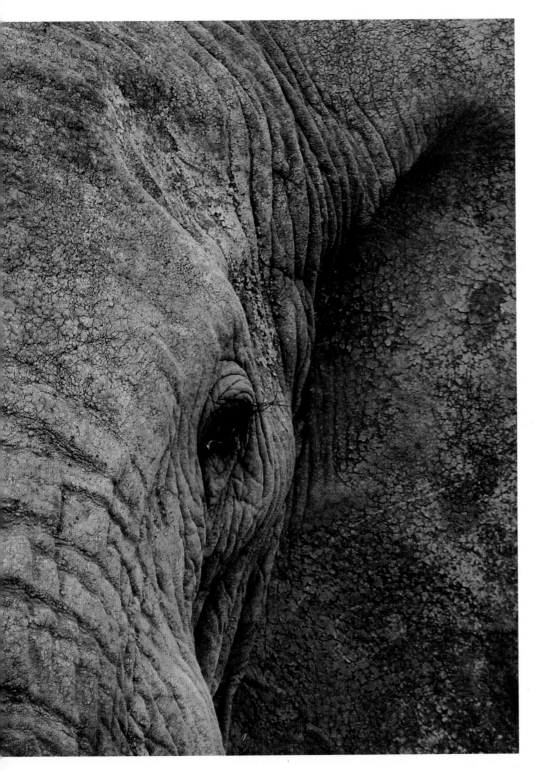

SOMETIMES, THE BEST WAY TO HUNT FOR WILDLIFE IS TO LET IT COME TO YOU. IF YOU POSITION YOURSELF IN A PLACE WHERE YOUR SUBJECTS WANT TO BE, YOU CAN SIMPLY SIT BACK AND WAIT.

MAMMALS

GEORGE AND KATHRYN LEPP

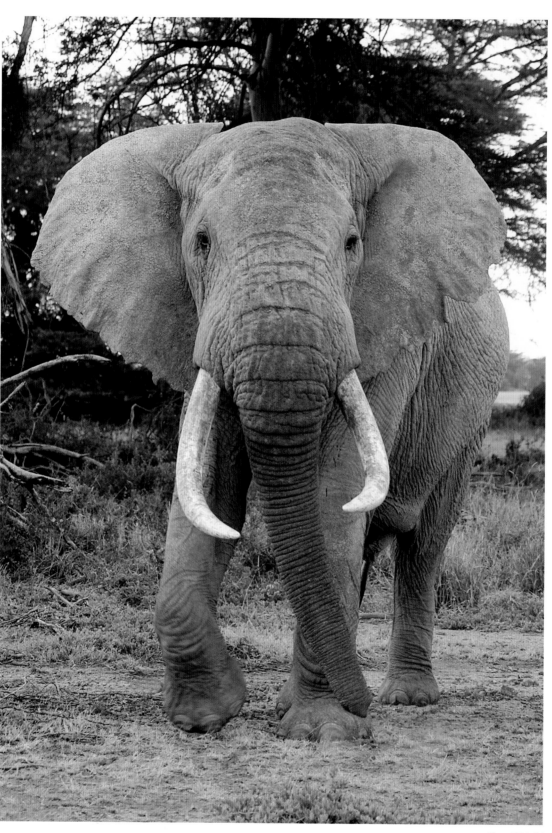

Canon EOS-1N

Above

At 100mm, this portrait of the same elephant featured on
page 26 is a much more traditional view, shot from the same
position, with the same gear.

visit remaining waterholes. Our guides at the Etosha National Park in northwestern Namibia positioned us at one spot two days in a row, certain that an elephant herd would arrive, and they were right. We had occupied ourselves with photographing the myriad other visitors to the waterhole: warthogs, antelope, zebras, hartebeest, and many birds. But suddenly, we became aware of a cacophony of trumpeting and stomping in the distance. As the herd moved closer, their dust and scent preceded them. On they came; the bulls, cows, and calves aggressively scattered the other animals until they had the waterhole completely to themselves. And we, of course, then had the elephants all to ourselves, so close around us that their huge bodies overflowed every frame.

Below

While I was working from a set position at the waterhole, a variety of potential subjects passed close by. I used a 500mm lens on this big female and her new calf to tighten the image and put emphasis on the very small infant.

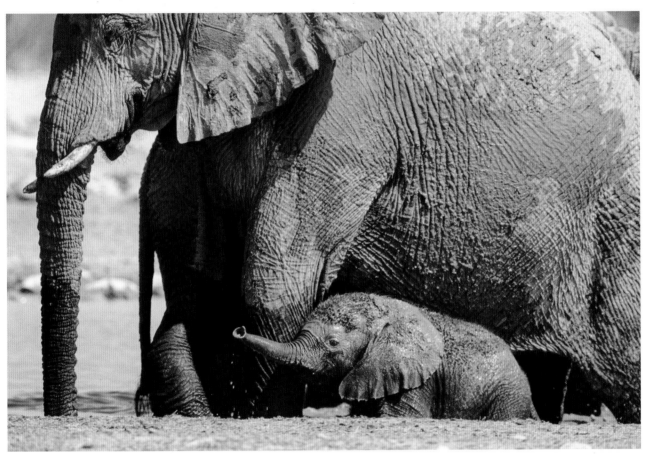

Canon EOS-1N

WHO SAYS YOU ALWAYS HAVE TO USE A LONG LENS ON WILDLIFE? SOMETIMES THE BEST WAY TO PORTRAY A HUGE SUBJECT IS TO WAIT FOR IT TO COME SO CLOSE THAT IT FILLS THE FRAME.

GEORGE AND KATHRYN LEPP

MAD MAMA: THE ELEPHANT WE'LL NEVER FORGET

Since elephants have no natural environments in the western hemisphere, we tend to view them only as we see them in captivity, as intelligent and amiable performers or unique transportation. When you observe elephant herds on their own turf, you learn that they are bigger than you thought—and they like to throw their weight around.

During our photo safari in Botswana in November 2007, we encountered several large herds of hundreds of African elephants, and some smaller breeding herds with newborn young. The 250-pound infants are sweet and funny to watch as they trundle along, uncontrolled ears and trunks flapping and waving every which way. Our guides made it clear that elephants are extremely dangerous animals, and it was somewhat unnerving to be in an open vehicle situated between a large group of elephants and the place they wanted to be. Still, an experienced driver will usually succeed in calling the bluff of a blustering young male, moving him aside with shouts and a steady, forward pace.

We met Mad Mama on a hot afternoon near Little Vumbura Camp on the Okavango Delta. Our driver stopped the vehicle on the road when we saw the big female with her young calf and a number of other cows about a quarter-mile away. We waited to see if the herd would continue its approach toward us. It did.

Almost immediately, the herd broke in a direction that would bring it across the road in front of our vehicle, and we all readied our cameras to photograph the action. But as Mad Mama reached the road, she led the group directly toward us, and everything about her told us she was really, really angry. Our guide, taking his own photographs, seemed not to notice her determined approach as she tore down the road with her baby and several adult females following. When she stopped about a hundred feet away, red eyes bulging and ears rigidly flared, the guide realized she was not bluffing and finally undertook measures meant to deter a charge: he banged the side of the vehicle with the flat of his hand and shouted. On she came, and as it became clear her intent was to destroy the vehicle and its occupants, the driver started the engine and threw us backwards as fast as he could drive.

We careened in reverse, bouncing off the road, somehow evading trees and termite mounds that would have meant disaster. I kept my camera firing on Mad Mama until her head and extended ears overflowed the frame, her tusks hit the front of our vehicle, and my buffer was full. At that point the driver, still driving backwards and gripping the steering wheel with his right hand, grabbed a full bottle of water in his left and threw it at the raging elephant, only four feet (1.2 meters) away. The bottle hit her right between the eyes, and she went down to her knees, stunned, just long enough for us to turn around and take off.

◇◇◇◇◇◇◇◇◇◇◇◇◇◇◇◇◇◇◇◇◇◇◇◇◇◇◇◇◇◇

I'VE BEEN PHOTOGRAPHING WILDLIFE FOR MORE THAN FORTY YEARS, AND IN THAT TIME, I'VE HAD A FEW ENCOUNTERS WITH BEARS, BIG CATS, AND MOOSE THAT MADE ME NERVOUS. BUT THE CLOSEST I'VE EVER COME TO BEING SERIOUSLY HURT BY ONE OF MY WILD SUBJECTS WAS A MEMORABLE MEETING WITH A RED-EYED, TRUMPETING, EAR-FLARING ELEPHANT WE NAMED "MAD MAMA."

◇◇◇◇◇◇◇◇◇◇◇◇◇◇◇◇◇◇◇◇◇◇◇◇◇◇◇◇◇◇

Right

Mad Mama lets us know we are not welcome on her turf, while her baby joins in the excitement and learns how to deal firmly with unwelcome intruders.

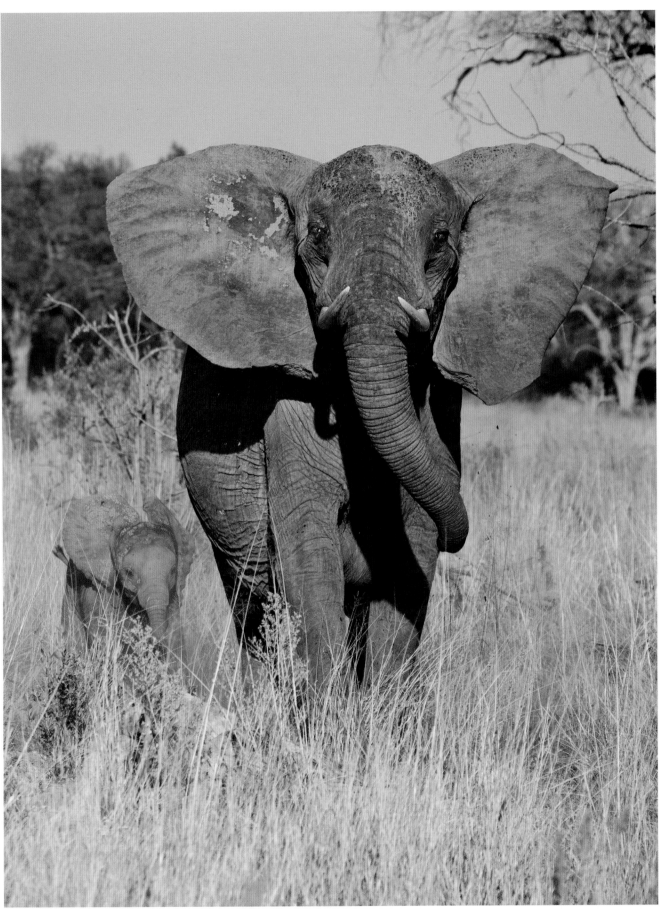

Canon EOS-1Ds Mark III, EF 100-400mm lens at 235mm

32

We'd love to know why Mad Mama reacted so furiously to our presence; we'd been in the middle of other breeding herds that seemed completely unthreatened by our photography. But the elephants of southern Africa migrate long distances, their habitats are shrinking, their herds are decimated by both licensed and illegal hunting, and they live long lives with many violent experiences. It's easy to understand how an elephant's intelligence, strong social networks, and complex emotions could lead to pre-emptive strikes against human intruders who are, after all, an elephant's only real and continuing threat. Maybe a 600mm lens looks a lot like a gun to an elephant who has had a bad experience with hunters. If that's the case, Mad Mama—wherever you are—you go, Girl!

WHEN YOU ENCOUNTER AN ANIMAL IN THE WILD, YOU REPRESENT ALL OF THAT INDIVIDUAL'S CUMULATIVE EXPERIENCES WITH HUMANS, AND YOU ARE ADDING TO THAT EXPERIENCE WITH YOUR OWN ACTIONS.

This spread

In the first of a multiple-capture sequence, Mad Mama lowers her head, rigidly extends her ears, and begins to charge. In the last capture, she prepares to ram the push bar of our vehicle with her tusks.

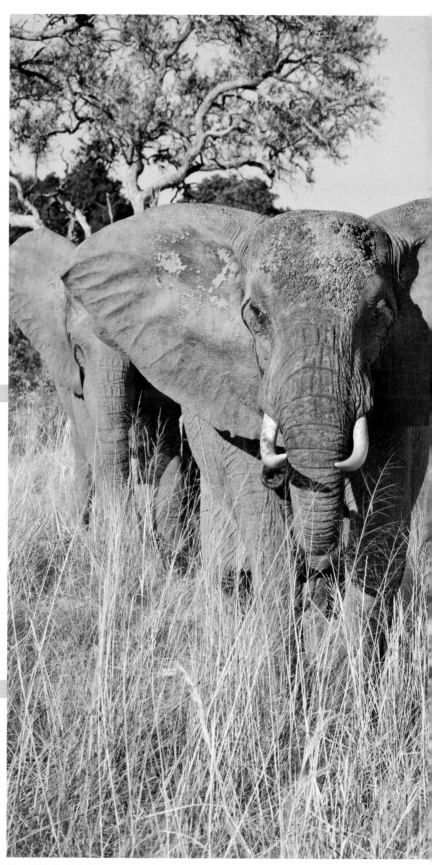

Canon EOS-1Ds Mark III, EF 100-400mm lens at 100mm

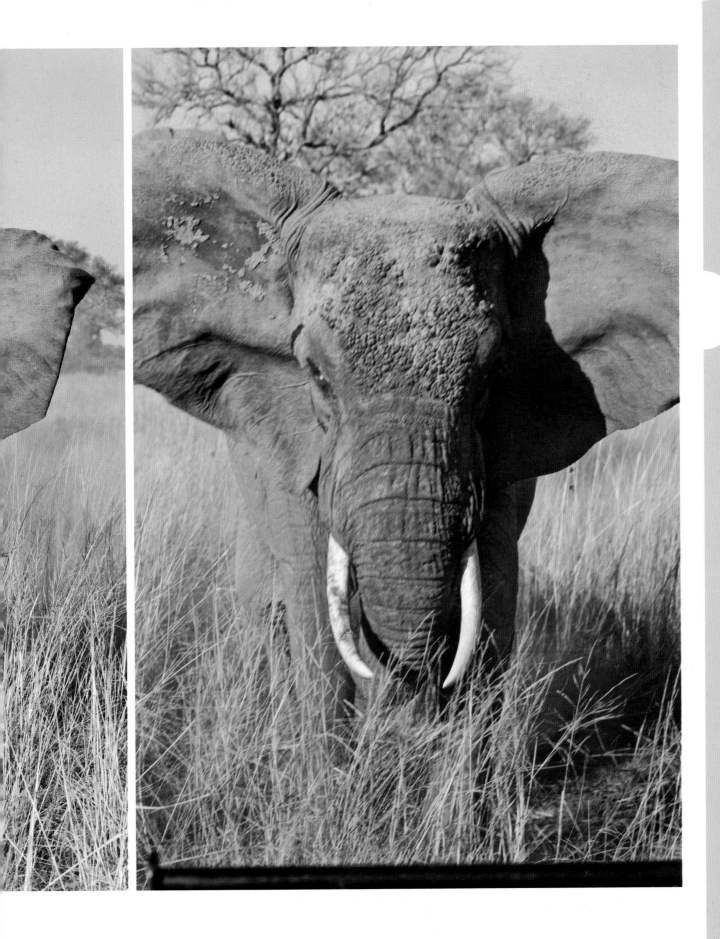

Canon EOS D30, 500mm f/4L lens with a 2x tele-extender

THE LIFE-SIZED GIRAFFE: CAPTURING TWO EXTREMES

ONE DAY ON THE SERENGETI

This is a picture about a giraffe and her calf, but their environment—the grass and the tree—makes its own statement as well. I used the equivalent of 1600mm and a technique I call "optical extraction" to make this image.

I headed to Tanzania for a two-week safari with a certain portrayal of a giraffe in mind: I wanted to emphasize the animal's height by taking a vertical composite panorama that I could, someday, print at life size. Never mind that no printer to which I had access could make the print; someday it would be possible, and it would be very cool.

On this trip, I was carrying the very first Canon D-SLR (digital single-lens-reflex), the D30, and while I had been creating panoramic images with film for decades, I had a sense that the digital camera was going to vastly enhance my success with multiple-image composites. All I needed was a cooperative giraffe that would hold still while I captured the series of images. That subject was, it turned out, quite elusive.

I love how giraffes move through their environment; they flow, they're calm, and they almost never run. But they don't really stand motionless for long, even when they're looking right at you and sizing you up. So while I kept trying to capture my vertical panorama, I had to be open to other ways to interpret a giraffe's size and to explore the potential of my new digital equipment.

One afternoon I looked out across the Serengeti and saw in the distance a female giraffe with her baby. The two were dwarfed by a massive umbrella thorn acacia tree, the giraffe's staple food source. These two iconic symbols of Africa, the giraffe and the towering umbrella tree, told the story of an unusual animal in an extreme environment.

Photographing an animal in its natural surroundings is not often an easy

composition. The environment needs to stand cleanly and identifiably as a supporting element in the image, but cannot overpower the main subject—the animal. At such great distance, this image could have been a couple of giraffe dots and a tree on a big, messy desert landscape—a throwaway. But I realized that with my 500mm lens, a 2x converter, and the 1.6x magnification factor of the Canon digital camera sensor, I had in my hands the means to photograph at 1600mm—a great tool for a technique I call "optical extraction," which is pulling a compelling composition from within a larger scene. The extreme result isolated the giraffes and the tree, making a simple statement that rendered the tallest of all land-living species small in its own world.

My two professional colleagues on the trip were still working exclusively with film, and they made no secret of their concern for my sanity as I worked again and again with my digital setup, trying to get everything I could out of all three megapixels. And on the next to last day of the safari, I was rewarded with a giraffe that was curious enough about me to watch quietly while I photographed it with seven horizontal captures that came together in a panorama. Three years later, with the advent of the 60-inch (152.4-cm) professional printer, I was able to make my 12-foot-tall print (approximately 3.66 meters). Some people think it's extreme, but they also think it's pretty cool.

In the end, I came away with my two favorite photographs of giraffes, depicted at opposite extremes of their existence: one dominates his environment, just as I had planned, and the other is dwarfed by it, as I discovered.

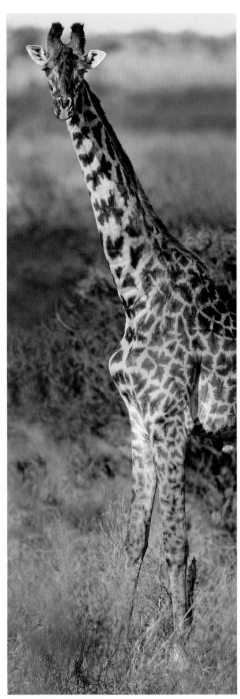

Canon EOS D30, EF 100-400mm zoom lens

35

Left

I knew I wanted a vertical panorama of an entire giraffe, but it was difficult to find a cooperative subject. This big giraffe stood motionless while I took seven horizontal shots to comprise a vertical panorama that I am able to print at near-life size.

BEFORE YOU GET TO YOUR LOCATION, IMAGINE THE IMAGES YOU WANT TO CAPTURE AND THE MESSAGE YOU WANT TO CONVEY. BUT WHEN YOU GET THERE, BE OPEN TO COMPOSITIONS THAT MAY PORTRAY THE EXACT OPPOSITE OF WHAT YOU HAD IMAGINED.

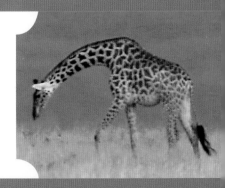

GEORGE AND KATHRYN LEPP

A TROPHY HUNTER'S PRIZE: THE AFRICAN BUFFALO

What is it about the African buffalo that makes it such a desirable target for game hunters? It is one of the African "Big Five," the five most dangerous animals to hunt on foot. It is also known as the Black Death. The African buffalo reportedly gores and kills more than 200 people each year. It's got attitude.

Due to animals like the African, or Cape, buffalo, and increasing aggression from elephants, photographers on a walking safari are really putting themselves in danger. Photographing from vehicles is much safer. The buffalo, like many other dangerous animals in reserves and national parks—including lions and leopards—seem disinclined to challenge vehicles or the people in them. (Though, as we experienced firsthand and covered on pages 30-33, elephants sometimes do.)

On an African safari, you'll likely come upon many buffalo herds, especially if you are following lions on the hunt. The groups of females and youngsters are much like domesticated cows in a field. They are prey, not predators. The cows stick together to protect themselves and their calves from the constant threat of lions.

We even encountered—with an intimacy we'd have preferred to forgo—an entire buffalo herd that surrounded our extravagantly beautiful tent lodging at Mombo Camp in the Okavango Delta. Because of lion activity nearby, the buffalo moved into the camp environs, pressing themselves tightly against one another and the elevated boardwalks we humans used to move about. Throughout the night, we heard them shuffling, squabbling, and muttering amongst themselves. Occasionally, one would challenge us as we walked above them. Seen that closely, penned up like dairy cows, the herd wasn't really very interesting to photograph.

PHOTOGRAPHERS LOOK FOR THE SAME QUALITIES THAT TROPHY HUNTERS SEEK IN AFRICAN BUFFALO: SIZE, STRENGTH, GREAT HORNS, TATTERED EARS, AND ATTITUDE IN A PRIME MALE. I AM COMPELLED TO POINT OUT, HOWEVER, THAT ONCE I'VE PHOTOGRAPHED A TROPHY-QUALITY BUFFALO, HE LIVES TO BE PHOTOGRAPHED ANOTHER DAY.

THE SAD TRUTH IS THAT THE MOST MARKETABLE PHOTOGRAPHS OF ANY SPECIES ARE THE ONES THAT DEPICT PRIME MALES, BUT AN IMAGE THAT OFFERS AN UNUSUAL PERSPECTIVE ON THE HERD CAN ALSO BE VERY SUCCESSFUL.

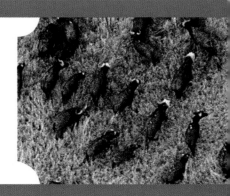

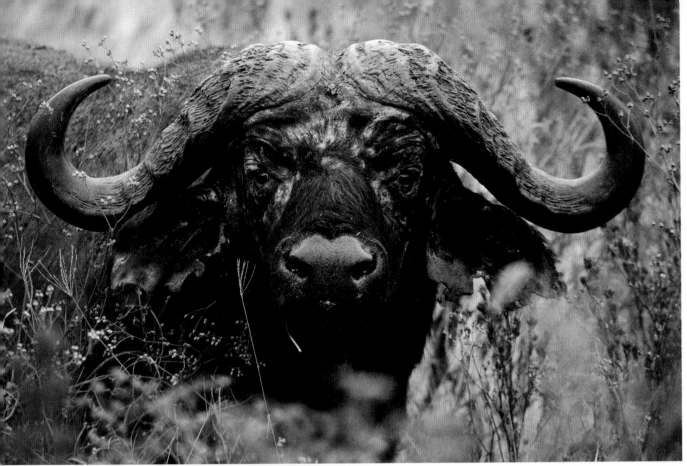

Canon EOS 1V, EF 100-400mm zoom lens at 400mm

Canon EOS 1V, EF 28-135mm lens

Above: AFRICAN BUFFALO

I photographed this standout specimen, a big old bull, off by himself in Tanzania's Ngorogoro Crater. He'd be a prize trophy for any hunter, and for the same reasons he's a prize photographic subject.

Left

For a different perspective, load yourself and your gear into a hot air balloon. An everyday herd of African buffalo becomes a compelling pattern on the Serengeti. By the way, hot air balloons don't land; they crash!

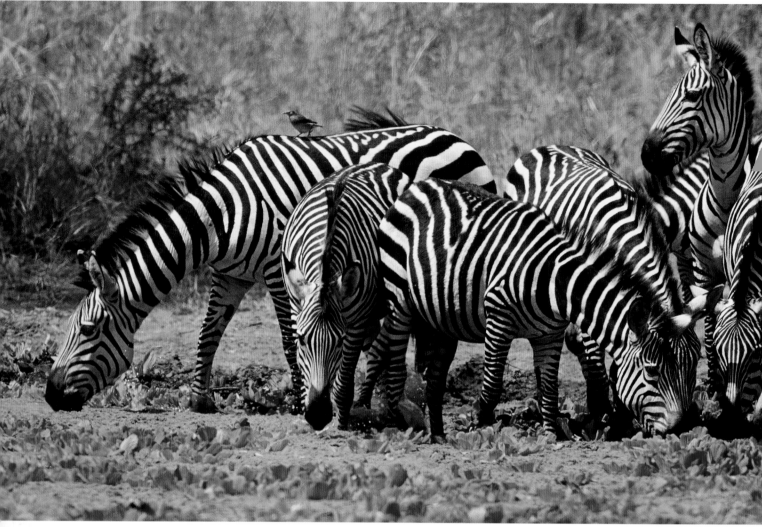

Canon EOS-1N, EF 100-400mm lens at 400mm

EARNING YOUR STRIPES WITH ZEBRAS

Two things keep me coming back for more zebra shots. First, their amazing stripes just say, "Look at me!" And, better yet, no two animals have the same pattern. Second, they tend to line up in a row, juxtaposing those flashy designs in combinations that range from aesthetic to chaotic. And a row of anything shouts "panorama" to me.

The idea of creating a multiple-image composite panorama of moving animals can be a little daunting. Add to that the complexity of the zebra's patterned pelage, and you might think matching all those seams would be impossible. Although zebras are often very animated, with the youngsters tearing about and the males picking at each other in some kind of conflict, when the group comes to a waterhole or great feeding location, differences are set aside; everyone shares in the bounty and, best of all, they position themselves attractively in a

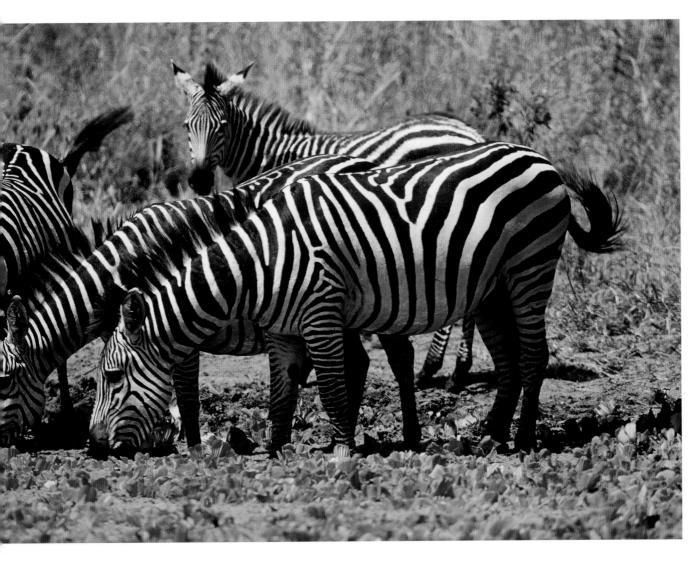

ZEBRAS AT THE POND
I captured this three-image panorama of zebras in Tanzania.

manner designed to protect the entire group from danger.

Before you work on zebras in Africa, you'll want to practice your panorama capture techniques so you can move quickly. Overlapping each photograph in the sequence by 50% will give you plenty of information for compositing the images, and those complicated stripes are actually an advantage because they provide an abundance of specific details to assist you in matching the seams. Still, a panorama of moving animals will defy most automated compositing software; you will most likely need to assemble your panorama manually in Photoshop. And there's more you can do with zebra images, of course. Close-up portraits and the interactions of big males, mares and foals, and adolescents all offer the usual appeal, enhanced and energized by those incredible patterns.

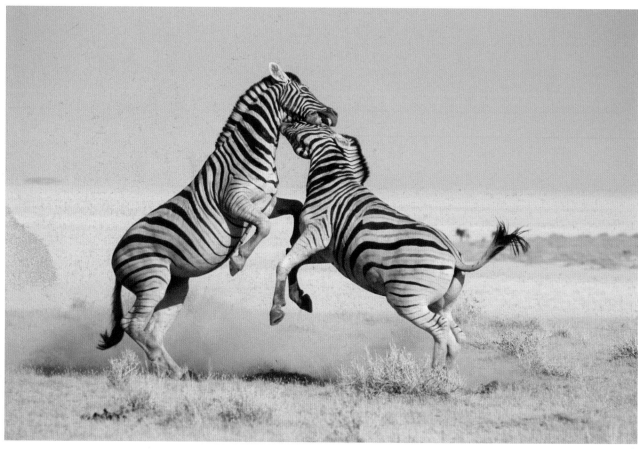

Canon EOS-1N, EF 100-400mm lens at 400mm

A ZEBRA IS AN INHERENTLY INTERESTING SUBJECT, SO MAKE THE MOST OF IT BY PHOTOGRAPHING INDIVIDUALS, AND THE HERD, IN WAYS THAT MAXIMIZE THE DESIGN AND HARMONY OF THE COMPOSITION.

Above

As these big stallions tussled on the edge of the Etosha salt pan (a dry lake bed), I quickly framed and captured an entire series of handheld images with a motor drive.

Below

I photographed these placid zebras at a water hole in Etosha National Park, Namibia, for a peaceful hour until the area was completely disrupted by the arrival of a herd of boisterous elephants. This multiple-image composite panorama was captured with the support of a tripod from within our vehicle.

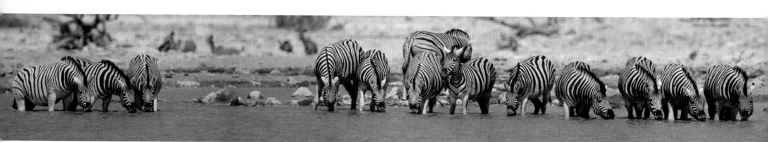

Canon EOS-1N, EF 500mm lens with a 1.4x tele-extender

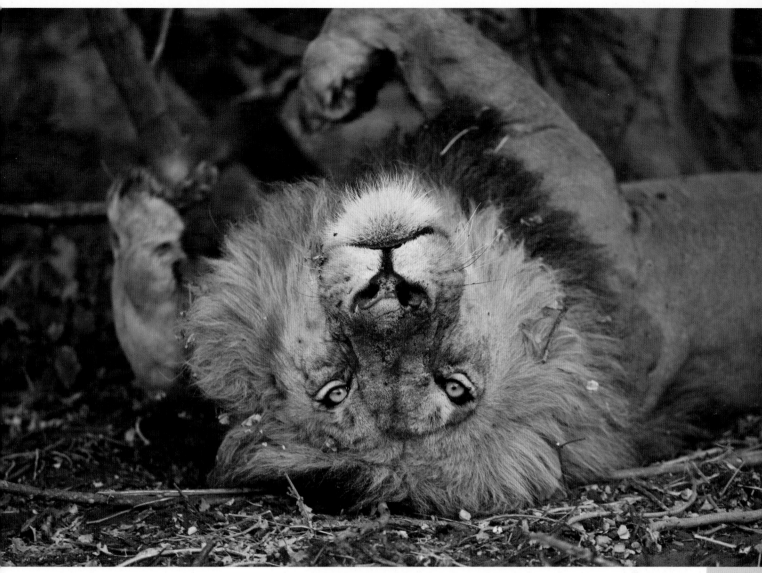

Canon EOS-1Ds Mark III, EF 500mm f/4 lens

THE BOYS OF DUBA: IT'S GOOD TO BE KING

In November, the Duba Plains are hot, and the winds offer no relief as they just transfer the dust from one place to another. One afternoon, we came upon a large male lion sleeping in the shade of some bushes close by the road. Our guide parked some 30 feet (about 9 meters) away, and we watched the dangerous animal do cute cat things as he napped. When he woke, he gave himself a lengthy grooming. Rolling charmingly on his back, he gazed at us with his golden, knowing eyes. Abruptly, he sat up and stared intently into the distance, where we could see a second big male moving toward us. We were in the presence of the famous Duba Boys, two big lion brothers

who had controlled the area for some ten years—three to five times as long as the typical tenure.

Many of the ranger guides employed at African camps are actually more like keepers of huge zoos without cages. They know the wildlife that frequents their area of responsibility well, including the intimate details of who mates with whom, who gives birth to whom, who eats whom, and when. The extraordinary reign of the Duba Boys is well documented in personal journals, blogs, and YouTube posts. Their ability to fend off challenges from younger males and to sire strong, extra-large offspring with the females of the Tsaro pride became the stuff of legend

UPSIDE DOWN DUBA BOY

When I show this image in my programs, people always chuckle in response to the big male lion's cute, kittenish pose. But the image makes me sad because I know the whole story: This big old guy was badly injured and living the last months of his long and legendary life.

MAMMALS

GEORGE AND KATHRYN LEPP

42

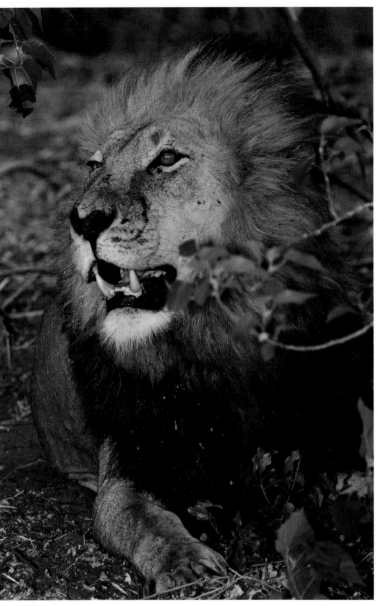

Canon EOS-1Ds Mark III, EF 500mm f/4 lens

Above

This is one of the famous Duba
boys, still regal, but showing
his age.

as literally thousands of visitors observed and photographed them over the decade of their dominance. Every guide could tell the story of each challenger, each violent encounter, each potential heir to the throne. The stories did not always match, but greatness was a constant theme.

When we met the Duba Boys that day in November 2007, they were about seventeen years old and the pride had been taken over by an intruder, introducing much-needed genetic diversity to the local lion population. But the two brothers had been broken by the young challenger. As we watched, the first limped around our vehicle, then dropped down in the full sun beside the road. We could see that he was badly injured; his left foreleg was either broken or infected, easily three times the size of the right, and he could not walk on it. We drove out to meet the lion's brother, who stretched out in the dust. This big cat had an infected eye, with a gash extending across his face to his nose. He died before the end of the year, and his lame brother was fatally gored by a buffalo a few months later.

It's good to be king, but no animal escapes the brutality that governs the African plains. Nearly every animal—predator and prey—bears the wounds of its experience. Still, I have to think that the long reign of the Duba Boys had to do with their steadfast and unusual partnership; it must always be harder to go it alone.

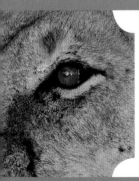

ALWAYS EMBRACE THE WISDOM AND KNOWLEDGE OF LOCAL GUIDES; THEIR LOVE OF THEIR PLACES AND THEIR CHARGES WILL GIVE RICH CONTEXT TO YOUR WILDLIFE PHOTOGRAPHY.

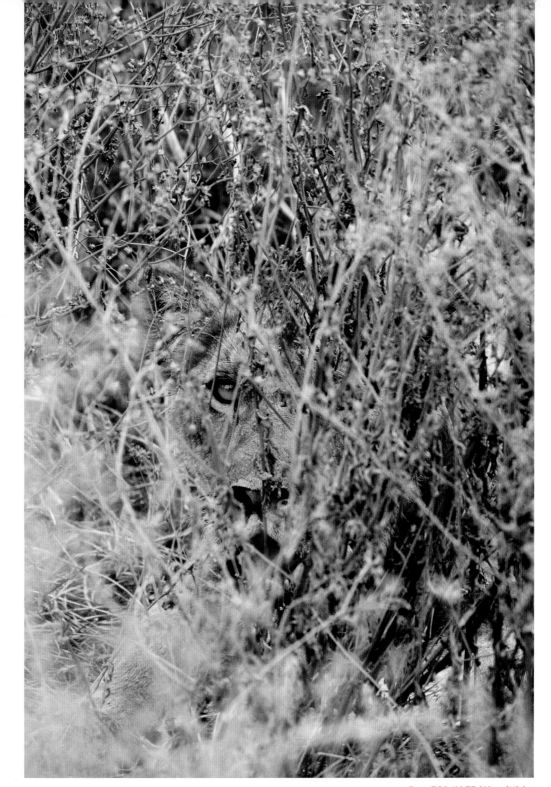

Canon EOS-1N, EF 500mm f/4L lens

THE BEAT OF AFRICA

Before Kathy went to Botswana for the first time, she was told she would fall in love with "the beat of Africa." And she did. There's background music everywhere on the Okavango Delta in Botswana, but you don't always hear it when you're on a game drive because of the noise of the vehicles, the firing cameras, the chatting and joking, and the guides' radios. Mostly, you hear it when you're alone.

Outside our camp lodgings, the air roils with the beat. In the distance lions roar and elephants trumpet; insects buzz like alarm clocks and chirp like cell phones; a frog makes a noise like hitting a reed pipe with

EYE ON YOU

This lioness uses golden grasses to good effect; her pink nose and glaring eye are the only visual clues to her presence.

a stick—multiplied by a thousand frogs and sticks. You hear caws, bleats, barks, yips, and honks like bicycle horns. Baboons squabble like bad neighbors. Women and men sing. And beneath it all, you can hear the steady chant of the red-eyed dove: HOO HOO hoo hoo—HEE hoo.

In the area around Mombo Camp, waterholes dot the wide green plains. The grasses and ponds draw thousands of animals; grazing herds of antelope, buffalo, zebra, red leche, and tsessebee are punctuated by rooting warthogs, baboon families, banded mongooses tearing in packs from one hole to another, an occasional elephant, and birds—storks, eagles, kits, skimmers, plovers, doves. Early one morning, we watched and listened to this energetic community, and under it all was the steady beat of one especially peppy red-eyed dove. We were enchanted

by our first look at a newborn impala and her doting parents. All sorts of interactions happen on the plain: play, male posturing, mock and real fighting, scampering and leaping just for the pure joy of it, courtship, mothering, nuzzling, nursing.

That morning, along the edge of the plain, a big lioness emerged from the golden grasses. Soon after, the thousand animals had eyes and ears on her as she confidently surveyed their community. We expected her to go for any number of seemingly vulnerable victims, but she kept moving and we followed her to the hippo pond. A family of baboons screamed furiously at her from a nearby tree as she rested. When she disappeared into the forest, the plain took up its life and song once more. The dove counted out a few more measures, then was silent.

Below

In the early morning light, everything turns golden. Photographing a backlit subject calls for precise exposure to maintain detail in the dark foreground while retaining the highlights.

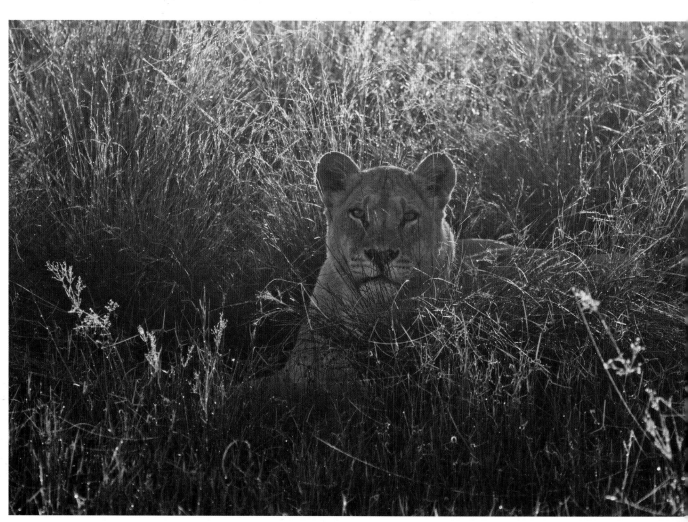

Canon EOS-1D Mark III, EF 100-400mm zoom lens at 210mm

Canon EOS-1D Mark III, 500mm f/4 lens with a 1.4x tele-extender

WE SEARCHED FOR OUR LIONESS AROUND THE TREES, AND ON THE EDGE OF A TERMITE MOUND WE FOUND HER, A RED-EYED DOVE BETWEEN HER PAWS, FEATHERS FLYING AND CLINGING TO HER WHISKERS. WITH ALL THE GAME SHE'D HAD TO CHOOSE FROM, SHE WAS EATING THE BEAT OF AFRICA!

Left

Bearing a leg wound from a previous struggle, this big female lion bypassed all the seemingly vulnerable prey on the vast plain and settled for an easy tidbit, a red-eyed dove.

THE SOUNDS OF A PLACE TELL STORIES IN MANY LANGUAGES, AND WILDLIFE PHOTOGRAPHY IS AS MUCH ABOUT LISTENING FOR, AS IT IS ABOUT SEEING, PHOTOGRAPHIC OPPORTUNITIES.

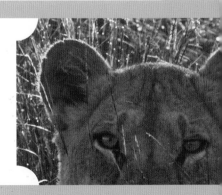

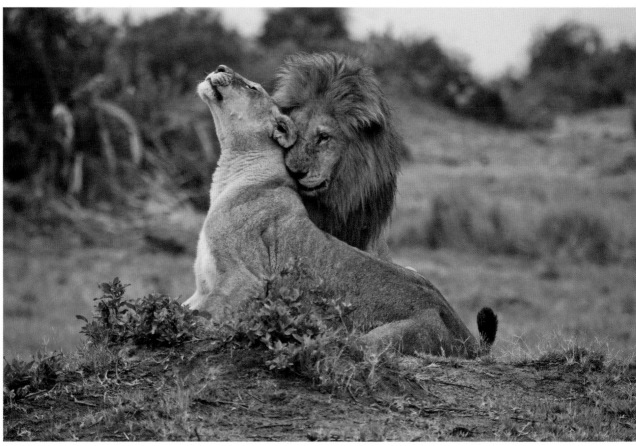

Canon EOS-1D Mark III, EF 100-400mm lens at 300mm

The Thrill of the Kill—Or Not So Much

LOVE SCENE

A big lioness of the Duba Plains pride accepts affection for just a moment before heading off with her colleagues to hunt. Wildlife experts in the region have been following the progress of this pride with concern, as older females have been killing most of the cubs born in the past few years.

The kill is one of the most dramatic aspects of an African safari, and some tours seem obsessed with it, keeping track of the hunting schedule, tearing around from one likely spot to another, alerting other guides by radio when a kill occurs, and spending hours watching the succession of predators working on a single carcass. It's part of the brutal, beautiful reality of the wildlife-rich deltas and savannahs of the African landscape and, as a nature photographer, I've had more than my share of opportunities to document the shocking sights, sounds, and smells of the kill. But I have to tell you, I'd rather not. It's much more fun, and a lot more challenging, to photograph the hunt. Especially when the hunters—or huntresses in this case—are the infamous, extra-large lionesses of the Duba Plains, and your guide

is the incredibly skilled Grant Atkinson, who can predict their every move and get you in front of it with the light in just the right position for prime photography.

The pride had killed a buffalo only the day before; we had come across the carcass earlier, with an old male and a three-month-old cub chewing on the remains. It wasn't expected that the lions would hunt again soon, and we were not surprised when we encountered two of the large cats and a ten-month-old cub sleeping it off on a termite mound. Not far away, a love-sick male tenderly nuzzled another big female. As we looked on, the sleeping lionesses began to stir, watching with little interest as a guinea hen, and then a jackal, passed by. The courting female abandoned her suitor to join her colleagues; the cats stretched, scratched, paused, and then they began to hunt. It was

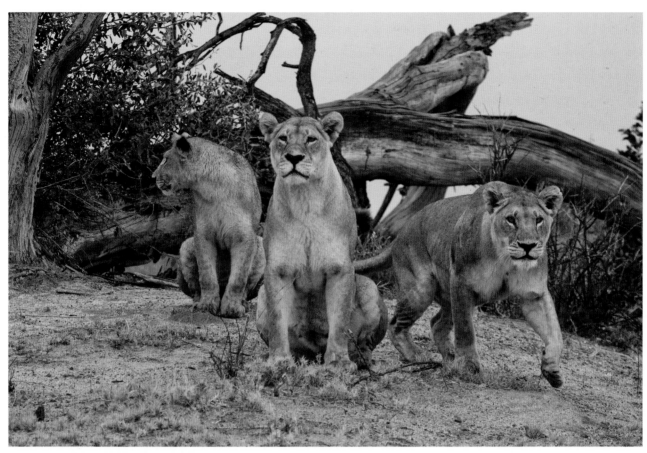

Canon EOS-1Ds Mark III, EF 100-400mm lens at 220mm

as if one said, "Let's go out to that great buffalo place again for dinner tonight," and the rest answered, "You're on!"

The nearest herd was not far away; we could hear it ourselves. Our guide, Grant, drove ahead, positioning our vehicle first below the approaching hunters, then above. We photographed the lionesses as they confidently moved toward the buffalo that grazed beyond a small, heavily treed hill. The lions positioned themselves in the undergrowth as we drove around the hill toward the herd.

I heard Kathy murmuring, "Don't go in there… don't go in there," and I turned to see a lone female buffalo, lagging behind the herd, move into the brush where the lions waited. A moment later an unforgettable moan lifted on the air. We rounded the corner to see the big animal on the ground,

brought down by just one lioness. It took thirty minutes to die, slowly suffocated by the lion at its throat. There was no marketable photography there, but it seemed disrespectful to leave while the buffalo still lived, so we stayed until it was clear that, for the buffalo, it was over.

We moved on to a fish trap—a place where floods have receded to leave a pool of concentrated fish. It was teeming with saddle backed storks and pelicans. Another killing and eating frenzy was going on, but this was one where the prey were silent and eaten whole. We stayed there, under a brilliant sky, watching the vividly colored birds eat their fill until all the trapped fish in the small pool had been consumed. Then the birds rose together and moved on.

Above

These extraordinarily large females are extremely successful hunters living in a region of abundant food sources.

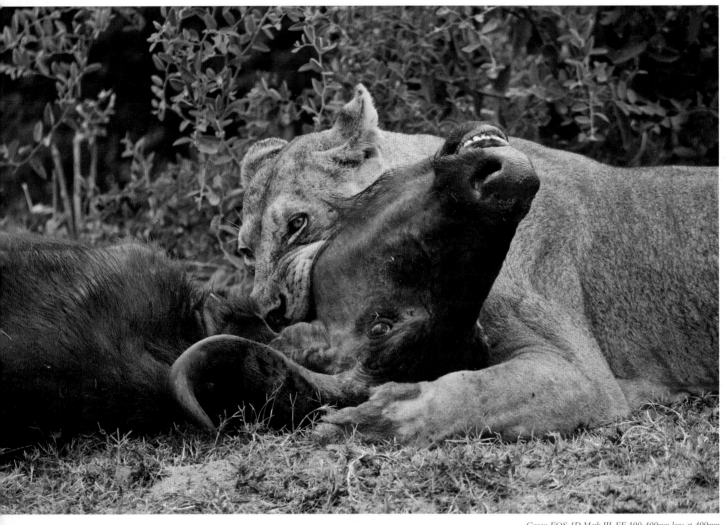

Canon EOS-1D Mark III, EF 100-400mm lens at 400mm

Above

A Duba Plains lioness brings down an adult buffalo on her own; the prey will die slowly from suffocation.

ON SAFARI, BE PREPARED FOR, AND RESPECTFUL OF, THE EVERYDAY BRUTALITY OF THE FOOD CHAIN IN THE WILD. PHOTOGRAPHING IT REPEATEDLY, HOWEVER, HAS LITTLE ARTISTIC MERIT. THERE ARE FEW VARIATIONS, AND WITH CONSTANT REPETITION THE SUBJECT LOSES ITS SPIRIT AND POWER.

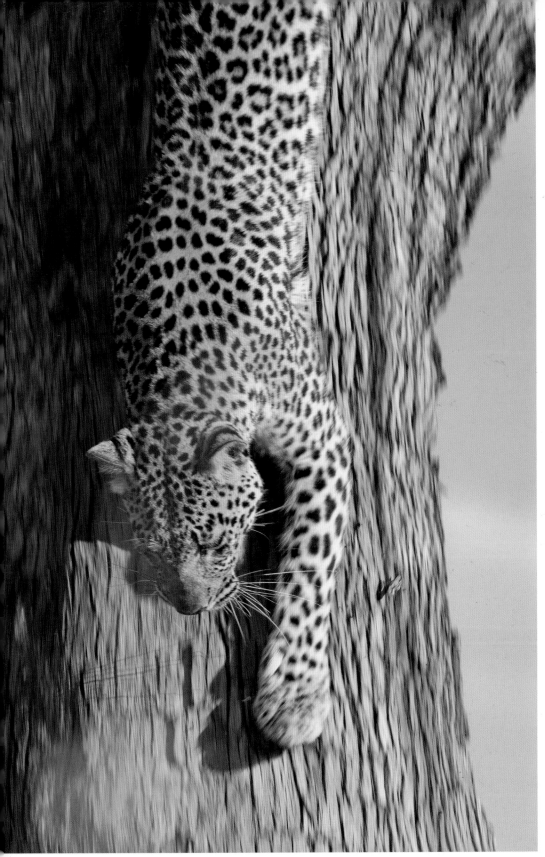

LOOKING FOR LEOPARDS? LOOK UP!

WHAT GOES UP MUST COME DOWN

Leopards move quickly and with determination, so you've got to be ready.

Canon EOS-1Ds Mark III, EF 500mm f/4L lens, exposure of 1/125 second at f/11, ISO 200

PERHAPS THE BEST THING ABOUT LEOPARDS AS A PHOTOGRAPHIC SUBJECT IS THEIR PROPENSITY TO LOUNGE ABOUT IN LARGE TREES, OFFERING A UNIQUE BACKDROP THAT NEVER FAILS TO PIQUE A VIEWER'S INTEREST.

MAMMALS

Opposite

Without projected flash, this close-up portrait of a backlit leopard would have been impossible. Intensely focused light brings out the shadows around the big cat's eyes and mouth and sharpens every whisker.

Below

Because of the backlighting, it was challenging to capture this leopard as it repositioned its prey, an unfortunate jackal. Projected flash coupled with ambient light caught all the detail of the action and maintained the natural background.

Leopards can often be seen in sub-Saharan Africa; in Botswana's Okavango Delta, we encountered and photographed several of them. Memorably, we found our first leopard of the safari when we came upon a surreal sight: a dead jackal, slung over a tree limb like a wet towel on a rack, twenty feet above the ground. Hundreds of insects buzzed dizzily around it, and a large female leopard reclined on a termite mound nearby. She had an open neck wound, and perhaps a headache. Occasionally, she threw a half-hearted snarl towards a silly grouse that uttered repeated alarm calls while shuffling around in the grasses not ten feet away from the cat (about three meters).

Our guide placed the open Rover between the leopard and its lunch in the tree, and we watched and waited. When finally she stood and walked toward us to reach the tree beyond, it was as if we were invisible to her, although she could easily have jumped into our vehicle. Effortlessly she scaled the tree trunk and moved among the limbs and branches to her jackal, which she threw around for awhile to position properly for eating. She seemed oblivious to the noise of cameras and the projected flash I was concentrating on her, but her eyes sent the light back to us in an eerie way.

One of the challenges of photographing a leopard—or any animal—in a tree is the problem of contrast. Typically, the sky behind the subject will be light, and the subject itself will be in shade. Using a flash on the subject with a fast shutter speed lights up the animal and stops action, but it wipes out the background, making it appear that the photograph was taken at night. By decreasing the shutter speed, and coupling it with a shorter flash duration focused on the subject, both the animal and the background light are captured in the image. For photographing wildlife at a distance, I use a projected flash attachment, which concentrates the beam through a Fresnel lens to light up an animal's eyes and mouth, stop movement, and render every whisker and eyelash absolutely sharp.

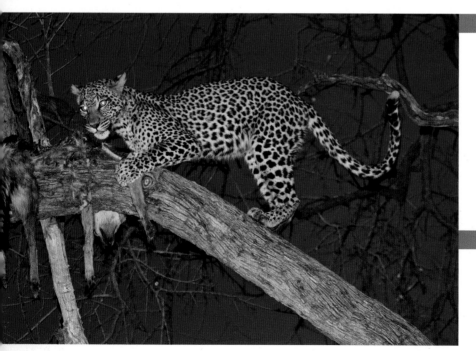

Canon EOS-1D Mark III, EF 500mm f/4L lens, projected flash

EXPECT THE UNEXPECTED. MAMMALS DON'T ALWAYS KEEP THEIR FEET (OR THEIR FOOD) ON THE GROUND!

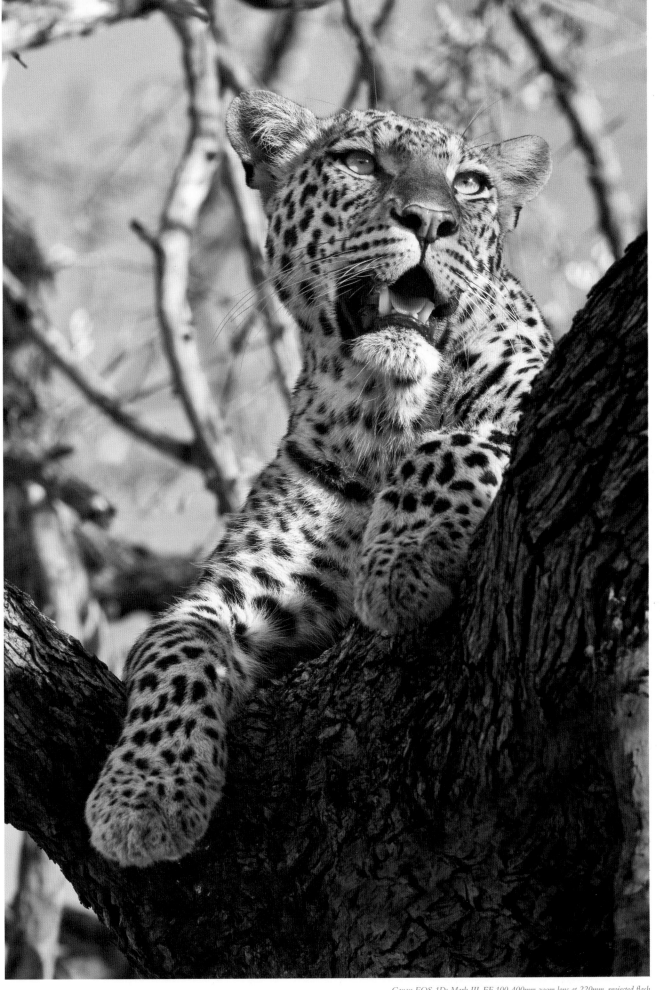

Canon EOS-1Ds Mark III, EF 100-400mm zoom lens at 220mm, projected flash

ON THE CATWALK

O f all the big African cats, the leopard possesses an elegance that I find especially fascinating. A leopard seems in complete control of itself and its environment. Each graceful movement is imbued with purpose.

Instead of operating and feeding in packs, as lions do, the leopard mostly lives and hunts independently. Leopards are seemingly cooperative subjects, too, if you take the time to follow them. They move confidently through the grass, then pause (and pose) to survey the area, selecting natural "stages" that complement and emphasize their strength and form. They move into the curve of a termite mound; they recline sensuously along a tree limb; they stand squarely to your lens, looking at you and through you at the same time.

A LEOPARD HAS THE SLEEK, SELF-ASSURED ATTITUDE OF A HIGH-FASHION MODEL, AND THAT'S WHY KATHY AND I REFER TO A LEOPARD PHOTOGRAPHY SESSION AS SHOOTING "THE CATWALK."

LEOPARD ON TREEFALL

The graceful strength and assurance of this young leopard are evident in its stance—perfect for a natural portrait.

Canon EOS 1D Mark III, EF 500mm f/4L lens

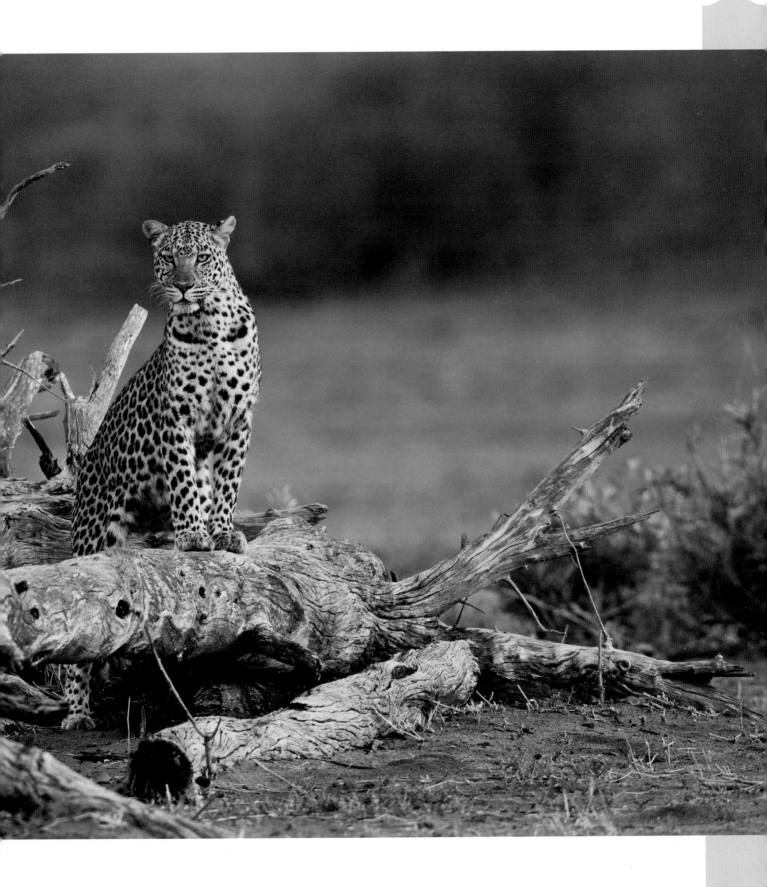

Right

A strong young male shows
me some early morning
attitude.

Opposite

Do these spots make my butt
look fat? No way! Sleek,
serene, assured, in charge,
and so beautiful, this leopard
surveys its territory.

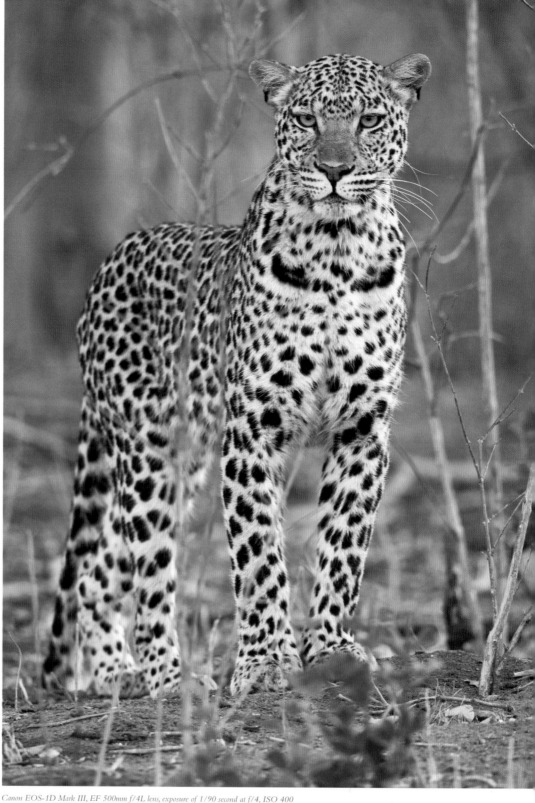

Canon EOS-1D Mark III, EF 500mm f/4L lens, exposure of 1/90 second at f/4, ISO 400

WITH LEOPARDS, THE BEST STRATEGY IS TO FOLLOW AND WATCH UNTIL THE ANIMAL CHOOSES THE PERFECT SETTING FOR PHOTOGRAPHY. THEY KNOW WHAT MAKES THEM LOOK GOOD.

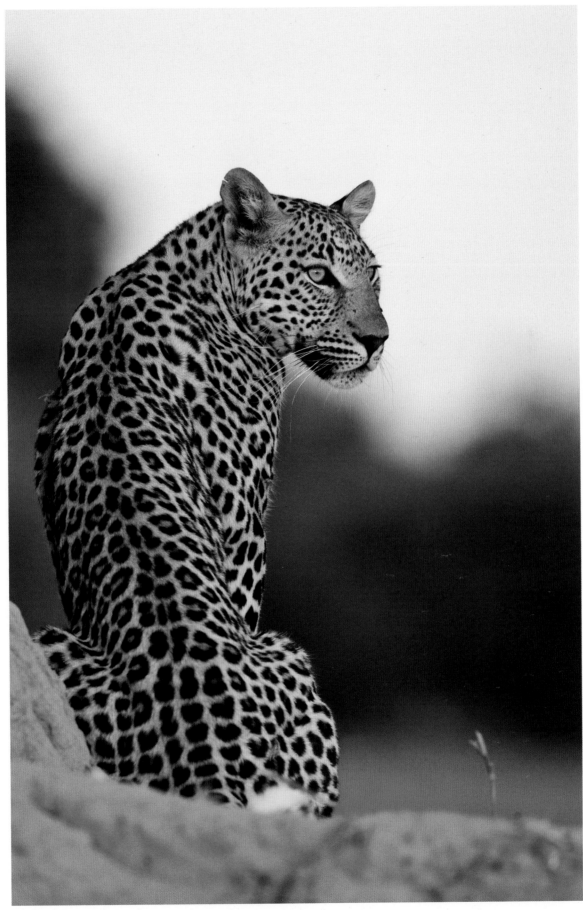

Canon EOS 1D Mark III, EF 500mm f/4L lens, exposure of 1/350 second at f5.6, ISO 400

THE BAT-EARED FOX: CUTENESS COUNTS

M A M M A L S

GEORGE AND KATHRYN LEPP

56

It's very difficult to get good scientific video of bat-eared foxes. Well, the video is okay, but the audio always has to be trashed because you just can't help repeating, "Oh, they're so darned cute!" But, I digress…

The wildlife experiences around Duba Plains in the Okavango Delta are pretty brutal. We encountered a den of bat-eared foxes late in the day, following a series of life and death dramas involving big lions and leopards. Driving across the plains in the relative coolness of dusk, we felt a lightness of purpose. Bat-eared foxes eat bugs.

As we approached, we saw the two big-eared adults dash to the opening of the labyrinth of tunnels that comprise a bat-eared fox's den. They watched us intently, while occasional sets of ears popped up from within the hole. Suddenly, four kits bounded out of the den and tore off across the prairie. I thought I heard their parents sigh.

For an hour, until there was no light left, we watched and photographed the foxes playing, nipping, and cuddling each other. They cared little about our projected flash and clattering shutters. They cared even less about our low-pitched chuckles and murmured appreciation for their absolute, unabashed cuteness. We stayed and stayed, unwilling to let go of this joyful experience, until finally, in darkness unrelieved by moonlight, we returned to camp, smiling.

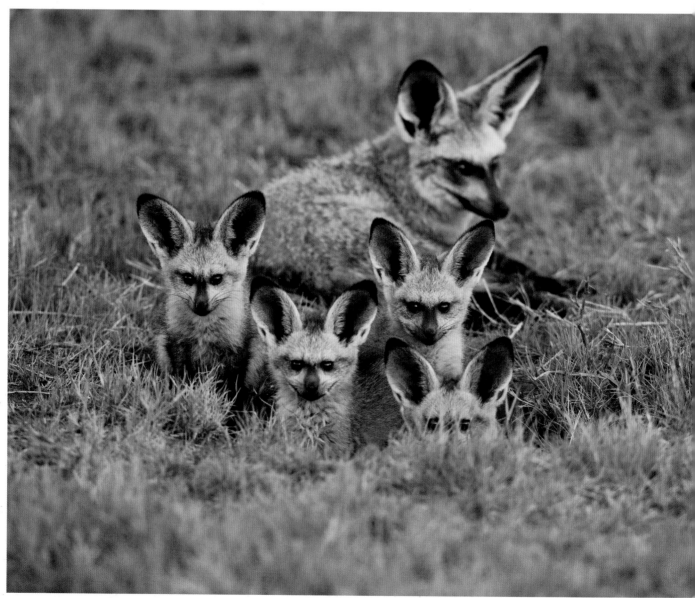

Canon EOS-1D Mark III, EF 500mm f/4L lens, exposure of 1/90 second at f/5.6

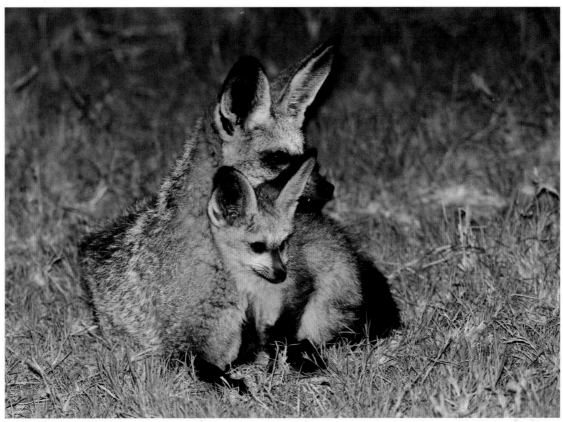

Canon EOS-1D Mark III, EF 500mm f/4L lens, exposure of 1/90 second at f/6.7, ISO 800

Left

FAMILY PORTRAIT

In the low light, ISO 800 made this image possible.

Above

The bat-eared fox's disproportionately large ears are critical for hunting insects, such as dung beetles and termites, which comprise about 80% of the animal's diet. The ears also make for very cute photography subjects. With no remaining ambient light, projected flash was my only light source.

PHOTOGRAPHING THESE LITTLE GUYS CAN BE AS CHALLENGING AND REWARDING AS PHOTOGRAPHING BIG GAME, AND IT CAN ALSO BE A LOT MORE FUN.

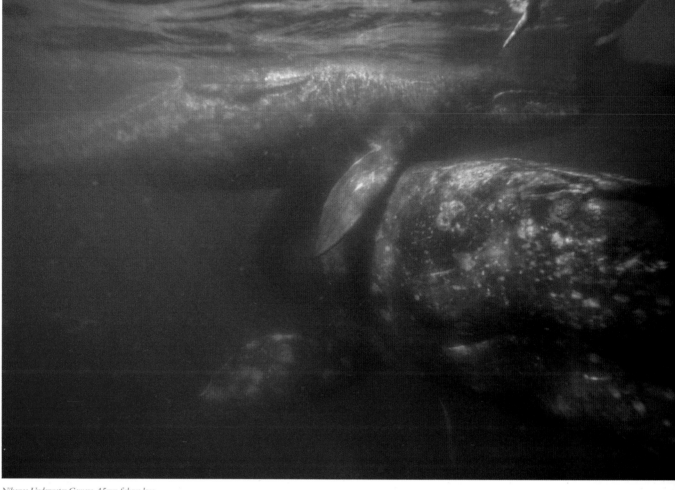

Nikonos Underwater Camera, 15mm fisheye lens

THE GRAY WHALE:
OBSERVER OR OBSERVED?

Above

You might have heard that gray whale cows are very protective of their calves, but this photograph shows they also push the young toward new experiences. A Nikonos underwater camera with an extreme wide-angle lens (15mm) revealed the female lifting her calf up to touch and be touched by the delighted humans above.

Of all the inspiring migration stories in nature, the annual 12,000 mile round-trip odyssey of the gray whale (approximately 19,312 kilometers) must be one of the most amazing. The migration begins in the Arctic's Bering Sea in the fall and goes all the way to the breeding lagoons off the Baja California Peninsula, where they spend January through March, returning to the Arctic with calves in tow in late spring. En route, the whales travel along the most highly developed shoreline in the world and face threats from shipping lanes, U.S. Navy sonar systems, and pods of murderous orca.

Global climate change is warming the Arctic seas and pushing the whales and their summer feeding grounds farther north each year. But at the southernmost point of the whales' migration, the warm lagoons off the coast of Baja California are still welcoming, protected, and fertile destinations for mating, calf-bearing, training the young, and friendly interaction with humans. We can thank the Mexican government and the people of the region for their actions to isolate and preserve the breeding lagoons, and for offering expert local guides for small groups in designated observation areas.

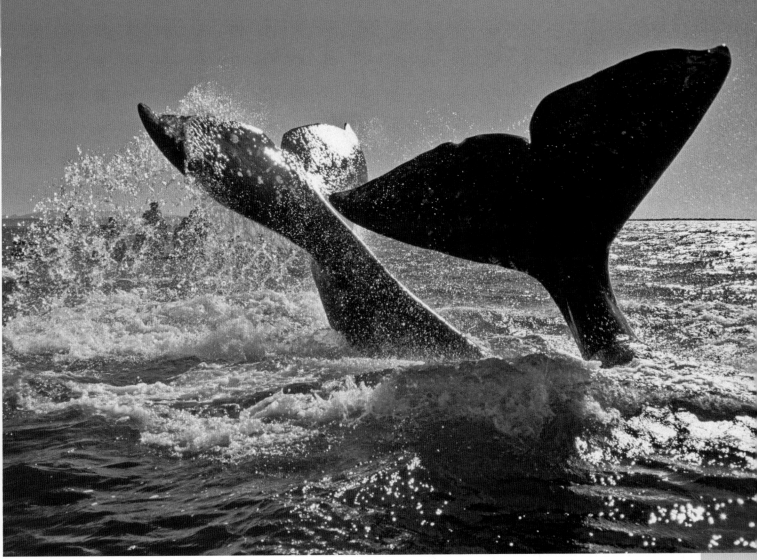

Canon EOS-1N, EF 28-135mm lens at 28mm

Things are a bit tense in January and early February, when birthing and mating are most active. Calf-bearing females are left alone to deliver in the warm shallows, away from the viewing areas, while in deeper waters, groups of two males and one female thrash and roil the seas in spectacular marine ménages à trois. When this mating behavior is in process, the animals seem oblivious to the panga boats filled with human observers, and the best strategy is to stay well out of the way. In February and March, the boisterous males—and the females without calves—head north, leaving behind the mothers with young to interact with the whale-watchers.

Early encounters between human observers and whale cow/calf pairs were characterized by the mother's efforts to shield and protect her offspring from humans in boats (considering the history of whaling in the region, these were certainly smart moves on mom's part). But with protected status and repeated seasons of unthreatening interaction, both whales and humans have learned new ways to communicate. The pangas are not allowed to approach the whales, but adult whales frequently approach the small boats, roll over on their sides to watch the human occupants, and invite petting and scratching.

Above

The most dangerous time to observe gray whales is during mating, as they are intent upon their purpose. These two males are either competing or cooperating in their attempts to copulate with a female, unseen below the surface.

GEORGE AND KATHRYN LEPP

MAMMALS

60

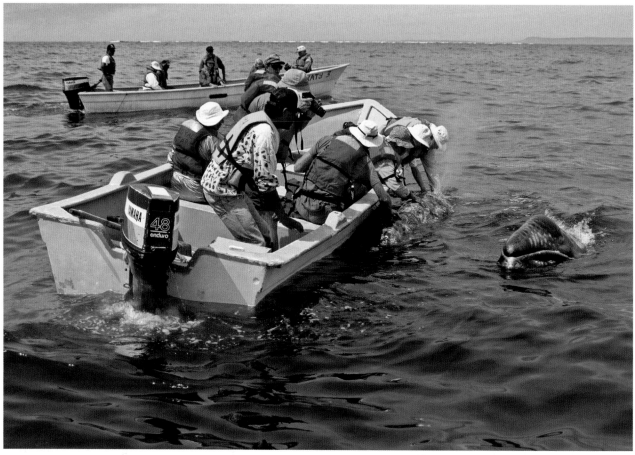

Canon EOS-1N, EF 28-135mm lens

Above

Gray whales readily approach small boats, or pangas, in San Ignacio Lagoon, seemingly eager to interact with the human observers.

During one of my visits to the lagoons, the calves were repeatedly coming close to the boats to be touched and stroked, and we didn't understand why their mothers allowed this interaction. On a subsequent trip, I used an underwater camera to record what was really going on; Mom was underneath the calf, lifting it up to the outstretched human hands.

THERE'S ALWAYS MORE TO LEARN ABOUT AN INTELLIGENT SPECIES, BECAUSE THEIR RELATIONSHIP WITH THEIR ENVIRONMENT (INCLUDING THE HUMANS IN IT) IS CONSTANTLY EVOLVING.

Marine Mammals:
Now You See 'em—Now You Don't

When it comes to photographic effort versus actual results, my success ratios with dolphins are pretty low. Penguins are even harder to capture when they're in the water. The problem is the same in each case: They disappear beneath the surface, then leap out without warning in a fast arch, then disappear again. How can you be ready?

As with all wildlife photography, it helps to know your subject, or to have a guide who knows your subject. An experienced captain will be watching the pressure wave that the bow of the boat makes as it cuts through the water. Dolphins often move into that wave and seem to fly in front of the boat. They look like they're having fun, but I don't really know if that's what it's all about.

Dolphins also like to frolic in a boat's wake. They can sometimes be enticed to join your boat if you run parallel to them for a while. Once they've decided you're friendly, the group may make a turn en masse to enjoy the turbulence created by your vessel. If a large pod of leaping dolphins crosses in front of your boat, you've got a brief chance to capture their form, their behavior, their spirit, and their beautiful environment, all at once. It's magical.

Below

A single common dolphin rides the wake of our boat.

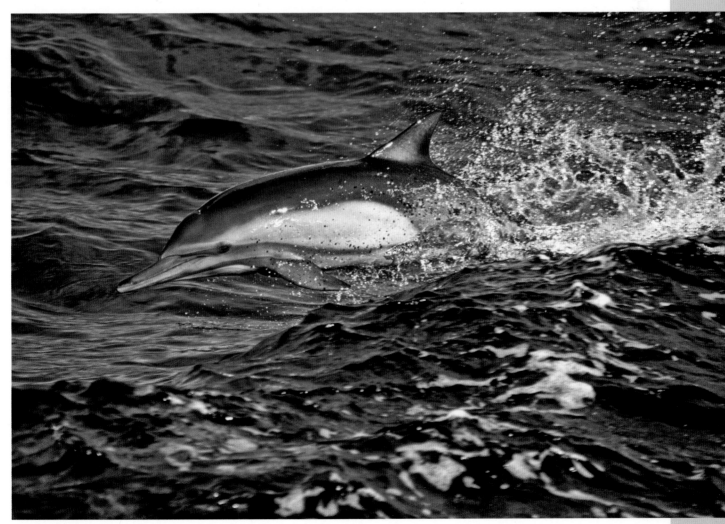

Canon EOS-1N, EF 75-300mm zoom lens

MAMMALS

GEORGE AND KATHRYN LEPP

62

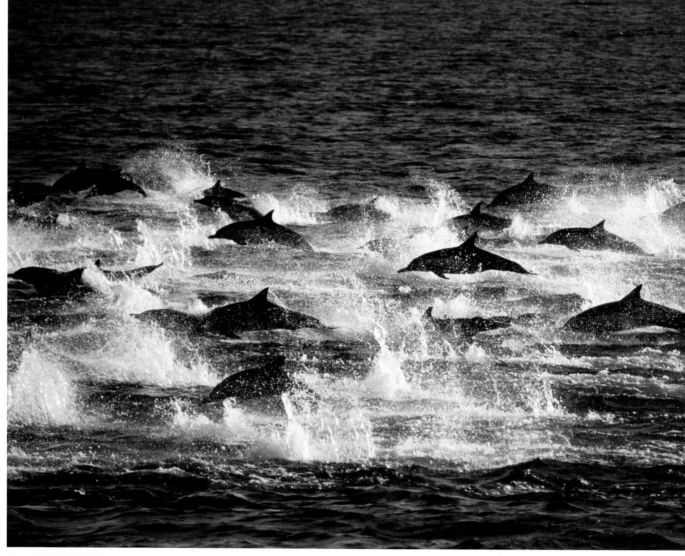

Canon EOS-1N, EF 75-300mm zoom lens at 300mm

DANCE OF THE DOLPHINS

This large dolphin pod sped through the water in choreographed leaps, right across the bow of our boat. We don't know if they were chasing food, being chased, in a hurry to get somewhere, or just showing off, but we loved the look of them.

Later in this book, we describe how the advent of autofocus transformed wildlife photography (see page 110); indeed, there are some wildlife subjects that simply could not be well-photographed prior to autofocus technology. It's a tremendous advantage with dolphins and spouting, spy-hopping, breaching whales. Like much in nature, whale behavior is somewhat predictable. Whales tend to breach in a series of three. So, when you see the first leap, be ready for two more chances to locate, frame, and capture the animal.

One of the most interesting manifestations of whale behavior is the "spy hop;" like a ballerina en pointe, the whale stands straight up, pushing its upper body out of the water, suspended for a moment while the magnificent creature turns its eye to look—at you! It's another case of the observer being observed, and a reminder that whales like to engage you on their own terms.

And that engagement isn't always harmless. I remember the big gray whale that bumped and tossed our Zodiak (a small, inflatable rubber boat) repeatedly, seemingly determined to surface with us on her back. It may have been playful, but the potential for disaster was serious. Our guide's answer was to get moving—fast! As the whale chased us past the other boats, she chose another victim to harass and veered away from us. We felt a little bit guilty for laughing.

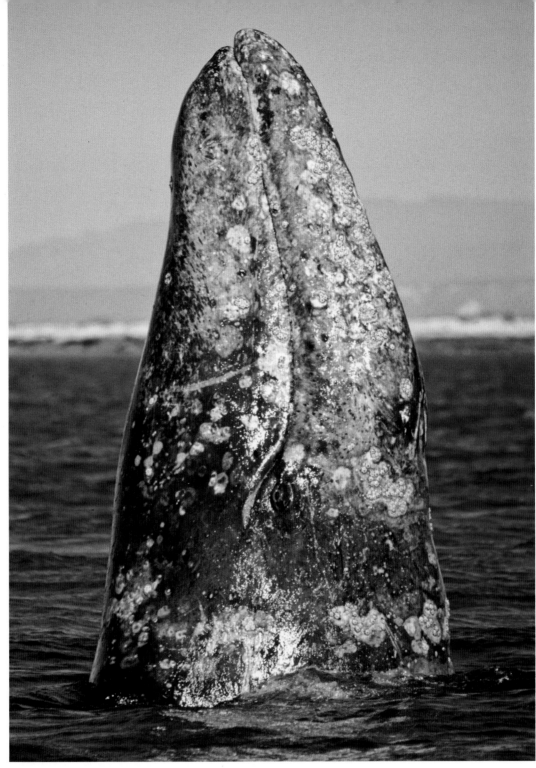

Canon EOS-1N, 75-300mm zoom lens

SOMETIMES, IT'S A GREAT FEELING WHEN YOUR WILD SUBJECT ACCEPTS YOU AS AN OBJECT OF CURIOSITY OR PLAY. AND SOMETIMES IT'S NOT.

Above

This gray whale is "spy hopping" to get a look at us; the curious animal stayed in this position long enough for framing, and autofocus helped me make the capture.

GEORGE AND KATHRYN LEPP

POLAR BEARS: THE ADVANCING CURSE OF ENDLESS SUMMER

I really worry about some of my wildlife subjects. Sometimes, I even imagine that I may have been among the last to see them in their natural environment. There's no better example than the polar bear, whose future is severely threatened by the warming Arctic.

Ringed and bearded seals are the main source of polar bears' nutrition. The bears typically catch the seals from the ice by raiding nests of newborns, waiting for the unsuspecting seals to surface at breathing holes, or by sneaking up on resting seals. For the bears, eating depends on solid ice. As the temperature warms, the sea is covered by ice for fewer months each year, greatly reducing the amount of nutrition the polar bears can secure for themselves. The shortened feeding times are especially deleterious for cubs and pregnant and nursing females.

When I first photographed polar bears on the Hudson Bay near Churchill, Manitoba, ice began to form on the sea in early October. Males, juveniles, and non-breeding females would start gathering on the shoreline early in the month, where they would lounge about and engage in play and mock fighting while waiting for the ice to extend far enough into the bay for seal

hunting. Later in the year—from December through March—females with new cubs joined the group. In spring, courtship and mating took place on the ice, and all the bears, especially newly pregnant females, hunted aggressively and ate voraciously. All of these activities were rich subjects for the lucky nature photographers with access to the area, and as word got around, new tours and viewing opportunities developed. Now the big, snow-tracker tundra buggies that once held a dozen photographers have morphed into buses that carry more than fifty tourists each.

During the warmer summer months, all the bears fast; only a small amount of nutrition is gained from terrestrial animals and grasses. Now, the warm season and, consequently, the bears' fasting period, is getting longer, and the opportunity for feeding (and photography) is getting shorter. Cub mortality is on the rise, the general health of the bear population is diminishing, and the population is in precipitous decline. Some scientists predict that the bears' habitat will disappear in only forty more years. The Arctic ice of winter will yield to endless summer—the polar bear's worst possible future.

TRACKS

A large male polar bear makes tracks towards Hudson Bay. He's quite fat from an early meal; he found a dead beluga whale washed up along the shore.

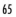

Canon EOS-1N, EF 28-135mm zoom lens

G E O R G E A N D K A T H R Y N L E P P

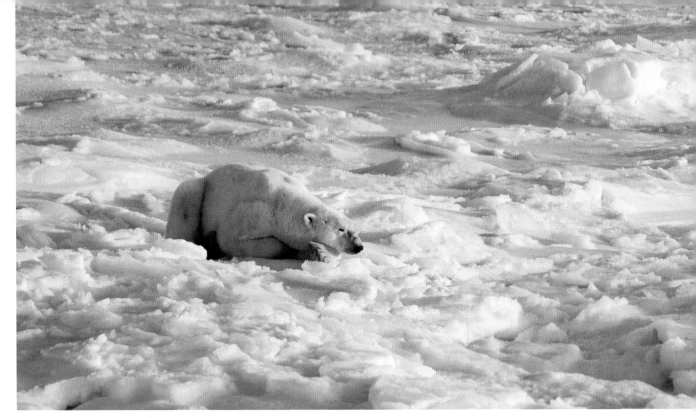

Canon EOS-1N, EF 100-400mm zoom lens

Canon EOS-1N, EF 100-400mm zoom lens

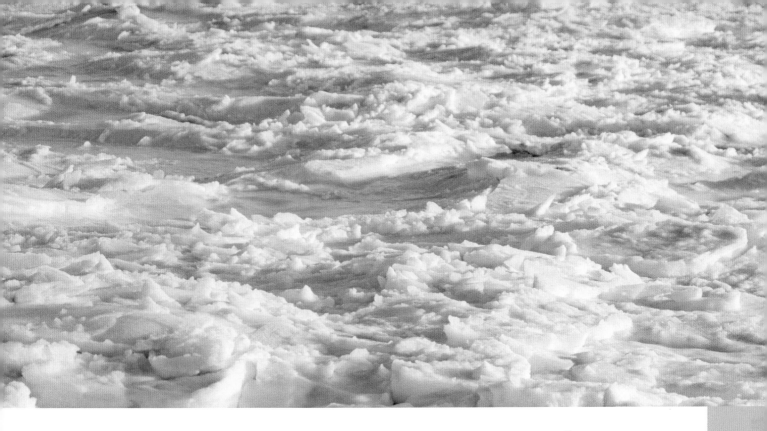

ACTIVELY PURSUE AND SUPPORT INITIATIVES THAT CONSERVE
AND PROTECT WILDLIFE RESOURCES ALL OVER THE WORLD.
THE GREATEST THREATS TO A SPECIES MAY COME INDIRECTLY
AND FROM A GREAT DISTANCE, AND THE SOLUTIONS REQUIRE
EDUCATION AND GLOBAL COOPERATION.

G E O R G E A N D K A T H R Y N L E P P

A Lesson in Unbearable Sweetness: The Polar Bear Pair

Mother and child interactions are always compelling subjects. For one thing, there's a cute kid or two involved. For another, there's a wide range of relationship behavior going on—nurturing and grooming, playing and teaching, protecting and casting loose. But if you have the opportunity to observe polar bear sows and their cubs, you'll see that their two-year relationship seems to be especially intense and committed, and their combination of beauty and vulnerability invites emotional and intimate portrayals.

Set against the harsh realities of the Arctic environment and their threatened future, polar bear females and their youngsters often demonstrate a most engaging joie de vivre. Mom emerges from her maternity den, nearly starving, and must travel with her young for long distances before reaching the ice of the bay and food. In some populations, the cubs' survival rate is now only about 40%.

Mom plays both the role of affectionate parent and willing playmate to her offspring. Watching them together is bittersweet. They seem to enjoy each other so much, and I imagine that it is very difficult to part when the time comes for the youngster to go off on its own. Some would say that it's wrong to impose our own emotions as explanations for animal behavior, but I'm always drawn by obvious similarities. When photographing the behavior of polar bear mother and child pairs, I feel a powerful and undeniable emotional connection.

Canon EOS-1N, EF 100-400mm zoom lens

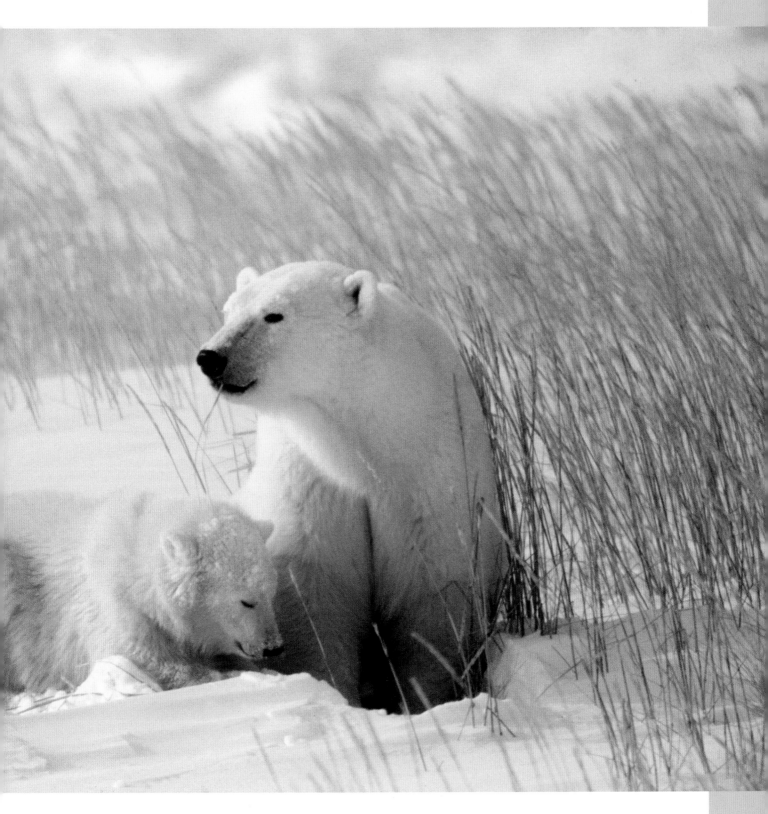

MAMMALS

70

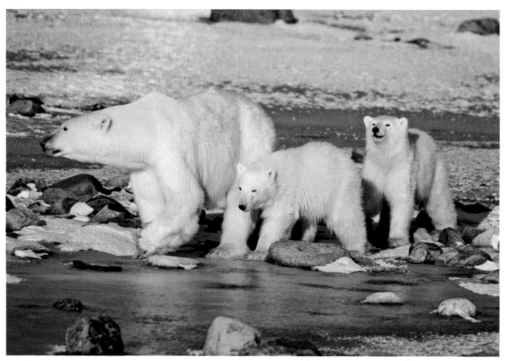

Canon EOS-1N, EF 100-400mm zoom lens

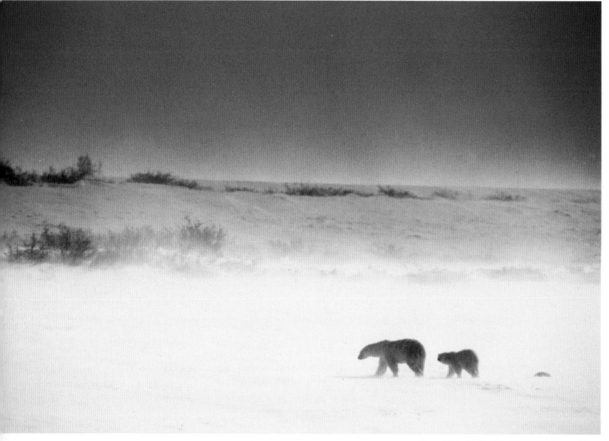

Canon EOS-1N, EF 100-400mm zoom lens at 400mm

Top left

Lean and nearly starving, a female marches her young cubs across the tundra; she's seeking the ice-covered bay and her first meal in many months.

Above

It's not always wrong to put the subject in a corner of the frame. In her search for food after months of fasting, this sow leads her cub into a vast, harsh environment—and an uncertain future.

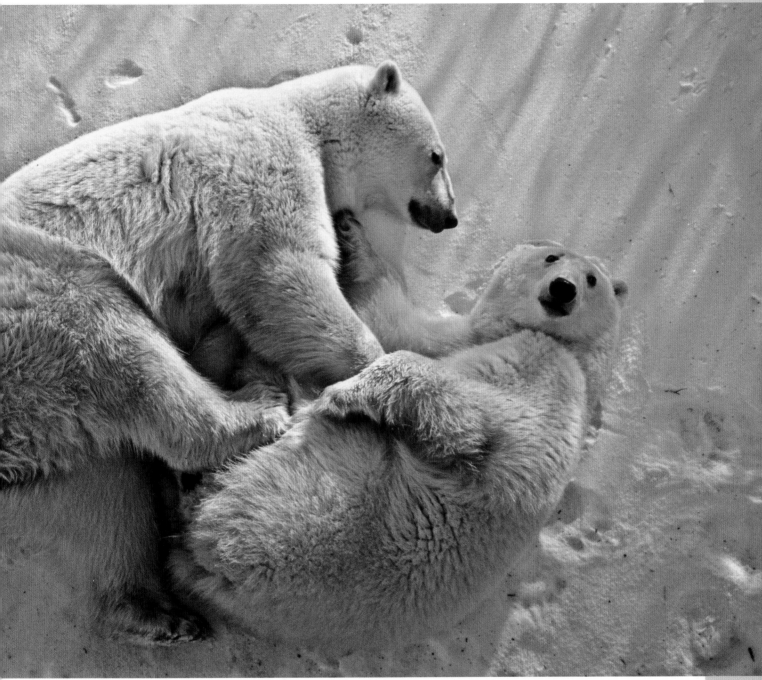

Canon EOS-1N, EF 28-135mm zoom lens at 28mm

Above

This mother and second-year cub played with each other for a full hour below my safe perch in a tundra buggy. I was hanging over them, photographing with a 28mm lens, and they were so attuned to one another that my presence just didn't matter. My delight in their enjoyment was tempered by the knowledge that they soon would separate forever.

WHEN A SUBJECT SPEAKS TO YOUR SPIRIT AND EXPERIENCE, LISTEN.

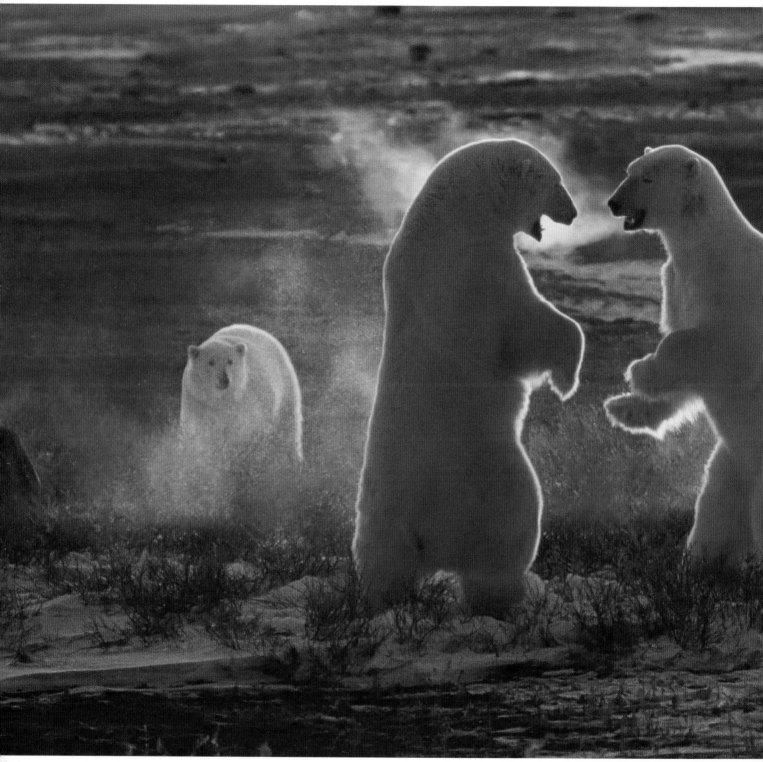

Canon EOS-1N, EF 100-400mm zoom lens, exposure 1/60 second at f/5.6, E100 VS film pushed to 200 ISO

THE REFEREE

A seemingly impartial observer monitors the sunrise sparring of
two male polar bears. As they wait on the shores of Hudson Bay
for ice to form a pathway to food sources, male bears, especially the
adolescents, entertain themselves with half-hearted fights, rehearsals
for the serious competition for females that takes place in spring.

When you embark on a polar bear expedition, choose a photo-oriented tour so you'll share the ride with others who are happy to watch and wait for the best photographic experience. Beyond that, you've got two comfort options, and your choice will either limit or expand your photographic opportunities. It's not surprising that the least comfort usually yields the best photography.

Tour operators to Manitoba's prime polar-bear country on Hudson Bay often house their participants in nearby Churchill. It's cold, so you can sleep in under a down comforter, have a leisurely breakfast, then hop a big bus to the edge of the bay, board a waiting tundra buggy, and get to the bears by about 10 A.M., returning from the outing around 3 P.M. for a restful evening. For serious photographers, however, polar bear camps are a better option. They offer basic housing in co-ed dormitories (located in big trailers on the edge of Hudson Bay at Point Churchill), wholesome meals in dining halls, and—the best part—access to the polar bear environment by tundra buggy from before sunrise to after sunset. You really don't want to miss that.

The extreme angle of the sun to the horizon in the far-north regions produces short-lived, intense red glows at sunrise and sunset. If you're lucky enough to encounter bears that early in the morning, the combination of white snow, creamy bears, and red light renders a stunning photographic environment.

On one such morning, I photographed two big male bears engaged in play fighting against a bright red sky. Their hot breath seemed on fire in the cold dawn. Some who've seen these images are sure the color is "Photoshop red" when, in fact, the only added color is whatever was contributed by the warmish tones of the Kodak E100 VS transparency film I was using and the satisfied glow of a lucky photographer who got up early and was rewarded with a great shot.

MAMMALS

74

GEORGE AND KATHRYN LEPP

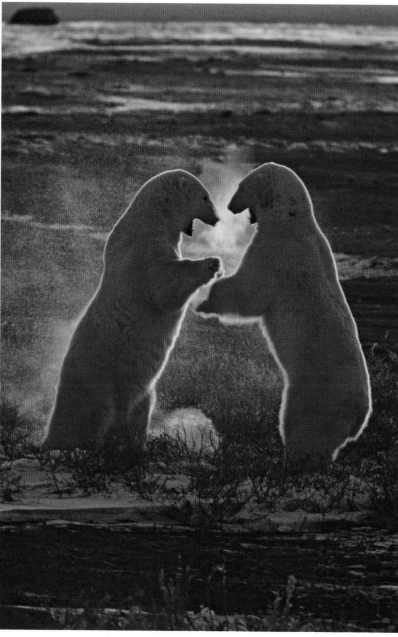

Canon EOS-1N, EF 100-400mm zoom lens, exposure 1/60 second at f/5.6, E100 VS film pushed to 200 ISO

Left

These male bears engaged in play fighting seem almost to dance in the red light. In the fall, they take care not to hurt one another. One season, however, a lone female fought them aggressively, besting one male after another. Before long, the males refused to fight her.

IF YOU INVEST THE EFFORT AND MONEY TO TRAVEL TO A RICH LOCATION FOR WILDLIFE PHOTOGRAPHY, PUT IN THE TIME ONCE YOU GET THERE. SOME OF THE MOST BEAUTIFUL BACKDROPS AND INTERESTING BEHAVIOR HAPPEN AT SUNRISE AND SUNSET.

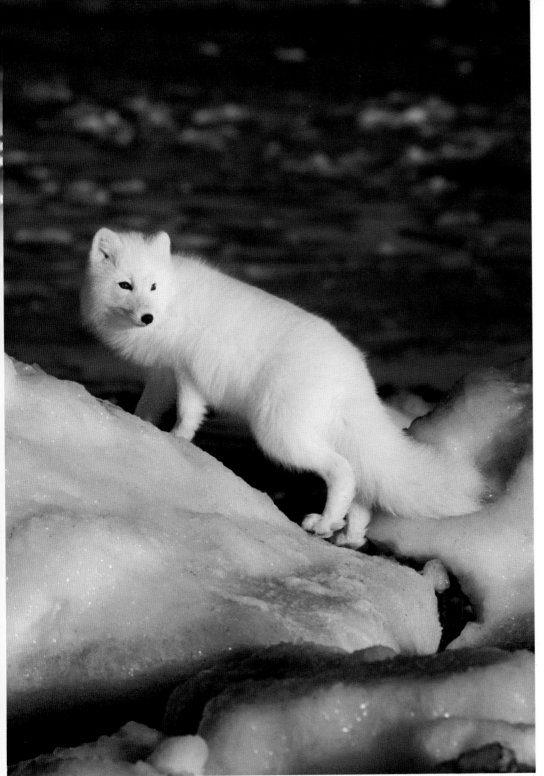

Canon EOS-1V, EF 100-400mm zoom lens

ARCTIC FOX ON HUDSON BAY

A beautiful Arctic fox, in winter white, paused for just a moment to be photographed against the brilliant blue of Hudson Bay.

Foxes, in general, are difficult to photograph because they are constantly on the move. Whether it's the beautiful red foxes that visit our Rocky Mountain Colorado home every day, or the amazing Arctic foxes in winter white, they're just busy, and they rarely stop to pose for a photograph.

We got lucky with this pair of Arctic foxes. We spotted them looking for food—or something—within a heap of ice alongside Hudson Bay. After checking the area for polar bears, we left the protection of our tundra buggy and got into position at ground level. The foxes were completely unafraid of us; they moved quickly around

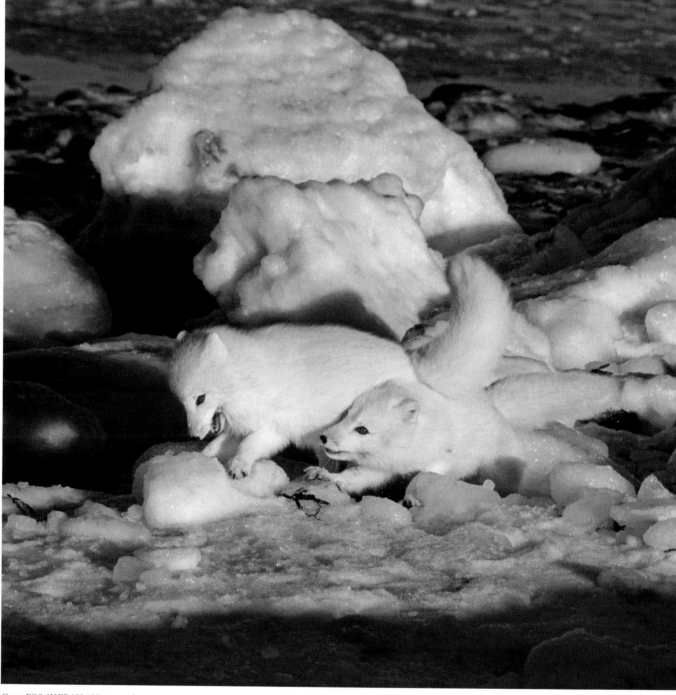

Canon EOS-1V, EF 100-400mm zoom lens

the area, jumped up onto chunks of ice the size of boulders, and played with one another. The lens had to be on them constantly so that the smallest opportunity for a good composition wasn't missed. We watched; they did what foxes do, and we waited for the perfect shot and hoped we wouldn't miss it.

Shooting subjects in snowy scenes can be a challenge, but there is an advantage to shooting white animals on white ground; you can expose for the bright white tones, and the sunlight bouncing off the snow actually fills the shadows and lights the eyes of the subject like a built-in reflector. Make sure, though, that the white is actually

rendered white. If you go with the exposure your meter suggests, you'll get grey snow.

When calculating exposure for white on white, you have to seek the place where white is truly white, with detail. In the digital realm, consulting the image file's histogram on the LCD monitor is the answer to this problem. Set your exposure manually to capture the brightest area of snow in the scene (one to two stops underexposed) and check the resulting histogram. If it shows image data up against the right edge, reduce your exposure further until there is space between the end of the data display curve and the right edge of the graph.

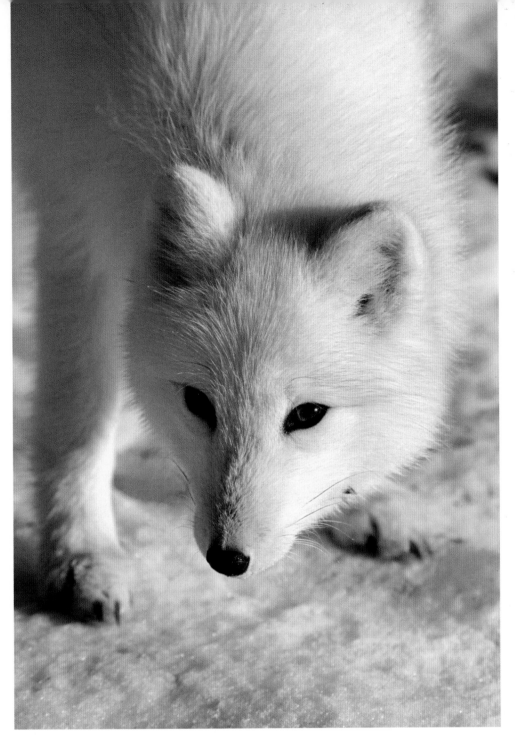

Canon EOS-1V, EF 100-400mm zoom lens

This page
If the area is clear of polar bears, you can get down on the ground with the curious, fearless Arctic fox. This one checked out my lens as I lay on the snow and gave me a close look at its golden eyes.

Opposite
Two Arctic foxes at play, or perhaps hunting for something under the ice piled up beside the bay.

SOME ANIMALS, LIKE FOXES, ARE SO BUSY THAT THERE'S LITTLE TIME TO COMPOSE YOUR IMAGE. YOU'VE GOT TO CONCENTRATE, STAY FOCUSED, AND BE READY TO CAPTURE THE ULTIMATE SHOT.

A MOOSE FOR ALL SEASONS

I t's not always hard to find great wildlife subjects; a good photograph doesn't have to involve a ten-mile hike at 12,000 feet and twenty below (approximately 16 kilometers, 3,658 meters, and -29°C). Some locations offer rich opportunities for easy photographs, and Denali National Park is one of my favorites of these. Denali is an especially rewarding environment for photographing moose from June through September, the four-month interval that covers spring, summer, and fall in Alaska. (The rest of the year, it's winter.)

One spring, I was bringing a workshop group into Denali in a big van, and we encountered several cars stopped at a pullout on the main road. Although a traffic jam usually indicates that there's something to see, I have a natural inclination to pass right by any spectacle. In this case, however, my eager students urged me to stop, and we were greatly rewarded. There on the sedges grazed a moose cow with her twin calves; they gave us wonderful photo opportunities for the next half hour.

While photographing a summer landscape in Denali, I heard a ruckus in the nearby woods. It sounded like a moose, and, hoping that it was, I walked a short distance and found a big bull chomping away at the fresh green foliage. Bull moose can be cantankerous critters and are known to charge humans more often than bears will, but sometimes they don't even acknowledge your presence. In this case, I got a few shots while the moose continued to eat; when he looked me in the eye, I knew it was time to back off.

MOM AND THE TWINS
A 500mm lens isolates this moose family on the brilliant green sedges of spring in Alaska.

Canon EOS-1N, EF 500mm f/4L lens

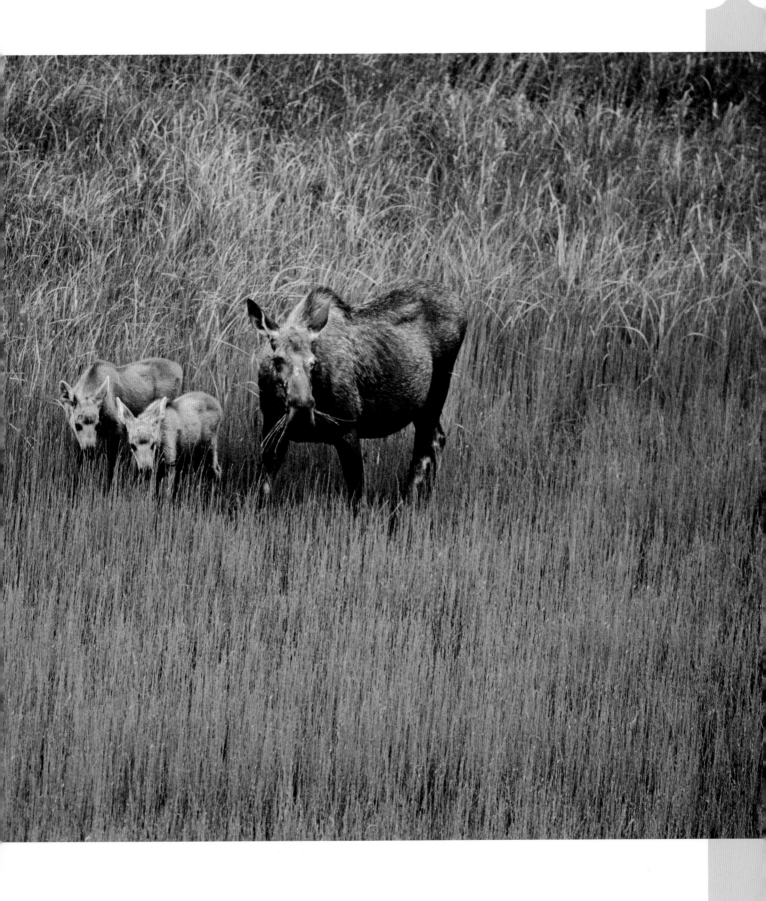

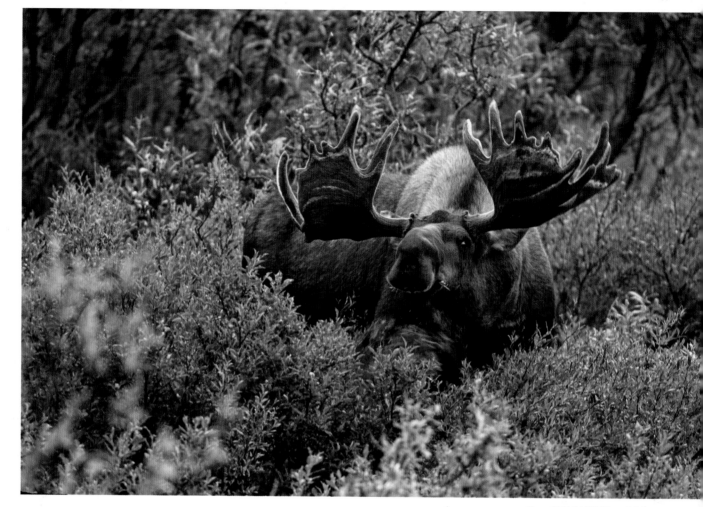

Canon EOS-1N, EF 500mm f/4L lens

Above

A big bull moose feeding in summer foliage looks closely into my 500mm lens. That look means that it's time for the photographer to retreat.

Opposite

From the road in Denali National Park, I photographed this bull moose in shiny new antlers and brilliant autumn landscape. I call this kind of easy-to-find composition a "roadstill."

Fall foliage in Denali National Park looks a lot like New England, but it's only about a foot high. Autumn is my favorite time to photograph there, because the animals are in their finest form. From beside the road near Camp Denali, where I was teaching, we photographed this prime bull, antlers just freed of velvet, on the beautiful stage of the flaming tundra. You really don't want to get in a bull moose's

way in the early fall, however, because his primary agenda is mating. And any moose cows in the territory that still have calves with them aren't interested in courtship and are very protective of their youngsters. So, though they all make for great fall photography, the moose are preoccupied and won't be smiling at you. It's better to stay near your vehicle.

FOR A BIG SUBJECT LIKE A MOOSE, AN ENVIRONMENTAL SHOT FROM THE ROAD CAN TELL A BIG STORY. IT MAY HAVE BEEN EASY, BUT THAT DOESN'T MAKE THE PHOTOGRAPH ANY LESS WORTHWHILE.

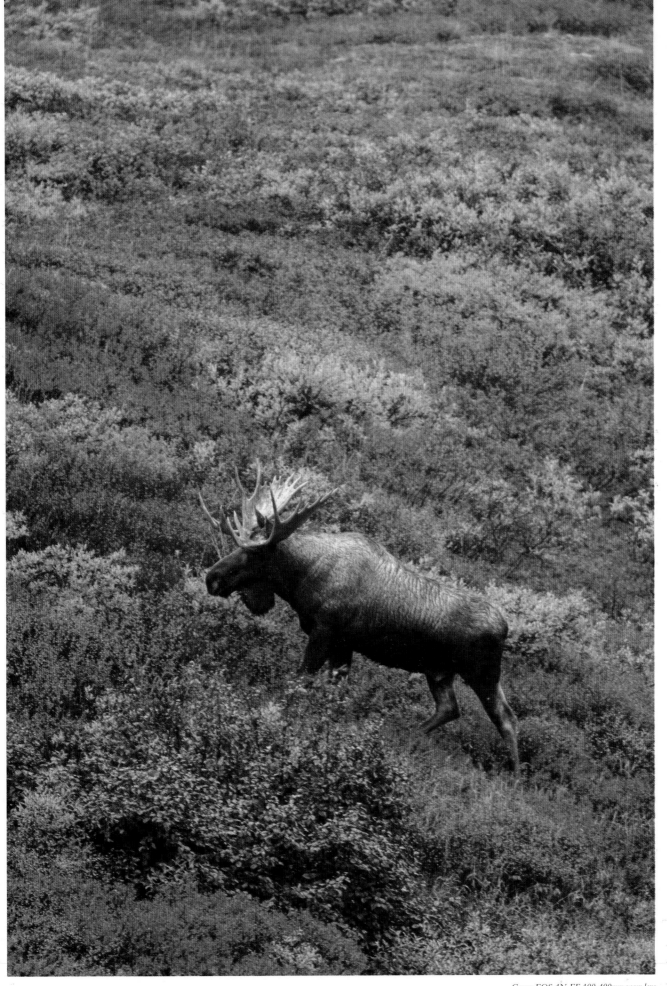

Canon EOS-1N, EF 100-400mm zoom lens

GEORGE AND KATHRYN LEPP

SHARED TERRITORY: BEARS, FISH, AND PHOTOGRAPHERS

Each June brings a strange confluence of populations to Alaska's Katmai National Park. First, masses of salmon are working their way to spawning grounds upstream, swimming mightily against the churning spring flow of the Brooks River. As they approach the hurdle of Brooks Falls, the salmon become densely packed in the pools below. Enter the brown bears, which fish by the dozens in the pools and at the top of the falls. Cue the photographers, all ready to capture their own versions of Tom Mangelson's iconic image of a salmon catapulting into a bear's gaping mouth.

All the players in this drama are tense and competitive. It's hard to tell what the salmon are thinking, but whatever drives them up that river to spawn (and die) must be pretty intense. The bears, hungry from a long winter, are determined to get as much high-protein fuel as possible while they have the chance. Sows need even more nutrition, but while they are fishing, they must also protect their unruly cubs from aggressive males. The observers are vying for great vantage points on this crazy scene, and the rangers are trying to protect all the bears and the photographers from each other.

So, there are rules, and the day I took the photographs featured here, the threat level was "red." On the previous day, a ranger had been bitten by an aggressive bear. The bears can approach the salmon banquet from any direction they want to, but the people must follow a marked path through dense woods. Rangers send us along the trail in groups of three, with the following instructions: (1) let the bears know where you are at all times by calling "Hey, bear… nice bear," or some variation; (2) never get between a sow and her cubs; and (3) yield to oncoming bears by getting off the path. I was grouped with two young women who were clearly embarrassed to be calling greetings to invisible bears, so I led the way, making as much noise as I could, while they trailed behind me, amused at my calls. But their sanguine attitude changed abruptly when I stopped suddenly for a sow and two cubs approaching us on the path ahead. We pulled back into the woods,

Canon EOS-1N, EF 600mm f/4L lens

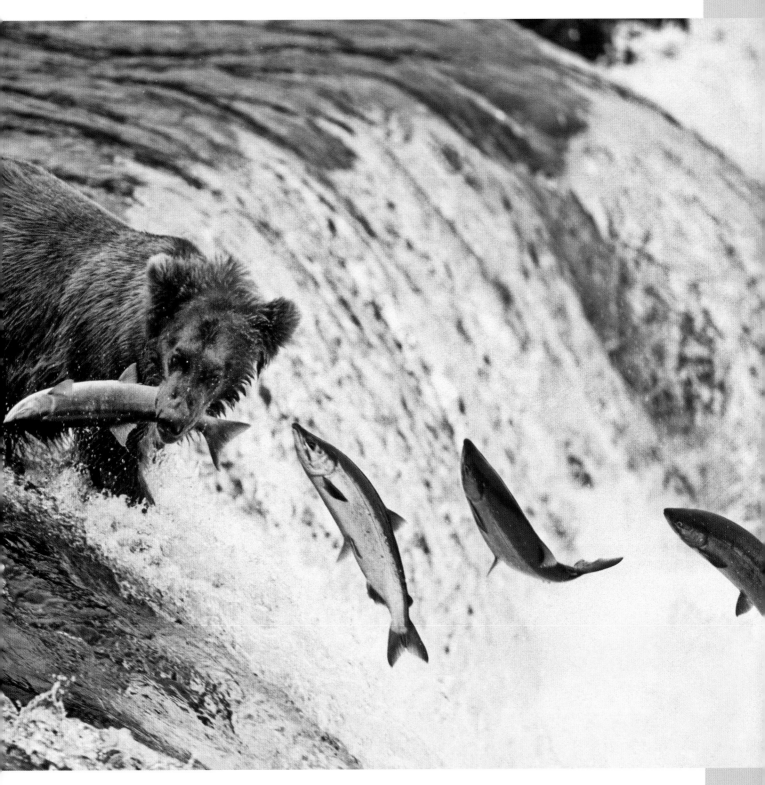

A Fish in the Mouth is Worth Three in the Air

This brown bear is standing in the perfect spot to catch the pink salmon hurling themselves over Brooks Falls. While his mouth is full, he's eyeing the salmon coming toward him. The location is so popular that there must be a paw print imbedded in the rock and permanent tripod holes on the observation platform at the best vantage point to photograph the action.

MAMMALS

84

GEORGE AND KATHRYN LEPP

Below

Before she went out to fish, this sow placed her cubs close to the observation platform, perhaps with the strategy of protecting them from male bears fearful of approaching the human observers. The female bears have their paws full with trying to manage and feed their foolish cubs while keeping them safe from aggressive adult males.

the bears trundled by, and we moved on, but not quite the same as before; our trio of bear calls filled the woods with sound all the way to the river.

One of the most challenging aspects of photographing active wildlife is securing your place on the sidelines. At Brooks Falls in Katmai National Park, the observation platform is a crowded gallery, and it's so popular in high season that people must

be sent in and out in scheduled shifts. The photography is as competitive as the fishing, and it's no fun to be packed tripod to tripod like, well, salmon swimming upstream. Still, watching all those bleeding fish can kill your appetite, and that's a good thing. To get these shots, I stayed behind while the rest of the crowd answered the dinner bell at the lodge, and I had the bears, the fish, and the platform all to myself.

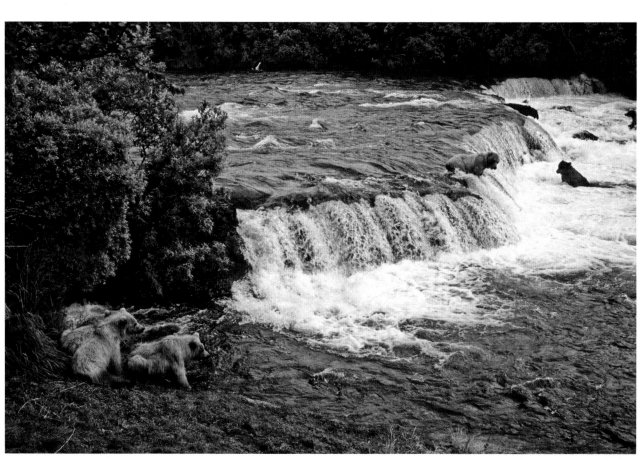

Canon EOS-1N, EF 28-135mm zoom lens at 28mm

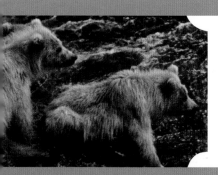

TAKE TIME TO EAT WHILE FOOD AND TIME ARE PLENTIFUL BECAUSE, WHEN PUSH COMES TO SHOVE, YOU MAY HAVE TO MISS A MEAL TO GET THE SHOT.

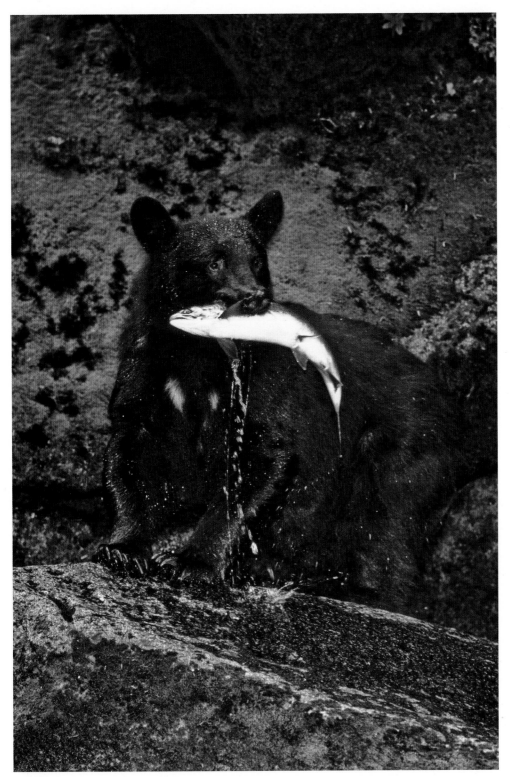

Canon EOS-3, EF 500mm f/4L lens, projected flash

Big Catch

This black bear made a
successful catch from the
shallows of Anan Creek.

The Anan Creek Bear Observatory near Wrangell, Alaska is more than just another place to photograph bears eating salmon. You will find some brown bears there during the pink salmon runs, as in Katmai, but Alaskan black bears are more common at Anan. Black bears aren't really suited to fishing, and they expend a lot of effort trying to trap the fish in small, shadowy inlets and pools. The bears have dark fur and eyes, so the photography is challenging.

You can reach Anan only by boat or floatplane, but this helps to control the flow of visitors only a little. I took these photographs before the construction of modern facilities there, and I was for the most part alone. Since then, beautiful viewing platforms and a photo blind have been constructed to encourage visitors; now, more photographers find their way to Anan. Predictably, schedules and rules have been put in place to manage the traffic and limit humans' impact on the bears.

Canon EOS-3, EF 100-400mm zoom lens

Further, the rangers prohibit flash photography on the grounds that it adversely affects the bears, although I've never seen a bear react to flash, even projected flash, in any situation.

Anan is operated by the U.S. Forest Service, and wildlife management is not one of the agency's key strengths—or responsibilities, for that matter. During my last visit, I spent some time with the rangers in hopes of learning more about their bear research programs. I had been frustrated in my photography by the colored ear-tags and radio collars some of the animals were wearing that year. The rangers explained that a couple of years previously researchers had tranquilized, tagged and collared many of the bears for a project designed to determine whether human presence was causing the animals to avoid Anan. (With straight faces, they noted that they had purposefully used small ear-tags so that they could easily be "Photoshopped" out.) To everyone's surprise, very few of the tagged bears returned to Anan the following year. As I left, the rangers reminded me not to traumatize the bears with my flash equipment.

The latest advances in digital photography, especially expanded ISO capabilities, have greatly improved low-light capture, but it's still hard to shoot productively at Anan. Overcrowding and the inevitable restrictions following the location's increased popularity make the viewing area a difficult place to work. Now, I wish I had spent more time there when it was a relatively unknown place.

IF YOU FIND AN EXCELLENT LOCATION FOR WILDLIFE PHOTOGRAPHY, DO THE BEST WORK YOU CAN FROM THE VERY BEGINNING, BECAUSE AS WORK IS PUBLISHED, OTHERS WILL FOLLOW YOU.

This page

You'd think it would be easy to catch a fish when the stream runs solid with them, but for black bears, it's a challenge.

Right

Black bears aren't as well suited to fishing as brown bears are. One of the former's favorite strategies at Anan is to trap salmon in narrow corners of the creek.

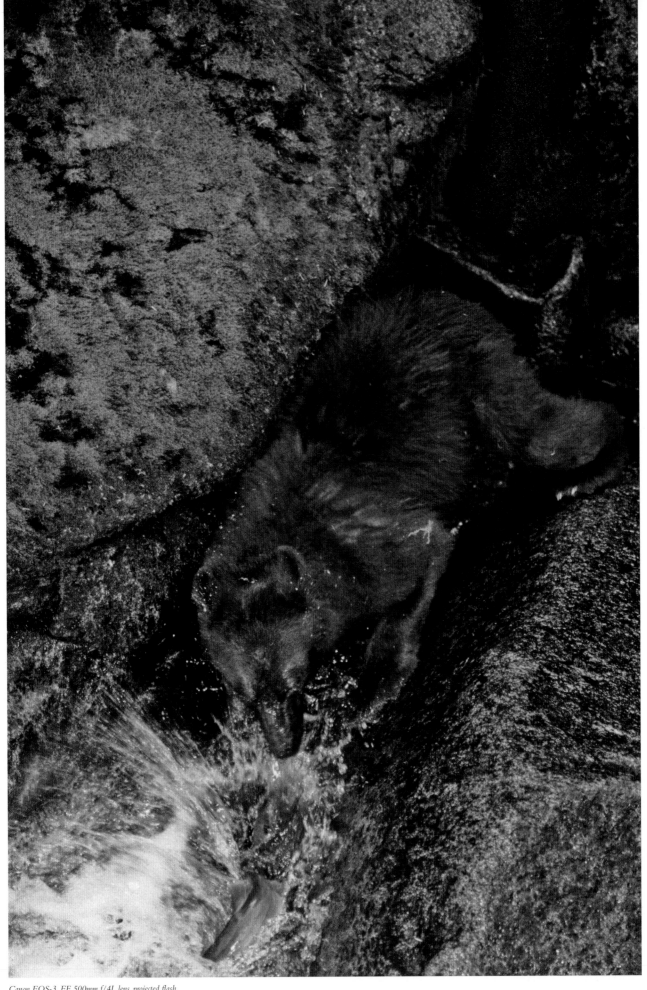

Canon EOS-3, EF 500mm f/4L lens, projected flash

THE MARKETABLE IMAGE: WAIT FOR IT

There's some kind of lightning-fast intra-species communication that takes over in Yellowstone National Park when one photographer comes across an animal working on a carcass. Within a very short time, every photographer in the park will arrive on the scene. It's vulture-like behavior: One bird finds a body, and the next thing you know, the sky and trees are full of big, hungry birds.

When I encountered a cinnamon black bear working on an elk carcass on the edge of the Yellowstone River, I was not alone. On the opposite bank, more than a hundred photographers stood shoulder to shoulder, tripod to tripod, all getting the same picture with their monster lenses: a bear in weeds, feeding on an ugly carcass. It's not an image that would have much market value, but sometimes, we photographers are just another in the line of predators that attend a kill.

While the bear-on-elk scene was not very interesting to me, I was reluctant to leave a promising subject: the bear. It offered one essential component of a possibly worthwhile composition. So, after the bear left the carcass and wandered away, a few of us followed. In my opinion, the more interesting photograph was captured as the bear entered a thicket of wild rose bushes and began to eat rose hips—for dessert, as a digestive aid, or just to round out the meal. Favorable light and a 600mm lens made the shot possible from a safe distance.

Canon EOS-1N, EF 600mm f/4L lens

This page

The cinnamon black bear looks scruffy in the weeds by the Yellowstone River as it feeds on an old elk carcass. Most of the hundred or more photographers working on this bear got only countless variations on this unmarketable shot.

Right

BEAR IN ROSE HIPS

A cinnamon black bear is looking very fine, framed by wild rose bushes. I've sold this image countless times.

THE FIRST POSSIBILITY ISN'T ALWAYS THE BEST ONE. WAIT FOR A PROMISING SUBJECT TO DO SOMETHING SIGNIFICANT; THEN YOU CAN CAPTURE A MORE MEANINGFUL—AND VALUABLE—IMAGE.

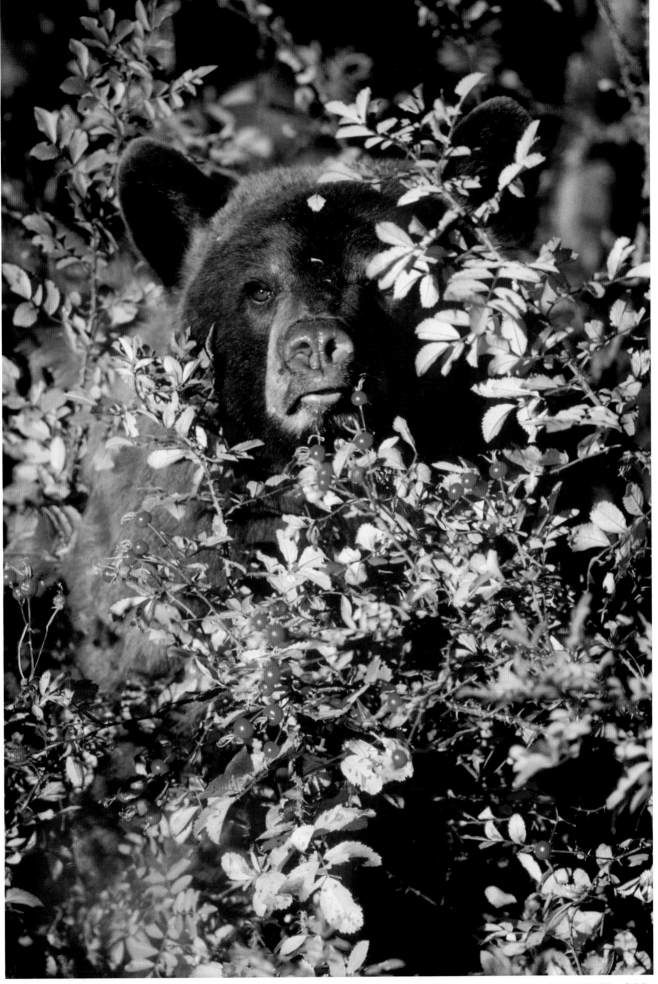

Canon EOS-1N, EF 600mm f/4L lens

IT'S NOT ABOUT EWE

I have often photographed bighorn sheep in Yellowstone National Park, a long way from home. Now that I live in Colorado, I sometimes see them within the city limits at Garden of the Gods, a municipal park unlike any other you've ever seen. When Kathy and I drive through the Rockies, we're always on the lookout for a herd of bighorns, and frequently our search is rewarded. There they are, beside the freeway, or alongside the Arkansas River, or crossing Highway 67 on the way to Cripple Creek, or on the cliffs of Cottonwood Pass. Before I moved here, I never knew that bighorn sheep were so ubiquitous, but a sighting still seems like a very special occasion. If we encounter them, we never fail to stop and watch for a while, even if we don't get out the cameras. To just move on by seems so ungrateful.

Still, Yellowstone is a great place to photograph bighorns. They're predictably found in the area between Gardiner and Mammoth Hot Springs, and there's good access from the road. You could stay all day and watch them do what big horns do,

Canon EOS-1Ds MK II, EF 500mm f/4L lens

Right

This is my best-selling photograph of a bighorn sheep, captured in fall in Yellowstone National Park. The composition emphasizes the design of the big ram's most recognizable characteristic: the curl.

Opposite: **PORTRAIT OF A BIGHORN RAM**

Allowing the subject to overflow the frame emphasizes its size. This ram, photographed in the snow in Yellowstone, was friendly and curious.

Canon EOS-1V, EF 600mm f/4L lens

Below

Two rams engage in horn clashing during the October rut. I photographed them on the "benches" above Gardiner within Yellowstone National Park.

which, except during the fall rut, is mostly to hang out and munch on grasses. This is the time for portraits, especially if you are fortunate enough to encounter a mature male with a big curl. That's the trophy shot. Nobody really cares about the ewes, unless they've got very cute kids.

During the rut, the subject is competition. The males engage in serious fighting, and the action is fast, furious, and a bit dangerous. The rangers will warn you to keep your distance. I watched the herd's patterns and placed myself ahead of them. The bachelor herd moved toward, then past me, alternating grazing with horn clashing. I stayed put, and they eventually moved on, apparently unaffected by my presence and my photography.

Canon EOS-1V, EF 500mm f/4L lens

STUDY YOUR SUBJECTS AND PREDICT WHAT THEY WILL DO, THEN PUT YOURSELF IN POSITION FOR THEM TO APPROACH YOU. THE MOST SATISFYING PHOTOGRAPHY IS ACCOMPLISHED WITH MINIMAL IMPACT ON THE SUBJECTS AND THEIR ENVIRONMENT.

In Search of the Wild Coyote

Why would anyone bother to photograph a common coyote, the scourge of many North American communities, despised for skulking through trash barrels in the night and preying on domestic pets? Because the coyote wasn't always an urban bother and, in some places, it still retains its natural dignity. In a natural environment, a coyote is a beautiful thing, and interesting, too. My best photography of coyotes has occurred in winter in Yellowstone National Park, where there's a healthy wild coyote population now kept in check by the reintroduction of wolves.

If you're looking for winter scenes, February is the best time to photograph in Yellowstone. There's generally a good base of snow, but the temperatures are not as bone-chilling as they are earlier in the winter. By March, the snow is diminishing, there's more melt and ice, and more mud.

COYOTE IN SNOW

We anticipated that our presence would force this un-habituated coyote to move off the plowed road into fresh snow, so we were ready to take advantage of the opportunity to photograph it in a natural setting.

93

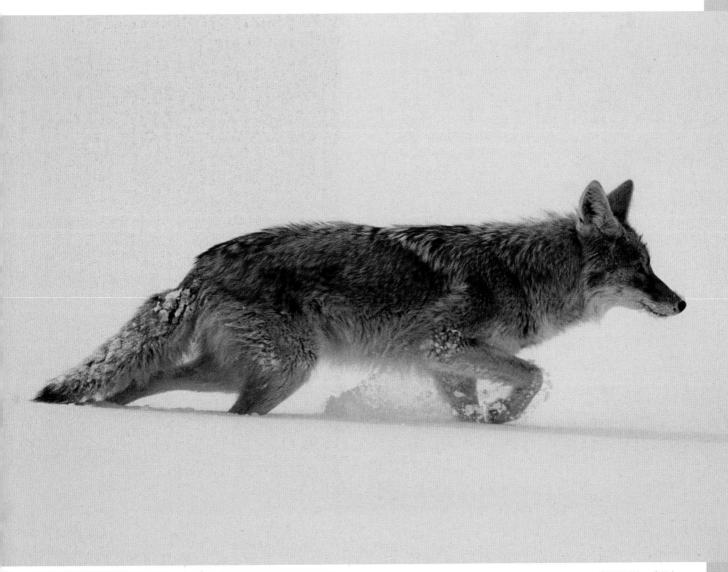

Canon EOS-1N, EF 600mm f/4L lens

On one crisp February day, a colleague and I were photographing along the road between the North Entrance and Cooke City, the only park route that's open to private vehicles during the winter. A fine coyote walked down the road toward us, on its way to somewhere beyond, and when we saw it in the distance, we set up our tripods and big lenses knowing that in order to get around us, the animal would be forced off the road and into the fresh snow. As the coyote passed us, it moved with purpose through the powder, looking healthy and proud in its winter coat against the snow, and we had the chance to photograph him the way a coyote would be in a place where there were no roads.

I have, however, had much less satisfying experiences with coyotes in Yellowstone. One fall day, I pulled into a turnout only to realize a big male coyote was standing nearby. I got out of my truck with camera in hand, and he walked toward me. This was a little unnerving, but I realized that this animal had learned that humans, especially photographers, would feed him to draw him nearer, and he was simply spending his days hanging out at parking lots, hoping for a handout. His fearlessness gave me the opportunity to get some great pictures, but I felt the weight of regret as I did so. I knew that as soon as a ranger discovered his panhandling, this coyote would be judged a danger to humans and condemned to death. I sat on the ground, and he lay down nearby, and we watched each other with interest for about 15 minutes before I picked myself up and moved on. In my rearview mirror I saw him sit up expectantly as the next car pulled in.

HABITUATION TO HUMANS CAN ROB COYOTES OF THEIR MYSTERY, DIGNITY, AND SPIRIT, BUT IN THEIR OWN ENVIRONMENT, THEY ARE BEAUTIFUL.

Canon EOS-1N, EF 70-200mm f/2.8L zoom lens

MAMMALS

94

GEORGE AND KATHRYN LEPP

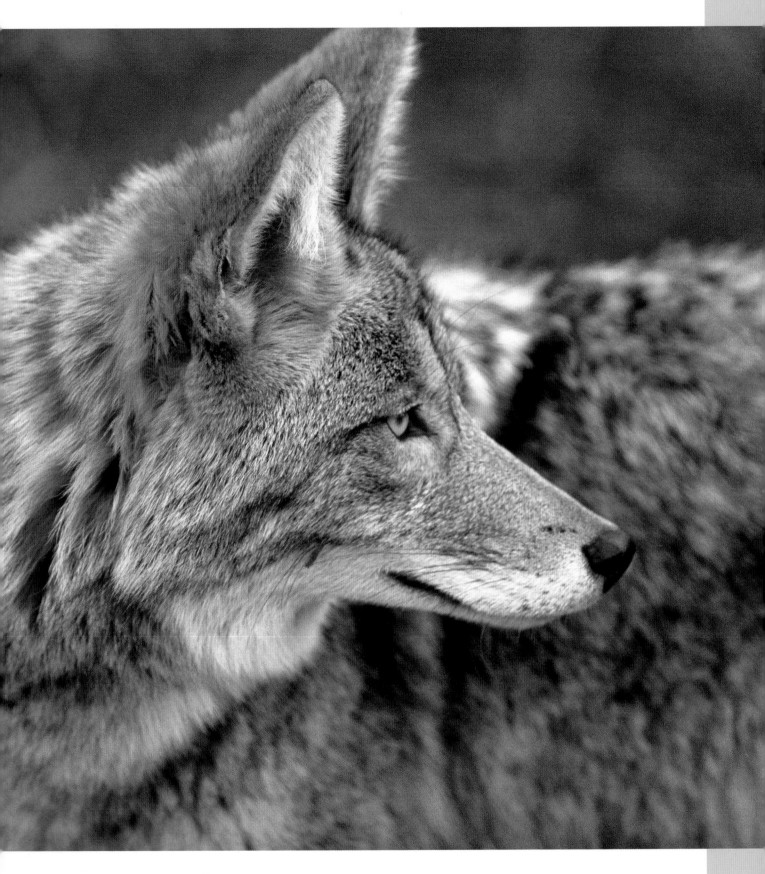

Above

This coyote approached me at a Yellowstone turnout, anticipating a handout. His fearlessness gave me a great shot with my 70-200mm lens, but I still feel guilty about it, knowing that his familiarity with humans spelled his eventual doom.

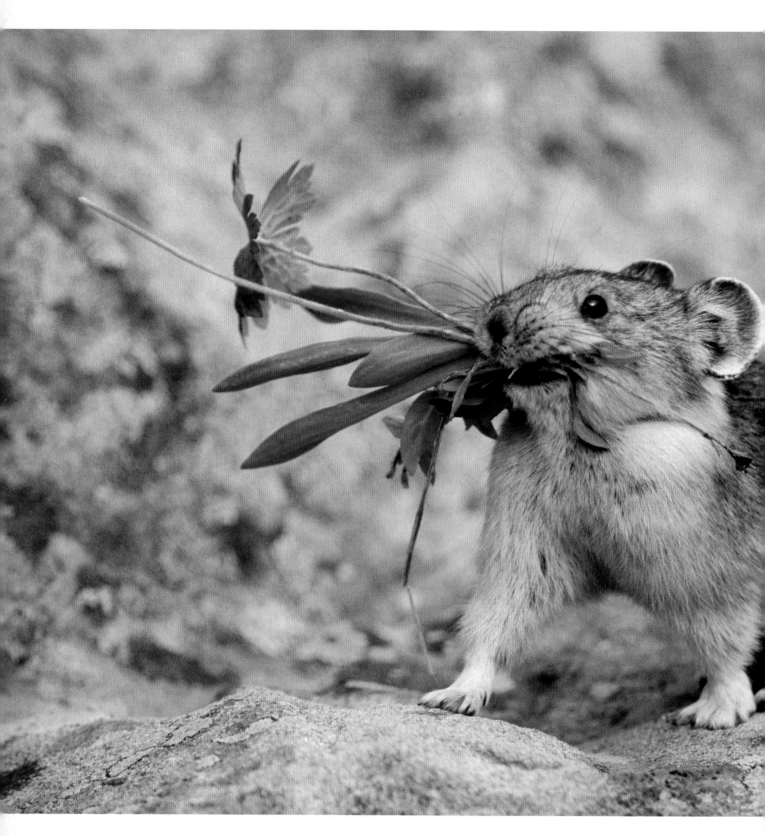

Above

While photographing wildflowers in Yankee Boy Basin near Ouray,
Colorado I happened upon a thriving pika colony. This little
guy posed charmingly for me against a lichen-covered rock as he
moved his crop of grasses into his den in preparation for winter.

IF YOU EVER HAVE THE CHANCE
TO PHOTOGRAPH PIKAS, DO IT.
AND THE SOONER, THE BETTER.

The pika is a member of the
rabbit family, and in fact it
looks a lot like a small rabbit
with little mouse ears, cute
whiskers, bright black eyes, a sparkling
personality, and a habit of running here
and there with grasses and wildflowers
charmingly tucked in its mouth. In North
America, you find pikas at high elevations,
typically on rocky slopes at just about the
tree line, roughly 12,000 feet (approximately
3,658 meters). Pikas cannot survive for even
a few hours at temperatures higher than
about 75°F (24°C), and therein lies the threat
to their future on earth. As temperatures
warm, they must move to higher elevations
to survive, but food at higher elevations is
much less abundant. Several North American
pika populations have disappeared over the
past few years, and efforts are being made to
include them on the U.S. endangered species
list; some states are reconsidering their status
in response to the growing concerns of
scientists and environmental groups.

I've photographed American pikas in
the Sierra Nevadas and the Rockies, and
collared pikas in the Alaska Range of Denali
National Park. They may be my favorite
small mammal subjects, and I'm always glad
to have the chance to spend a day with them
and their close neighbor, the marmot. Your
first clue that pikas are nearby may be the
little chirping alarm they call out; you can be
sure they'll see you first.

Canon T90, FD400mm f/4.5 lens

George and Kathryn Lepp

Right

I photographed this pika calling an alarm at a rock fall in Gold King Basin in Colorado's San Juan Mountains. Sometimes pikas are barking at the photographer, but they also alert their fellows to predators such as hawks, foxes, and puma.

Once you find a pika colony, settle down to watch them. Their patterns are repetitive, and thus predictable; when vegetation is available, they are busy gathering it in little sheaves, which they place in piles to dry. Then they move their tiny bales of "hay" into their dens as provisions for the winter. While engaged in this process, a pika will scamper repeatedly between a desirable patch of grass and its den, pausing occasionally to utter an alarm call, or bark (which may be due to the presence of the photographer).

The pika's territory is so small that you can survey the entire area and get great shots of these little critters with a 500mm lens. The challenge is that they are quick, and getting your tripod-mounted big lens into position is a bit like trying to follow the pop-up targets in a shooting gallery—an unfortunate but apt comparison. You'll have lots of misses, but the hits are so satisfying. And the best reward of all is returning to a colony you've photographed before to find that they're still there.

Take pleasure in observing the habits of small, seemingly insignificant critters, and accept the challenge of photographing them well, for yourself and for posterity.

Canon EOS-1N, EF 600mm f/4L lens

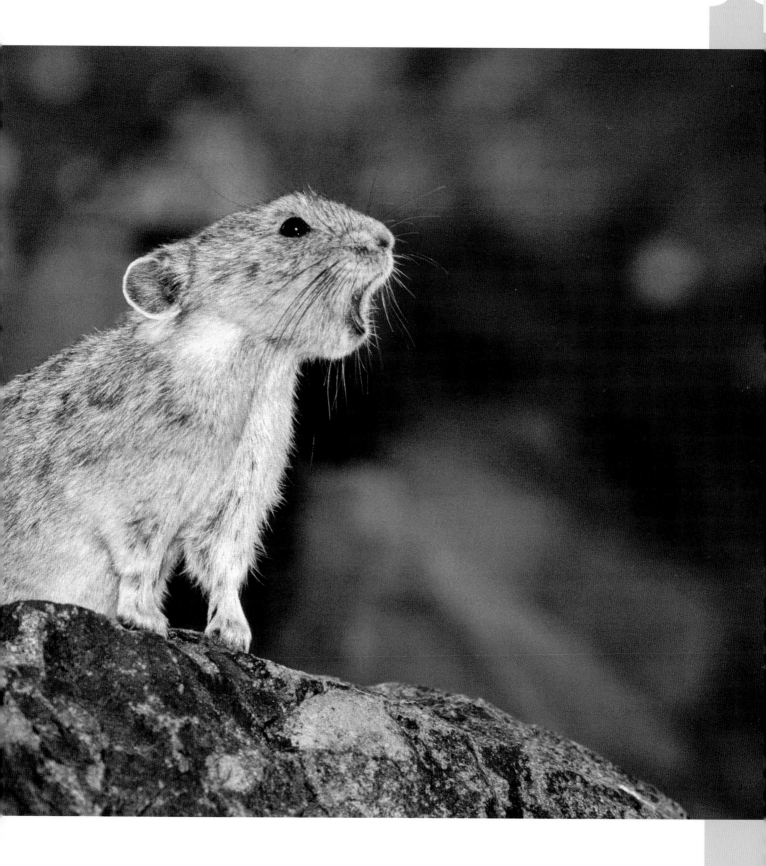

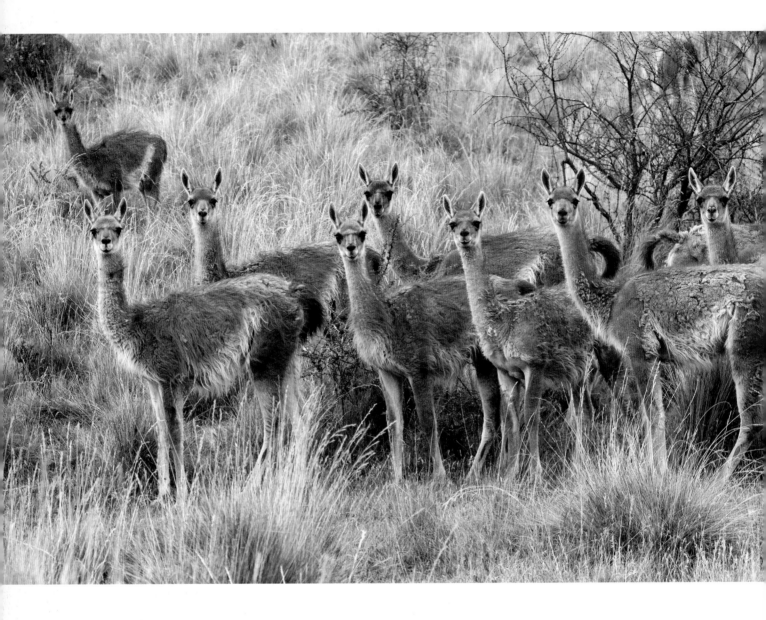

GUANACOS: YOU JUST HAVE TO LAUGH!

There are some animals that just make you laugh. Consider the guanaco, a member of the camel family, which lives in the high plains of South America. It's got that out-of-balance, dinosaur look, with a big body, long slender neck, smallish head, and flirty tail. The guanaco's face is very expressive, with big, long-lashed brown eyes under a pronounced beetle brow, and a curvaceous mouth. It's a very perky animal, too. The babies (called chulengos) have such erect posture and delicate structure, you want to put pink legwarmers on them and give them a stage and spotlights.

The funniest thing about guanacos is their intense curiosity about humans. This means that most photographs of guanacos are full-face portraits. Photograph a whole herd and it's as if you said, "Everyone look here and say, 'queso!'" Their faces are so uniquely different that you could name each one and identify it the next day in an entirely different environment. Kathy calls every single guanaco "Aunt" something, depending on the personality. Some faces seem to be smiling openly (Aunt Bea), some disapproving (Aunt Esther); some look fearless (Auntie Mame), or dithering (Aunt Clara); and some are just perpetually annoyed (you know who you are).

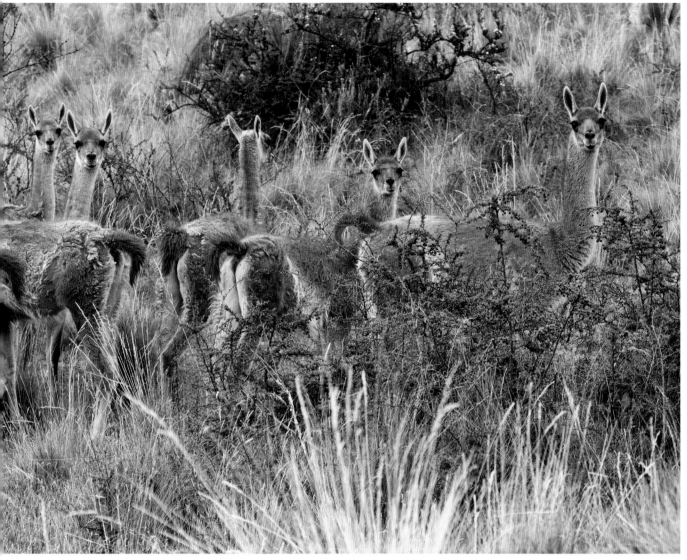

Canon EOS 5D MK II, EF 100-400mm zoom lens at 160mm, ISO 400

Despite their curiosity, you have to photograph wild guanacos on their own terms. If you move toward them, they are likely to turn as a group and race away. Young males chase each other for long distances in great looping curves across the savannah, up hills and down, leaping and nipping at each other, and rising up on their back legs to spar. I could watch guanacos for hours without even taking a picture.

We encountered these guanacos at eastern Valle Chacabuco, Chile, in an area previously devoted to sheep ranching, an activity that threatens grazing competitors such as guanacos. Two American environmental activists and philanthropists, Doug and Kris Tompkins, had purchased the land to create a new bi-national park as part of their mission of large-scale land conservation. With the ranching suspended, the guanacos returned, along with their only natural predator, the puma.

I had traveled to Chile specifically to photograph some unusual geological formations, so I wasn't prepared with a long lens for the guanacos. They helped me out by standing perfectly still, frozen in their intense curiosity about us, while I photographed them panorama-style with my 100-400mm lens.

GEORGE AND KATHRYN LEPP

DON'T LET AN UNEXPECTED PHOTOGRAPHIC OPPORTUNITY PASS YOU BY BECAUSE YOU DON'T HAVE THE PERFECT EQUIPMENT ALONG. THINK CREATIVELY TO GET THE SHOT WITH WHAT YOU'VE GOT.

Canon EOS 5D MK II, EF 100-400mm zoom lens at 260mm, ISO 400

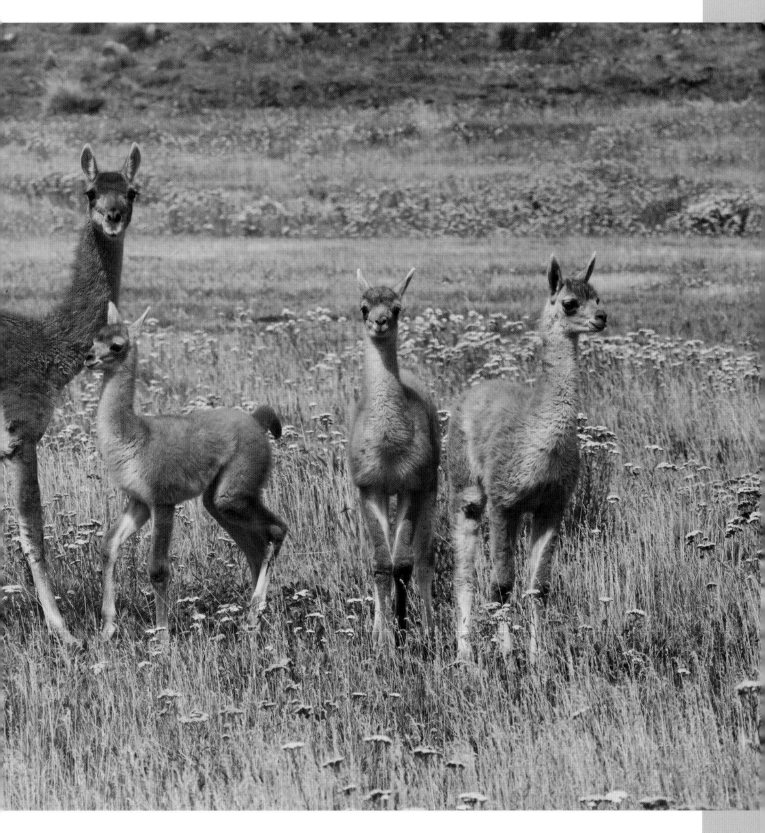

Above

Young guanacos, called chulengos, are pert and graceful. The baby on the left approaches its mother to nurse; the other two chulengos are just playmates.

R-E-S-P-E-C-T: PHOTOGRAPHING PRIMATES AT THE ZOO

Some wildlife photographers don't include zoo animals among their subjects, but you shouldn't underrate the potential of the zoo environment for behavioral studies and portraits. The combination of a photographer-friendly zoo and a patient, observant photographer can produce truly compelling and unique images.

For most of us who are engaged by animals of all kinds, the zoo is a complicated place we view as a haven for animals unable to function on their own in the wild, a critical repository for research in species preservation and propagation, a center for education… and a prison for animals bred and born in captivity. For obvious reasons, few zoo subjects are as fascinating and unnerving as the large apes. I can watch and photograph willing individuals all day long as they go about their routines and interactions (that's the fascinating part), but after a few hours I find myself so engaged by their personalities that I'm plotting to help them escape from their enclosures, no matter how natural-looking and spacious they may be (that's the unnerving part).

One way I mitigate these conflictive feelings is to offer caged primates my complete attention and respect, while recognizing that they may find my intense interest to be disrespectful. A case in point is the big silverback gorilla I photographed for only a short time in the Miami Metropolitan Zoo. I wanted to create a portrait of him that would reveal the angry-looking spirit in his dark eyes, so I photographed him with a concentrated projected flash. After two shots, he slowly and deliberately turned his back on me, ending the portrait session. He is the only animal I've ever photographed that visibly reacted to projected flash, but his message was absolutely clear. He did not turn around again while I was there.

Typically, large primates are not noticeably affected by my photography, and I've enjoyed capturing evocative aspects of their behavior in zoos around the country. I've had many pleasant interactive experiences with them as I work. The most important thing about zoo photography is to somehow eliminate the zoo while capturing the spirit and unique character of the animal. The zoo is not the place for an "environmental" shot. You'll need your long lenses so you can concentrate on portraits and close-ups that depict animal behavior and emotion. A wide aperture will render the background out-of-focus and neutral. Watch the quality and direction of light falling on the subject; it can make or break the image. If the subject will tolerate it, projected flash can be used to open up the faces of dark-colored subjects, and to add light to the eyes.

HEY, YOU! GET OUTTA MY FACE!

The solution to photographing an animal with dark fur, especially in contrasty conditions, is projected flash. This technique worked for the photographer, but not for the subject, a silverback gorilla, who already appeared to be having a bad day and was visibly annoyed by the flash. After only two shots, he turned his back, ending our photography session at the Miami Zoo.

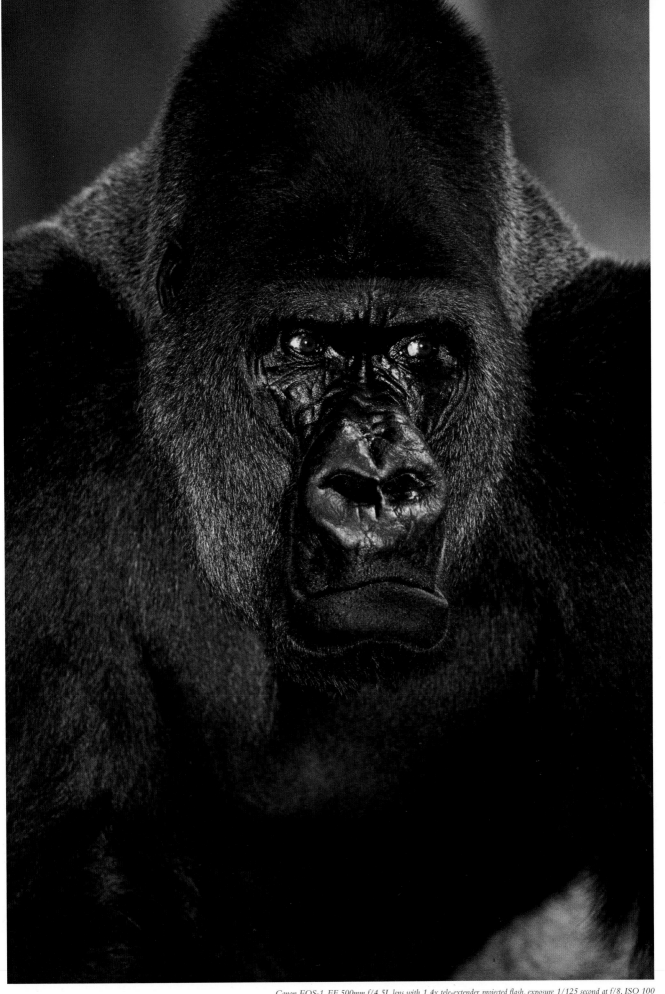

Canon EOS-1, EF 500mm f/4.5L lens with 1.4x tele-extender, projected flash, exposure 1/125 second at f/8, ISO 100

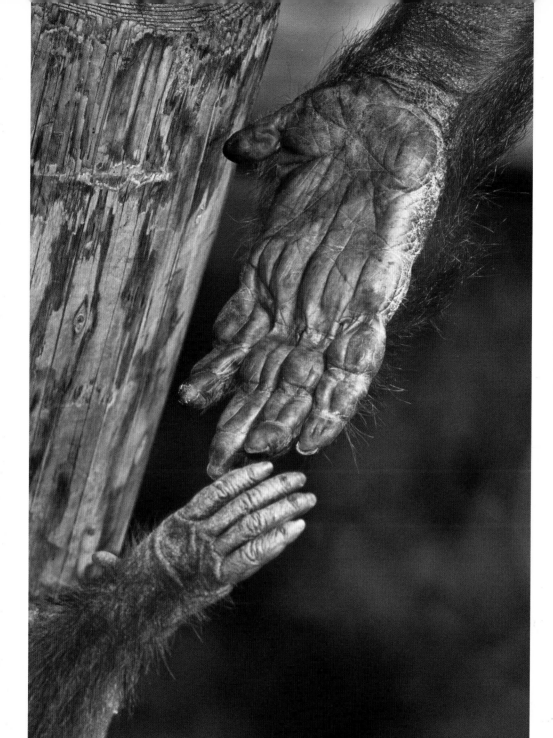

Canon EOS-1N, EF 500mm f/4L lens

Left

It's not only faces that convey emotion. Here's an image that evokes tenderness, maternal love, and trust in the juxtaposition of two orangutans' hands, photographed at the San Diego Zoo.

Opposite

This female gorilla, photographed at the San Diego Wild Animal Park, was preoccupied with her thoughts and didn't seem to mind my photography.

ONCE YOU'VE GOT A GREAT IMAGE FROM THE ZOO THAT LOOKS LIKE IT WAS TAKEN IN THE WILD, REMEMBER TO ACKNOWLEDGE IN YOUR FILE DATA AND ANY PUBLICATION THAT YOUR SUBJECT WAS RESTRAINED. IT'S JUST A MATTER OF RESPECT.

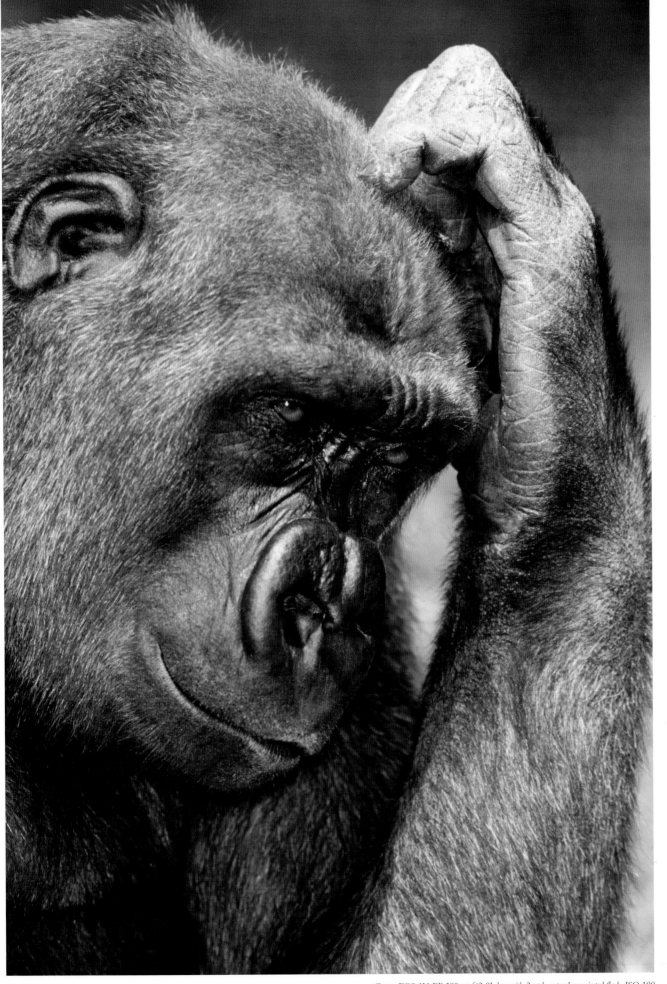

Canon EOS-1N, EF 300mm f/2.8L lens with 2x tele-extender, projected flash, ISO 100

THOUGHTS ON PHOTOGRAPHING CAPTIVE ANIMALS

HERE, KITTY KITTY

I photographed these trained (but not tame) Bengal tigers at their compound in Southern California. They ran willingly from a distance toward me as I lay on the ground next to a meat treat. A 600mm lens isolated them from their unnatural environment and made the photographs all about the cat and how it moves when it's on a mission.

If you want to photograph a Bengal tiger, your best opportunity would be in India. There you might shoot—from a jeep or an elephant's back—in one of the three Indian national parks that contain and protect approximately half of the world's remaining wild tiger population. Or, you might choose to photograph captive tigers at a game farm or local zoo, through fences. I chose a third option.

In 1995, I had the opportunity to photograph two beautiful Bengal tigers at their spacious Southern California training facility. These tigers weren't just languishing in an enclosure waiting for photographers to come along; they were highly prized working actors who had starred in a number of Hollywood films, including Disney's un-animated version of *The Jungle Book*. I really had to meet them, and, to do so, I had to make an appointment with their agent.

I had in mind some photography that you wouldn't be able to accomplish with tigers in the wild: I wanted to capture them running right toward the camera. So I lay down on the ground next to an assistant with a meat treat, and the cats' trainer released them. As they raced toward me, I fired away. I guess you could do this in the wild—but you'd only do it once. With these animals, I was able to photograph the run repeatedly;

This spread: Canon EOS-1N, EF 600mm f/4L lens

they seemed to love it, and they never confused me with their reward.

Later, we tried some photography in a large enclosure where the two tigers were able to move wherever they wanted. They were trained, but not tame, and as I was photographing one, I was unaware that the other was stalking me. As the big cat leapt toward my back, the trainer intercepted it with a tackle worthy of the Pro Bowl. Any doubt I might have had that the entire exercise was dangerous for the trainer, the tigers, and me was completely removed.

I was extremely happy with the results of the photography I did that day. It was a privileged opportunity to get a completely different perspective on the big, gorgeous animals in action, and the images have been used in many books about big cats. But I can't say that I'd do it again if I had the same chance today. While I know those two tigers were extremely well cared for and lived fine, long lives, I'm increasingly troubled by the prevalence of facilities that keep captive animals for photography. It bothers me, especially, that they seem to have cute new baby animals to offer every year, and I don't know where last year's babies go. I have my suspicions, though, that once the photographers are finished with them, they go to canned hunts, and I just can't be a part of that.

BEFORE YOU ENGAGE IN PHOTOGRAPHY OF CAPTIVE ANIMALS, INVESTIGATE THE CONDITIONS IN WHICH THEY ARE MAINTAINED, UNDERSTAND WHERE THE ANIMALS ORIGINATED AND WHAT THEIR FUTURE IS, AND SATISFY YOURSELF THAT THE IMAGES YOU TAKE AWAY WILL BE IMPORTANT ENOUGH TO JUSTIFY YOUR FINANCIAL SUPPORT OF THE ENTERPRISE. DON'T LET YOURSELF BE AN UNWITTING SUPPORTER OF UNWISE BREEDING, THE IMPORTATION OF WILD ANIMALS FROM THEIR NATURAL ENVIRONMENTS, INHUMANE TREATMENT, OR THE CANNED HUNT.

THE GREAT COUGAR CAPER: ALWAYS HAVE A PLAN B

MY FAVORITE IMAGE FROM THIS PROJECT, AND THE ONE THAT HAS BECOME MY SIGNATURE, IS THE RUNNING COUGAR. THE AD AGENCY PASSED IT OVER, BUT IT HAS SINCE BEEN A BOOK COVER, A MAGAZINE COVER, AND A POSTER, AND I'VE SOLD IT REPEATEDLY THROUGH THE IMAGE STOCK AGENCIES THAT REPRESENT ME.

Autofocus—one of the greatest advances in photography—was introduced to the Canon line in 1987 with the EOS 650. The photo world (especially wildlife and sports photographers) buzzed in anticipation of a professional version. So, when I got the call from Canon asking me to take a prototype of their first autofocus pro system, the EOS-1, and capture an iconic image to represent the new camera's capabilities, I was on a plane from California to New York that same day.

Canon's representative and their agency's creative staff brainstormed the kind of image that would convey everything predictive autofocus could bring to photography. I had recently photographed thousands of flying geese in southwest Louisiana, and the team seized upon this association with hunting—a masculine image the agency folk thought would appeal to Canon's professional camera market. Handshakes all around, and I was off to make good on my assignment.

The next thing I knew, I was shivering in a blind as the sun rose over Louisiana. The snow geese landed in a particular sandy spot to eat grit and socialize from sunrise to late morning each day. Both the geese and the camera performed perfectly and, a week later, I sent a batch of images off to the agency and anticipated their grateful response. But when the call came, the news was not good. Those beautiful white birds in flight, their feathers rendered so sharply and their eyes so bright, somehow didn't evoke the masculine tone the agency sought. Perhaps they were too evocative of angels. Did I have any other ideas?

In the intervening week, I'd been practicing my predictive autofocus skills using my standard poodle, Truffles, as a willing model. So, I bravely threw out a new suggestion: "How about a cheetah, or a lion, or a puma running right at the camera?" "Great!" they said. "Go do it!" As I hung up the phone, Truffles gave me a knowing look and left the room. No cat costume for her. How the heck was I going to pull this off?

Canon EOS-1, EF 600mm f/4L lens

This page

Here's Truffles, the stand-in, carefully trained to run to food. She willingly ran toward me (and a doggy treat) again and again while I honed my predictive autofocus skills in preparation for bolder subjects.

Right

THE RUNNING COUGAR

This trained animal was released at point A to run directly to point B (a raw meat reward), while point L (Lepp) photographs from the ground beside the treat. One of my iconic images, it appeared on the cover of *Outdoor Photographer* magazine and a major book on mammals. It's my favorite from a productive 1989 shoot for Canon's new predictive autofocus camera, the EOS-1.

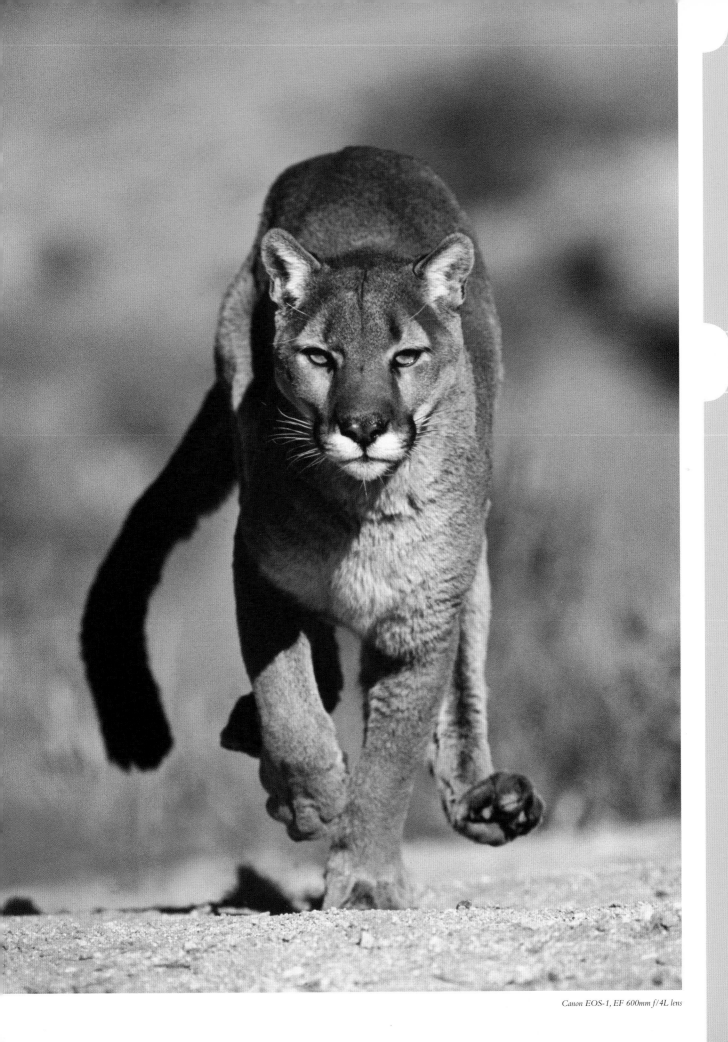

Canon EOS-1, EF 600mm f/4L lens

Hooray for Hollywood! After a few calls, I found animal handler Steve Martin and his company, Working Wildlife. He assured me he had three beautiful cougars that would run from point A to point B on command. My assistant, Dave Northcott, and I headed to the company compound in the dusty foothills north of L.A. We had two days to get the shot.

Martin's cats were trained to run to food (imagine that), and each of them would perform the run about six times before it was done for the day. So I sprawled on the ground with a 600mm f/4 telephoto propped up as if I were shooting a rifle from a prone position, a nice low angle through the sagebrush. Martin positioned a hungry cougar about 75 yards away, and his assistant stood next to me with some raw meat. When released, the cat ran at full speed towards the food. The first few runs were tests. How fast would the cat run? What path would it choose through the brush? Could I keep the single autofocus sensor point on the charging cat? At what point during the run did the cat fill the frame with an optimum image? They may have been big cats, but they were still cats, so some runs turned into relaxed jaunts or meanderings. All in all, the first day's images (processed that night by a pro lab in Los Angeles) were a learning experience.

For the next day's shoot, I made some adjustments in background, and the runs were much more productive. At Martin's suggestion, we worked with the big cats in some new ways; they would pose for portraits, snarl, and jump from one raised platform to another on command. So I positioned myself below the platforms, ready with a wide-angle lens, a slow shutter speed, and a flash on the camera. The result was a streaking cat, captured with the slow shutter speed and ambient light, along with a sharp image of the animal caught by the flash on the same frame. It was definitely different, and Canon loved it. The image became the centerpiece for the "Shoot it Hot" campaign for the Canon EOS-1.

Right

This streaking cougar was chosen by Canon USA as the centerpiece of its "Shoot it Hot" ad campaign for the EOS-1. Flash stopped the action, and ambient light caught the movement of the trained animal as it jumped from one platform to another over my head.

Canon EOS-1 with flash, shutter speed 1/30 second

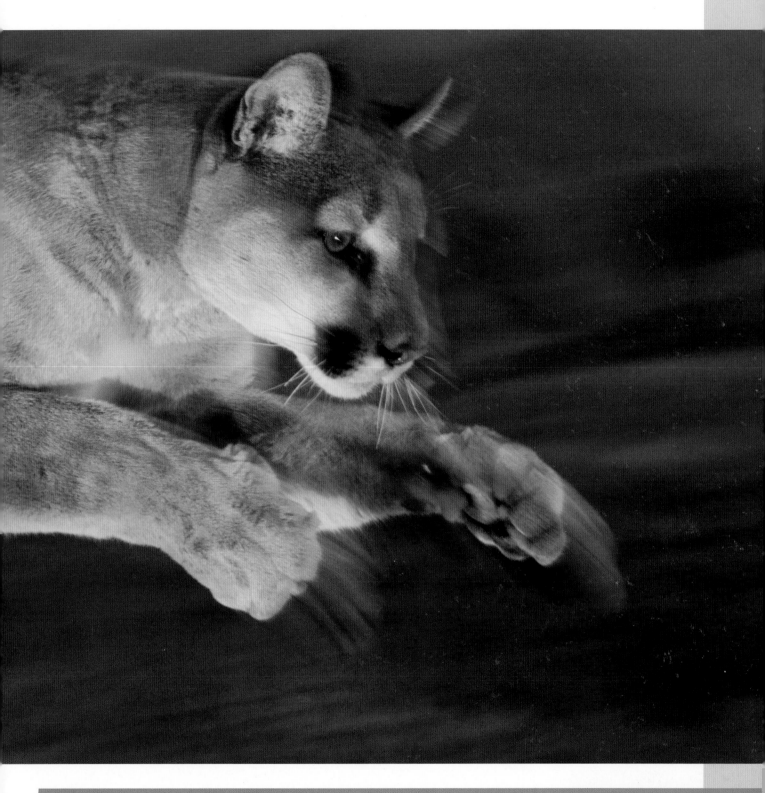

EVEN IF YOU'RE NOT SURE HOW TO APPROACH AN ASSIGNMENT AT THE OUTSET, TRUST YOUR SKILLS. BE PREPARED TO SAY YES, DON'T BE AFRAID TO TAKE A RISK, AND ALWAYS HAVE A PLAN B.

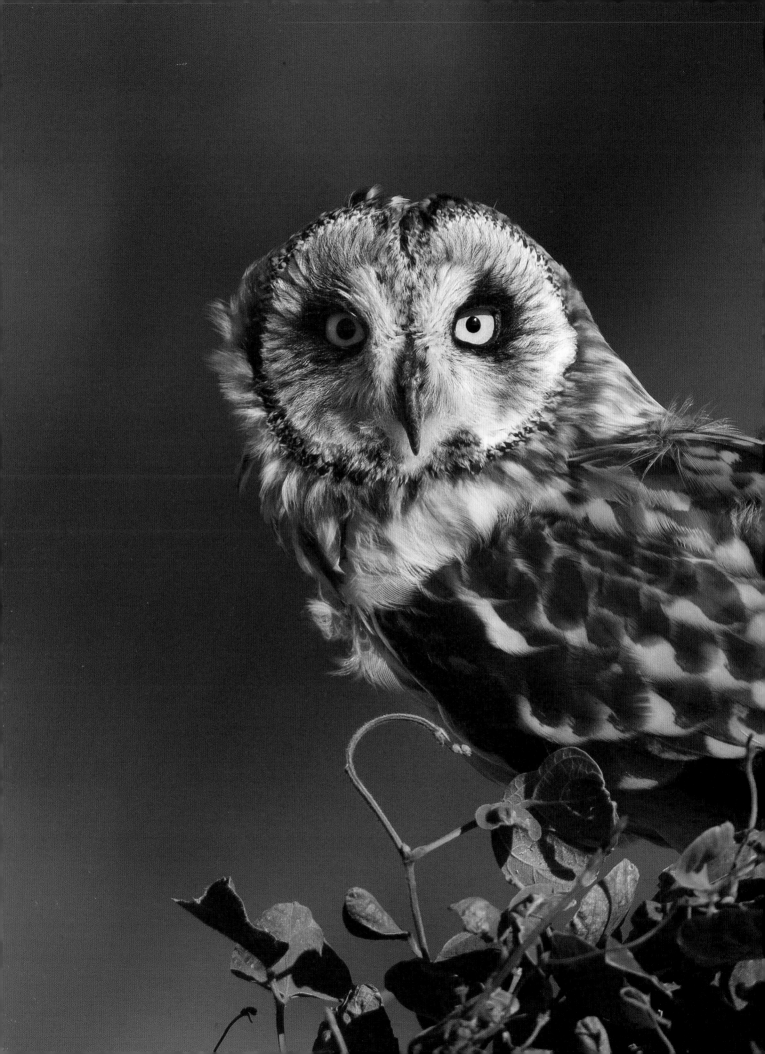

BIRDS

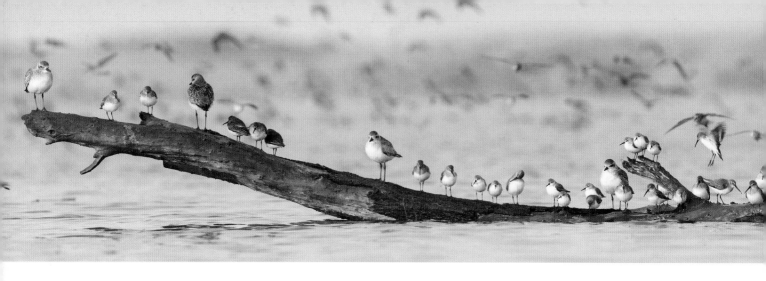

BIRDS ON A LOG: PLAN AHEAD FOR A LUCKY BREAK

Above

THE BEST OF LEPP

I think this photograph, taken on Central California's Morro Bay, is my best ever. Luck played a part in this five-image panorama, captured handheld at 700mm from a drifting kayak, but preparation and planning were the keys to success.

For twenty-five years, I lived and worked on the central coast of California, near Morro Bay, a haven for seabirds and wildlife photographers alike. An important stop for waterfowl on the Pacific Flyway, Morro bay and its estuaries host a wide variety of bird species throughout the year, and during key migratory seasons, the bay teems with shorebirds competing for feeding space along the tidal flats.

I had often observed the transformation of the Bay at high tide: the flats are flooded, and logs and driftwood are lifted to float on the rising waters. The shorebirds, displaced from their rich feeding grounds, vie for perches on the drifting wood while waiting for the tides to subside. Based on this

experience and my tide charts, I planned my approach for several weeks and launched my kayak into the Bay on a December morning, just in advance of the peak of the highest tide of the year. Armed with my Canon EOS-1Ds, an EF 500mm f/4L IS telephoto lens, and an EF 1.4x tele-extender, I went hunting for birds on a log.

In the far reaches of the Bay, I spied a large dead tree that had been lifted by the seven-foot tide. A few western sandpipers, plovers, and dunlins were camped out there, and others were flying in the area. I positioned myself between the log and the sun and with 700mm was able to maintain sufficient distance to avoid alarming the birds while I considered how to approach the shot. With the log floating in one direction

KNOW WHAT YOU'RE LOOKING FOR, PURSUE IT UNDER THE MOST FAVORABLE CONDITIONS, AND TAKE THE RIGHT EQUIPMENT. OH, AND ALWAYS LEAVE SOME ROOM IN THE BOAT FOR LADY LUCK.

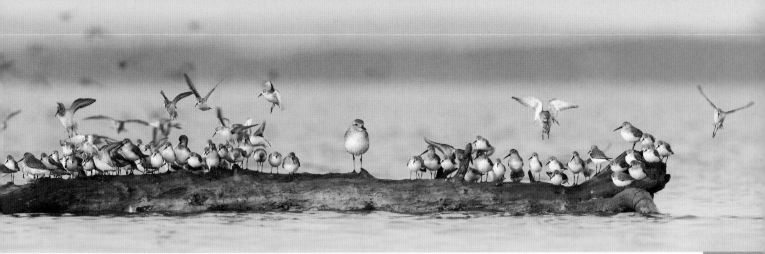

Canon EOS-1Ds, EF 500mm f/4L IS lens with EF 1.4x tele-extender, exposure of 1/500 second at f/8, ISO 100

and my kayak in the opposite, I began a panoramic series of five images with the handheld system.

I remember concentrating fiercely on keeping the lens stable to get optimum sharpness, maintaining the horizon in the same position from shot to shot, and overlapping the images by about 20%. In the ten seconds or so between the first capture and the last, the composition changed several times. If it worked, the final image would actually represent a progression through time *and* space! I shook my head as the birds all rose off the log and departed en masse; their shrill calls sounded a lot like derisive laughter.

Back in the studio, I viewed the resulting image in stunned silence. The five captures

✧✧✧✧✧✧✧✧✧✧✧✧✧✧✧✧✧✧✧

SERENDIPITY HAD JOINED INSPIRATION AND PREPARATION TO CREATE ONE OF MY BEST PHOTOGRAPHS EVER.

✧✧✧✧✧✧✧✧✧✧✧✧✧✧✧✧✧✧✧✧✧✧

came together seamlessly in Photoshop. Every bird was facing the camera, perfectly sharp, and exquisitely composed, whether perched or in flight. And in the photograph, the birds look patient, even a little curious about the photographer in a kayak.

Below
RESEARCH COUNTS

On my many expeditions into the Bay, I studied the ways the shorebirds' behavior changed with the tides, preparing for the ultimate panoramic shot I knew was possible. This earlier attempt, a study in browns, didn't satisfy my vision.

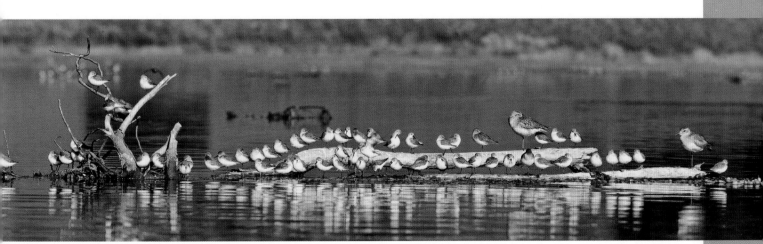

Canon EOS-1Ds, EF 500mm f/4L IS lens, three-image composite, exposure of 1/500 second at f/8, ISO 100

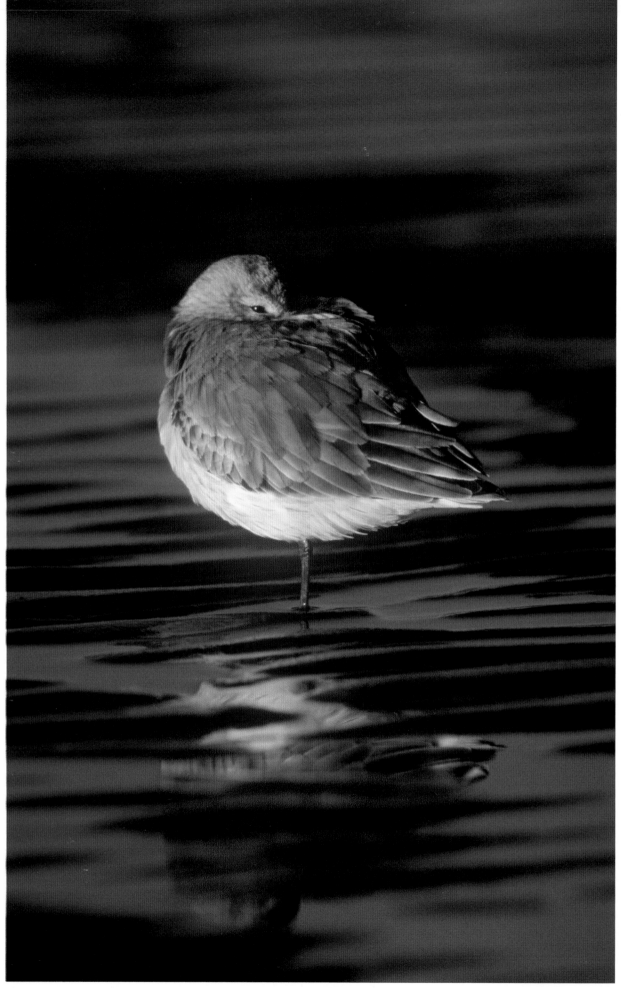

Canon EOS-1V, EF 100-400mm f/4.5-5.6L IS lens at 400mm

BIRDS BY DESIGN

Birds seem to lend themselves to highly-designed compositions; they position themselves in isolation against beautiful backgrounds and organize into symmetric patterns. Their distinctive forms serve as anchors or counterpoints in meticulously composed pieces of photographic art. And beyond capturing birds in flight, at the nest, or in courtship displays, birds at rest present yet a different perspective for the creative photographer.

There's no better environment for photographing design elements than the combination of water, sand, sun, and shorebirds in a coastal setting. Sand and water provide a highly textural shooting environment, and the sun creates shadows, reflections, highlights, and shimmering, sparkling expanses that showcase birds. Typically these elements are most evident at sunrise and sunset, when the sun's rays are cast long and low across the shore. The best environmental design photographs are not only compositionally compelling, but they also tell a story. These three examples of birds by design are some of my favorites from twenty-five years of walking the beaches and kayaking in Morro Bay on the central coast of California.

Left

A fluffed up willet at rest peeks at me as I photograph it and its reflection from a kayak in shallow water in early morning light.

WILDLIFE PHOTOGRAPHY DOESN'T ALWAYS HAVE TO BE LITERAL, ESPECIALLY WITH BIRDS. LOOK FOR THE DESIGN SHOT IN LOCATIONS AND ENVIRONMENTS THAT FEATURE BIRDS AS ARTISTIC EXPRESSIONS.

Canon EOS-1N, EF 500mm f/4L IS lens

Canon EOS-1N, EF 500mm f/4L IS lens

Above

Three great egrets crossed a sand dune for
no apparent reason, and the arrangement of
the three birds was especially compelling to
me. Photographing from a kayak below them,
I waited for the third bird to walk into the
composition. The long foreground leads the
viewer across the textured sand toward the birds,
which are positioned in the upper third of the
image to emphasize the expanse of dune.

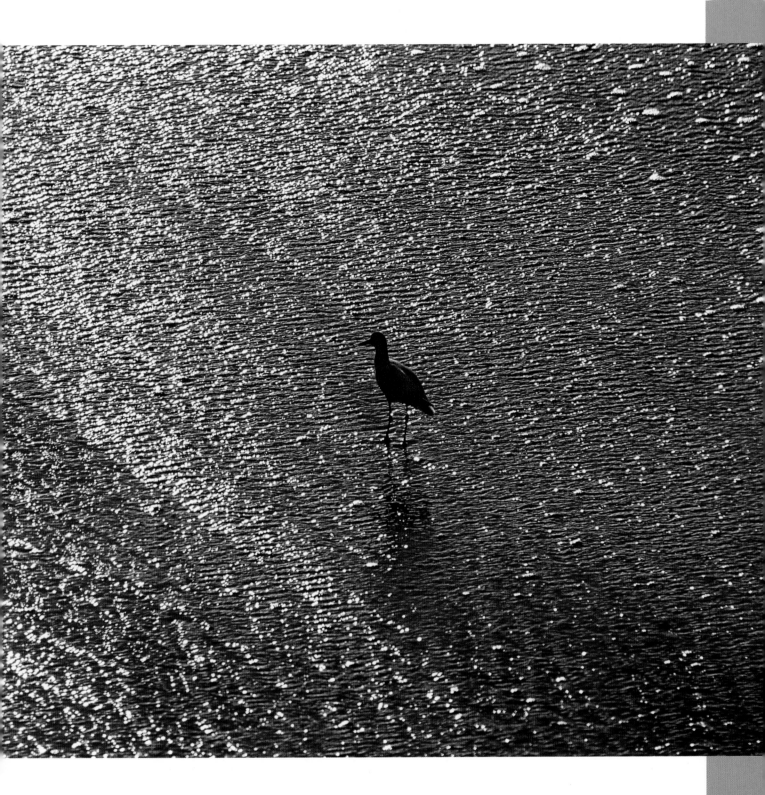

THE BEST ENVIRONMENTAL DESIGN PHOTOGRAPHS ARE NOT ONLY COMPOSITIONALLY COMPELLING, BUT THEY ALSO TELL A STORY.

SILHOUETTE IN GOLD

A lone willet takes a break from feeding in the golden light of sunset. To position the silhouetted bird within the expanse of reflected wet sand, I photographed the composition from a bluff above the shoreline.

PERSPECTIVES ON PELICANS

Since the pesticide DDT was banned in the United States, the brown pelican has made an amazing comeback. Placed on the endangered species list in 1970, all of the U.S. populations have now been "delisted" (a negative-sounding word that's really a good thing). For those of us who became acutely aware of the effects of environmental stress on wildlife in the sixties and seventies, however, the brown pelican was a big symbol. So even though the causes of the pelicans' decimated numbers were determined and reversed in time, I'm still pretty sentimental about the big birds, which recovered last on the Pacific coast where I made my home for twenty-five years.

Although I no longer live there, whenever I have a chance to photograph along the central California coast, I'm on the lookout for brown pelicans. They are the only pelican species that makes spectacular dives into the water, scooping up fish in their dip-net-like bills. While they fish alone, they travel in beautiful formations along the coastal bluffs, lifting and dipping sequentially on the air currents like a chorus line, or a well-executed wave.

Below

THE SQUADRON

I captured this formation of brown pelicans from the bluffs of Montaña de Oro State Park, California.

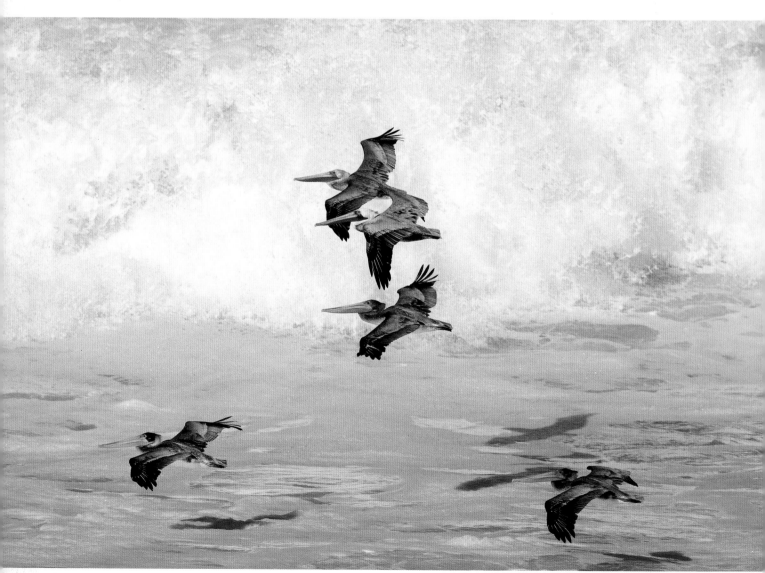

Canon EOS-1Ds, EF 500mm f/4L lens with EF 1.4x tele-extender (700mm), exposure of 1/3000 second at f/8, ISO 200

Photographing pelicans is all about positioning yourself for a great perspective. On the bluffs of Montaña de Oro, near Morro Bay, you can sit for hours and photograph the pelican formations as they ride the wind currents along the coast. When the birds fly below your vantage point, you can put the waves behind them as a dramatic backdrop. You'll get lots of opportunities to practice your autofocus as group after group of graceful pelicans moves past you.

From a kayak on the bay, you can photograph brown pelicans engaged in their solitary fishing behavior, cruising over the water, then dropping suddenly to hit an unsuspecting fish. When you're in a kayak, you become part of the bay's wildlife and your threatening human form is softened. You can slide in close to pelicans perched on posts, buoys, and piers to capture portraits.

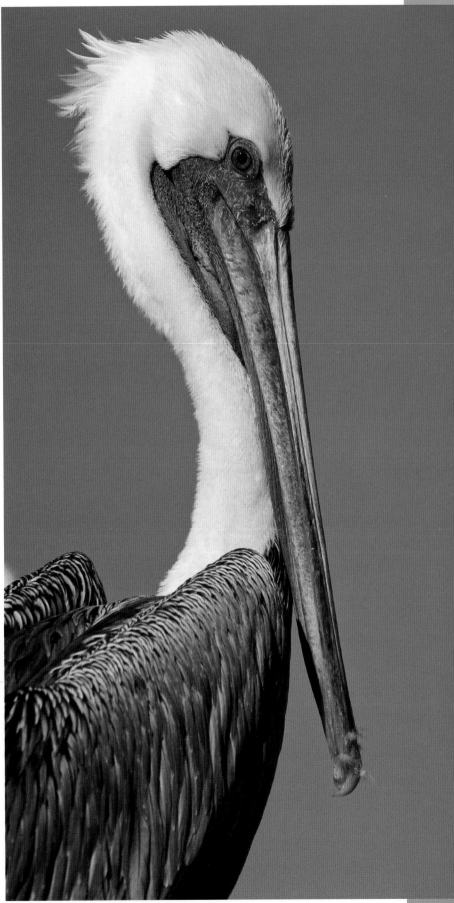

Right

A PELICAN PORTRAIT

In a kayak, a photographer becomes an unthreatening part of the community of wildlife on the water. This brown pelican allowed me to make a close approach in my "floating blind" in Morro Bay, California.

Canon EOS-1D Mark II, EF 100-400mm f/4.5-5.6L lens at 400mm, exposure of 1/1000 second at f/11, ISO 200

GEORGE AND KATHRYN LEPP

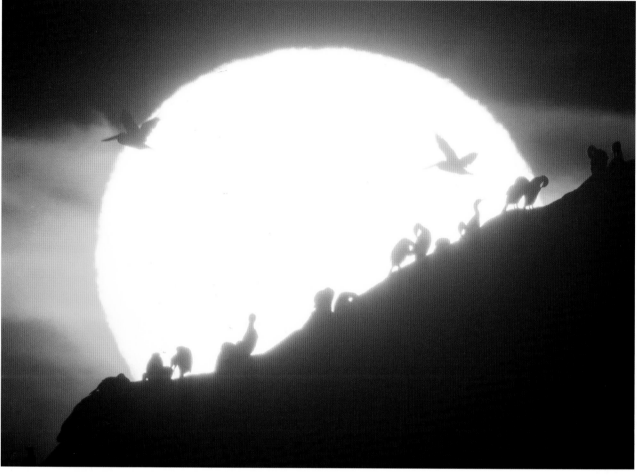

Canon EOS-1Ds, EF 500mm f/4L lens with EF 2x tele-extender (1000mm), exposure of 1/4000 second at f/27, ISO 200

Above

In a classic composition, pelicans and cormorants are silhouetted against the setting sun near Morro Rock in Morro Bay, California.

Brown pelicans are not mainland birds; they nest on coastal islands off Southern California and Mexico. Even when they are not nesting, they tend to take over little offshore outcroppings. Occasionally, hundreds of brown pelicans will roost for days at a time on a group of islands less than 100 feet (30.5 meters) off the bluffs near Pismo Beach. If you can position the sun properly behind them, the brown pelican's distinctive profile adds a perfect counterpoint to a backlit rock at sunrise or sunset along the shore.

PHOTOGRAPHING WILDLIFE SUCCESS STORIES IS ALWAYS A GOOD REMINDER THAT WE ARE NOT POWERLESS TO ACT TO SAVE ENDANGERED SPECIES, ESPECIALLY IF WE HAVE THE COLLECTIVE COURAGE TO MAKE THE CHOICES NECESSARY TO SAVE THOSE SPECIES MADE VULNERABLE BY OUR OWN ACTIONS.

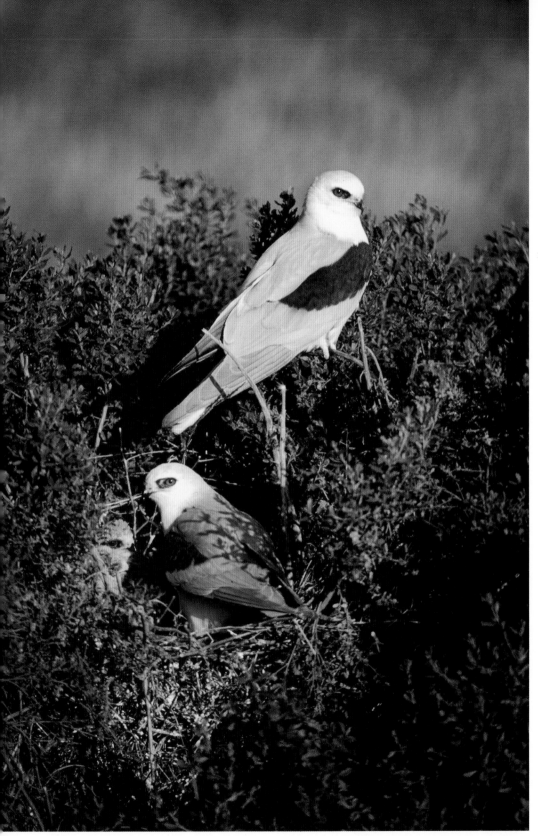

Nikon F2, 500mm f/8 lens

Left

ADULT WHITE-TAILED KITES AT THE NEST WITH YOUNG

The parents work cooperatively: The male does the hunting and brings food to the female while she is brooding and feeding the young.

My instructors at Brooks Institute of Photography in the early 1970s were in the business of training commercial photographers and cinematographers. They didn't know what to make of my obsession with nature and wildlife. I managed to redefine just about every assignment to suit a nature subject.

One of the most rewarding of my photo-school-era projects was working on Santa Barbara, California's More Mesa with biologist Lee Waian to document his dissertation research on white-tailed kites.

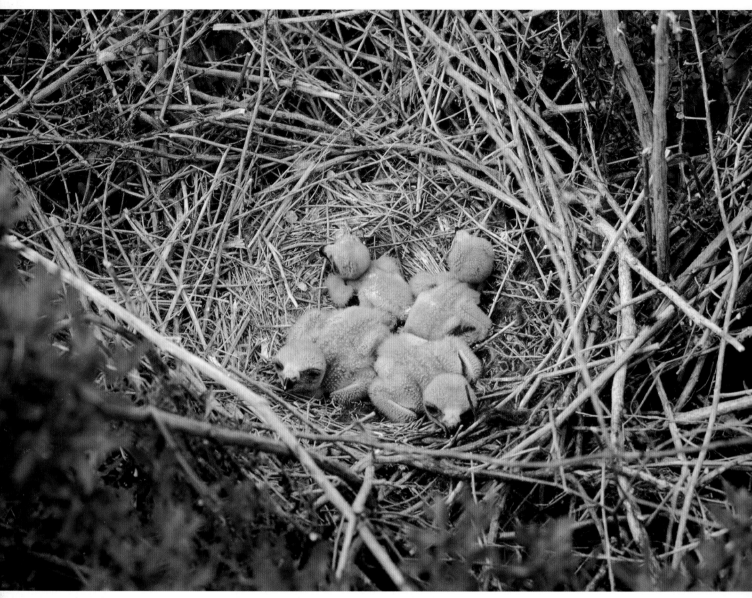

Nikon F2, 28mm lens

Above

The eggs are laid two days apart, so the first hatched has a significant advantage in development over the last. All of these nestlings survived to fledge.

For a three-month period, we set up almost daily to observe and photograph a nesting pair. (Keen observers will note that I used a Nikon camera to capture these images. Remember, I was just a student then!)

White-tailed kites were nearly extinct in California in the 1940s, but the population has recovered to abundance. The kite, a raptor known for its buoyant flight, hovers over a promising field to observe the options, then drops like a rock onto its prey, typically small rodents. Because of this unique behavior, the kite is easily identifiable from a distance. But with Waian—an expert—I could photograph the birds at very close range, knowing I was not jeopardizing them or their nest.

White-tailed kites often roost together in large groups, except during the nesting season. Then the birds form a monogamous pair and establish a territory. The nest Waian and I were studying was located not far from a road. I photographed the birds from a blind that was, unfortunately, visible to passersby. More often than I care to remember I simultaneously saw the birds take off and dropped my camera in surprise as a curious onlooker opened the back of the blind to see what was inside! (Sometimes I think camouflage is needed more to hide us from other humans than it is to fool the wildlife.)

When working with nesting birds, it's very important to be alert to the parents' feeding schedule and patterns of approach. Your activity should never deter the parents from the nest. It helps to have a biologist standing by when you put up a ladder to photograph nestlings. You've got to get your shot, and get out fast! I learned lessons from that early project that I've applied to my photography of wild birds ever since.

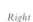

YOU CAN IMAGINE THE SATISFACTION I FELT WHEN THE INSTRUCTORS AT BROOKS SAW MY FINAL REPORT: IT WAS PUBLISHED IN *NATURAL HISTORY MAGAZINE!*

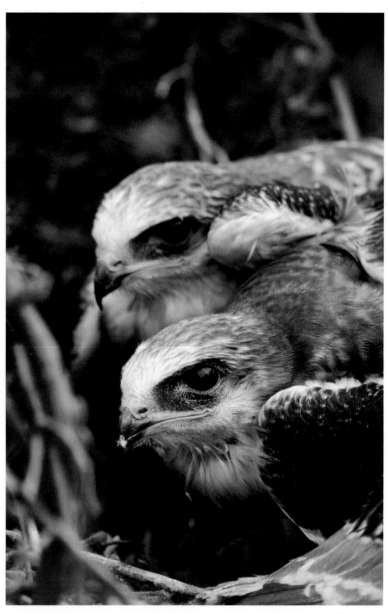

Right

Once the young kites have left the nest, feeding and training are the male parent's responsibility. He'll stay with the youngsters for several weeks until they learn to hunt on their own, while the female may prepare a new nest for a second family.

Nikon F2, 200mm lens

A NATURAL HISTORY PROJECT INVOLVING BIRDS CAN BE A REWARDING AND INSTRUCTIVE PHOTOGRAPHIC ENDEAVOR. YOU LEARN A LOT BY OBSERVING A PARTICULAR SUBJECT FOR AN EXTENDED PERIOD OF TIME, AND NESTING BIRDS OFFER THE ADVANTAGE OF STAYING IN ONE PLACE FOR AWHILE.

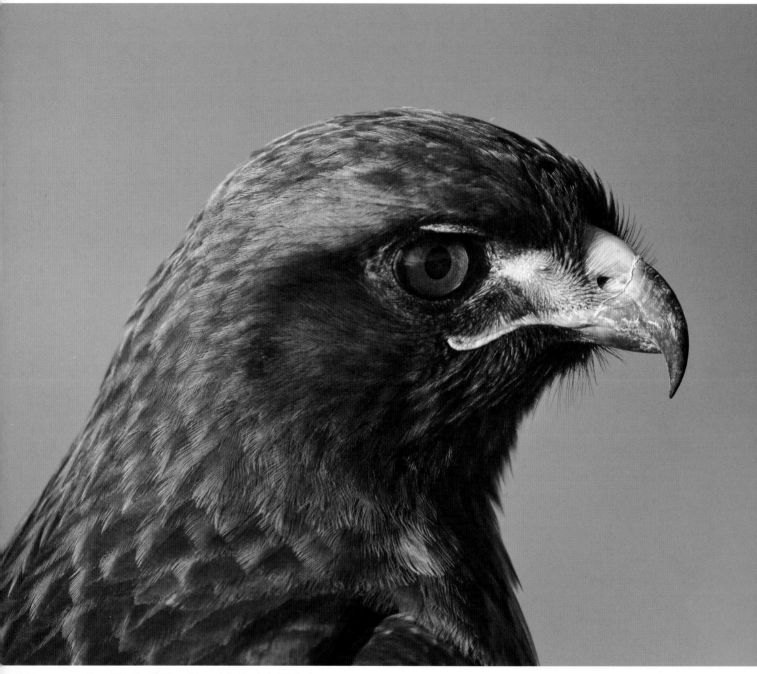

Canon EOS-1Ds, EF 500mm IS lens with 2x tele-extender (1000mm)

IN PRAISE OF THE TOLERANT SUBJECT

It's hard to sneak up on a raptor.
They've got such great eyesight and
range, and they're very alert to the
movement of man or mouse. The
usual routine when photographing diurnal
birds of prey, such as eagles, hawks, and
osprey, is that about the time you spot them
and get ready to take your first—long—shot,
they spot you and take off.

The one you're looking for is the indi-
vidual that will tolerate you for a longer time,
and occasionally, one will. I remember each of

Canon EOS-1Ds, EF 500mm IS lens with 2x tele-extender (1000mm)

Above

I was truly satisfied with this close shot of the hawk's head and shoulders, but since he allowed it, I moved closer.

these indulgent birds with fondness, but my favorite (and the one I use most often as an example of a successful approach technique) is a red-tailed hawk I encountered as I was photographing along the bluffs of Montaña de Oro State Park near Morro Bay, California.

The basic technique in such situations is to move, slowly and fluidly, as close as you think you can get without flushing the bird, and take a couple of shots. I did this with the 100-400mm lens I already had on the camera, not wanting to make any noise or

BIRDS

130

GEORGE AND KATHRYN LEPP

Canon EOS-1Ds, EF 100-400mm lens

large motions. Then, you move a little closer, and you take a couple more shots, and usually about this time, the bird flies off. But this hawk stayed, so I put on my 500mm lens with a 2x tele-extender and got serious. As I approached the hawk, he watched me and seemed to accept my presence. I had ample time to position myself properly for the best background and lighting, and still the hawk stayed. Once I got the head shot, I began to back away, afraid the bird was injured or sick and that my presence was stressing him even more. I watched from an unthreatening distance until finally, to my great relief, he rose and flew gracefully with the wind currents moving from the bluffs to the sky.

Left

This is how I found the hawk, and this is how I left him. The very best wildlife photography experiences involve a respectful photographer and a tolerant subject, with both parties safe and relaxed at the end of the session.

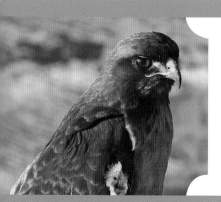

DON'T GIVE UP ON PHOTOGRAPHING A TYPICALLY CAUTIOUS SPECIES. JUST KEEP TRYING UNTIL YOU FIND THE ONE INDIVIDUAL WHO'LL TOLERATE YOU, AND THEN APPROACH WITH THE RESPECT YOUR SPECIAL SUBJECT DESERVES.

BLIND SIDED: EAGLES 2, LEPP 1

In Southeast Alaska, April heralds not only the spring thaw and the beginnings of wildflowers, but also the annual run of eulachon, or hooligan, fish along the deltas and rivers. The little oil-rich smelt gather and swim upstream to their natal waters to spawn and die. This event has always been of both nutritional and cultural importance to the residents of the area, which have been part of four nations: the Clingit, the Russian, the British, and the American.

The eulachon run is the basis for an intense gathering of wildlife each spring at the Stikine River Delta. As many as 1500 eagles—the second largest assembly in the world—adorn the logs and snags, trees and skies. It's an amazing phenomenon, and the first time I saw it, I had little time to do anything other than evaluate the possibilities; I took few images. The eagles may be abundant, but they're difficult to photograph because the area's shallow waters are accessible only by small boats, and getting close to the eagles means approaching them across the Stikine Flats, where there is no cover. Therein lies the challenge and the call. I was on it.

Below

A magnificent adult bald eagle takes a eulachon from a tidal pool on the Stikine Flats.

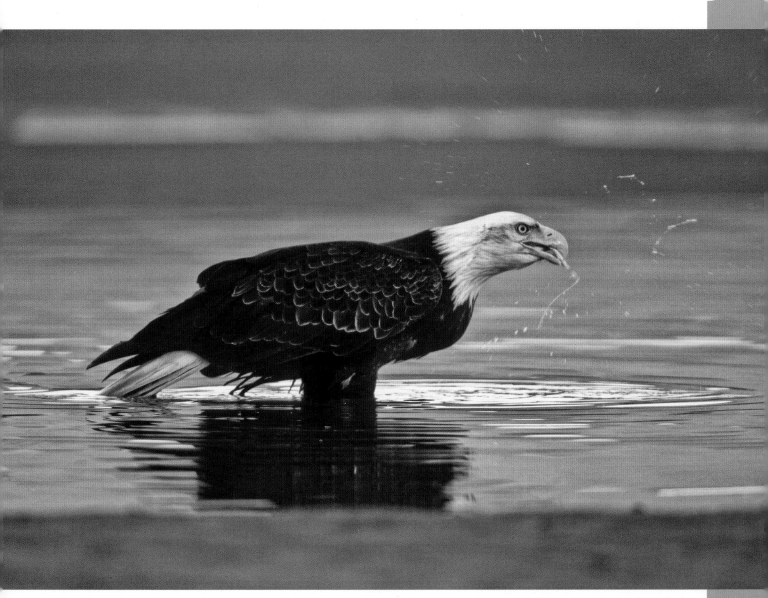

Canon EOS-1N, 600mm f/4L lens with EF 2x tele-extender (1200mm)

On my second attempt, Kathy and I headed to Wrangell, Alaska with an article for *National Wildlife* in mind. We spent several days on the delta and the river, where there were, indeed, more than a thousand eagles feasting on eulachon. A friend, Todd Harding, was in charge of getting us close to the eagles in his jet boat, which could navigate in extremely shallow water. But, it just didn't work. At low tide, the eagles were feeding far out on the flats, gorging on the fish trapped in the shallow pools and ponds. At high tide, the eagles roosted in the pine forest along the riverbanks, and all we had were eagle dots, their white heads looking like Christmas-tree ornaments against the deep green foliage of the Tongass.

But Todd had a bigger idea, and a bigger boat. Late one night, we boarded his logging salvage barge and moved upriver through light snowfall. At high tide, Todd anchored the barge on the water-covered flats, and then we all hit the bunks for a few hours' sleep while we waited for the tide to change. In the early dawn we woke to gray skies, our grounded barge surrounded by a sea of sand, fish-filled pools, and hundreds of disheveled, grumpy eagles fishing in the rain.

I'd like to say that Todd's brilliant strategy yielded all the great photography I could have hoped for, but it didn't.

WE WERE STUCK IN A REALLY BIG BLIND IN THE MIDDLE OF THE STIKINE FLAT, AND THERE WE STAYED UNTIL THE NEXT HIGH TIDE FLOATED US BACK INTO THE CHANNEL.

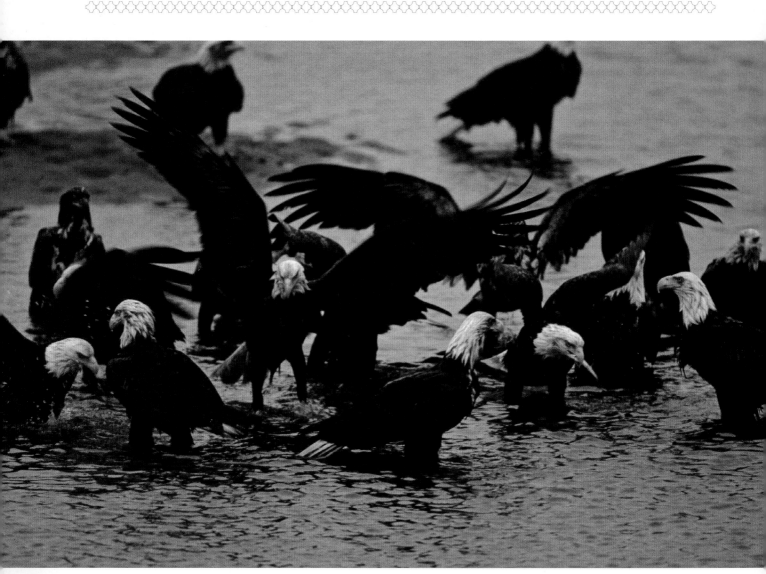

Canon EOS-1, 600mm f/4L lens with EF 2x tele-extender (1200mm)

132

The eagles steered clear of the barge, and my longest lens couldn't bring them close enough to fill the frame. I had some nice "environmental shots," but not the portraits I wanted. We left Wrangell determined to come back to try again.

The next April, I was ready with a new approach. My son, Torrey, and I spent the winter constructing a new blind, custom-designed for the flats of the Stikine Delta: an aluminum frame on wheels, covered with camouflage-painted fiberglass, and adorned with spikes suggestive of broken tree branches (or the crown of the Statue of Liberty, depending upon your perspective). We called it "The Trojan Stump." Somehow, we got the pieces shipped to Wrangell, and Todd helped us get it out on the flats, where we pushed it across the sand and sat in it for several days. The blind worked, but the results were disappointing; that season, the eulachon were widely dispersed, and the eagles were not as concentrated on the flats as they had been in other years. Still, we finally had enough images for the article, so I'd call the third trip a victory. We left the "Stump" behind with friends before we flew back home, where I moved on to other challenges, like how to "paint" Mono Lake's tufa formations with giant flashlights. Actually, that idea worked out a lot better.

Left

On a drizzly day, somewhat bedraggled eagles fish and argue over catches.

Right

We called this custom blind "The Trojan Stump," hoping it would look enough like a dead tree to fool the eagles. It did.

SOMETIMES—AND IT MIGHT BE A GUY THING— COOKING UP WAYS TO SOLVE A PROBLEM IS MORE FUN THAN ACTUALLY SOLVING IT.

A PERFECT DAY IN A PERFECT REFUGE

Right

SAND HILL CRANES AT SUNRISE

Three cranes begin their day of feeding in the fields near Bosque del Apache Wildlife Refuge.

It's 6:00 A.M., and the darkness is absolute. The air is so crisp you could bite it, and as people arrive on the viewing platform, their tiny penlights twinkle like fireflies. You hear the sounds photographers make when convening in the pre-dawn hours: a cough, a muffled greeting, the slick rustle of nylon over down, the metal-on-metal sound of tripods being extended, and the slip-click of cameras mating with flashes and lenses. Headlight beams swing and jump as more observers arrive and jockey for position on the road that rims the pond. And underneath it all, you hear the steady mutter and grumble of thirty thousand birds getting ready to greet the day.

On your mark: The birds begin to rustle, jostle, and speak to one another in increasingly eager tones, and the photographers are eager too; the quick flashes of light from their cameras expose for an instant the front ranks of geese and sand hill cranes.

Get set: In the first dim light that precedes the dawn, the acres of ghostly birds are revealed, all facing the same direction, waiting for the starting flag to drop.

Go! Suddenly, thousands of geese rise together in a

Canon EOS-1Ds Mark II, EF 100-400mm f/4.5-5.6L lens at 100mm, exposure of 1/2000 second at f/32, ISO 200

cacophony of calls and honks, flying over the waiting photographers who shoot them with streaks of light and bursts of flash, gathering the blurring wings, the falling feathers, and the bright red eyes into their cameras and their memories. (Note to self: Wear a hat.)

The sun breaches the horizon, and the first red rays stream across the ponds. A bald eagle arranges itself on the naked branch of a dead tree, and cameras grab its silhouette against the sunrise. As the day breaks, thousands of big sand hill cranes begin their synchronized take-offs in groups of three or four, running on their stilt-like legs, plowing

through the water and into the sky. For another half-hour, the transition from night to day, pond to sky, continues as the photographers on the viewing platform work feverishly, each wanting to capture the ultimate photograph, the one that will convey to everyone who sees it the very essence of the Bosque at sunrise.

It's just another perfect morning at Bosque del Apache Wildlife Refuge. Mother Nature may be in charge of the dance, but we have to thank the people who manage the refuge for creating and maintaining the stage that draws tens of thousands of migrating birds to spend the winter on the

Left

A single sand hill crane returns to the pond at sunset; the bird will join tens of thousands of other cranes, geese, and ducks to rest overnight on the water.

Canon EOS-1Ds Mark II, EF 500mm f/4L lens with EF 1.4x tele-extender (700mm), exposure of 1/90 second at f/8, ISO 400, with projected flash

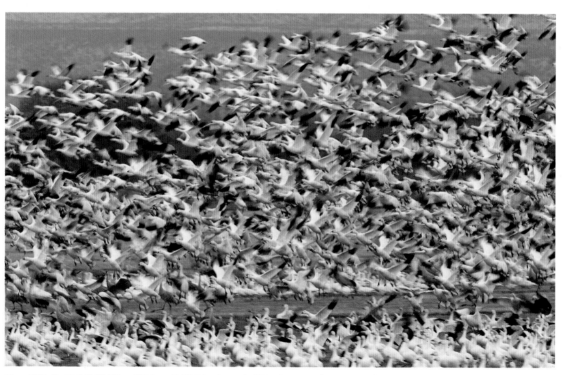

Canon EOS-1Ds Mark II, EF 500mm f/4L lens with EF 1.4x tele-extender (700mm), exposure of 1/45 second at f/16, ISO 100

Above

Flushed by a coyote, thousands of snow geese rise from a field at the refuge.

farmlands and artificially-created wetlands south of Socorro, New Mexico. Throughout the days, the birds feed on fields of cut corn, left there unharvested for them to feast upon. The snow geese and cranes are the stars of a production that includes many other species of waterfowl, songbirds, and raptors. Deer move gracefully through the refuge, and hunting coyotes flush the birds from their feeding grounds in a succession of mass risings and landings.

At sunset, the photographers reconvene at the observation platforms on the ponds to photograph the geese and cranes as they return, alone or in small groups, to settle for the night. Farewells are called, tailgates slammed shut, and engines started. Then a ribbon of red taillights moves through the gates and up the road to Socorro. As the darkness falls, so does the silence.

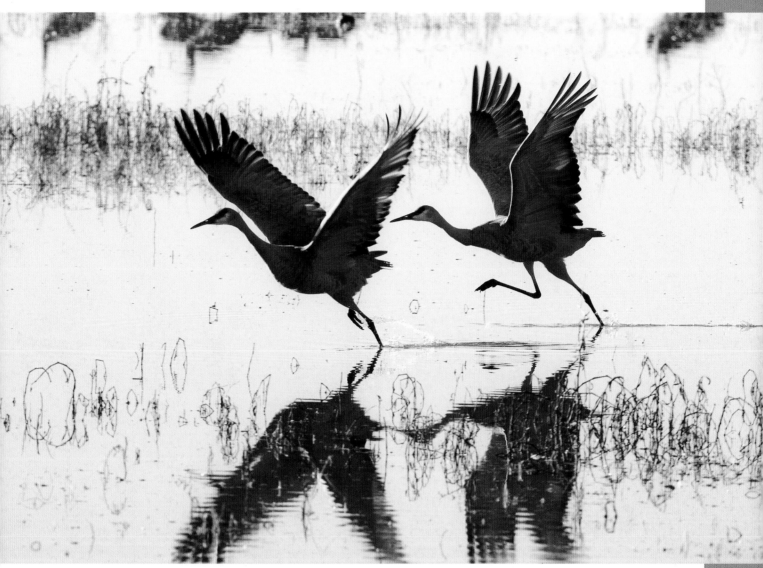

Canon EOS-1D Mark II, EF 500mm f/4L lens, exposure of 1/750 second at f/11, ISO 200

A WELL-RUN REFUGE IS A BLESSING FOR BOTH WILD-
LIFE AND THOSE WHO LOVE TO PHOTOGRAPH WILDLIFE.
SUPPORT AND SUSTAIN PROTECTED PLACES WITH YOUR
DONATIONS OF TIME AND FUNDS.

GEORGE AND KATHRYN LEPP

WHERE EVERY BIRD IS A KING

South Georgia Island, located in the southern Atlantic Ocean between the tip of South America and Antarctica, is one of the most incredible places on the planet to photograph marine wildlife, including birds that fly, such as the albatross, and birds that don't, such as the penguin. Among the latter, my favorite is the king penguin, spectacular in its abundance on South Georgia. Estimates of the number of breeding pairs range from 100,000 to 400,000, and that's a lot of birds. On the island's Salisbury Plain, the penguins' numbers are so large, and their distribution so graceful, that a colony becomes its own landscape.

King penguins have a prolonged breeding cycle that is congruent with their ability to go for periods of time without food. The parents alternate in extended shifts of egg warming and chick-feeding. When a chick reaches 30 to 40 days old, it remains ashore, huddled for protection and warmth with other chicks in large nursery crèches, while the parents head for the sea, returning at long intervals to feed the young. It's these sweeping concentrations of the fluffy reddish-brown babies among the sleek black and white adults that offers the photographer a beautiful and interesting penguin landscape.

So how does a penguin parent find its chick after days away? Somehow, the chicks know their own crèche and stay within it. I watched the hungry babies mob any adult who re-entered their group. The parent keeps moving, calling, and the chicks follow, answering. As they walk and talk, chicks drop out of the parade; the one that hangs on the longest is, presumably, the right chick, and the one that is fed.

King penguins were hunted extensively in the 18th and 19th centuries for their blubber, eggs, oil, and skins. Their gregarious nature made them easy prey, and some colonies were completely exterminated. Since the banning of commercial hunting, the population has rebounded. Currently, the greatest threat to the penguins' future is their lack of adaptability to environmental changes.

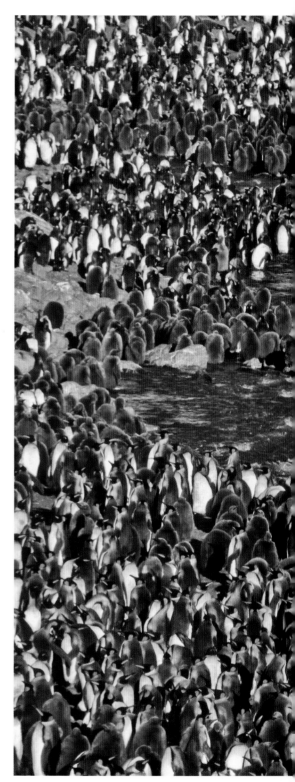

Canon EOS-1N, EF 100-400mm f/4.5-5.6L IS lens

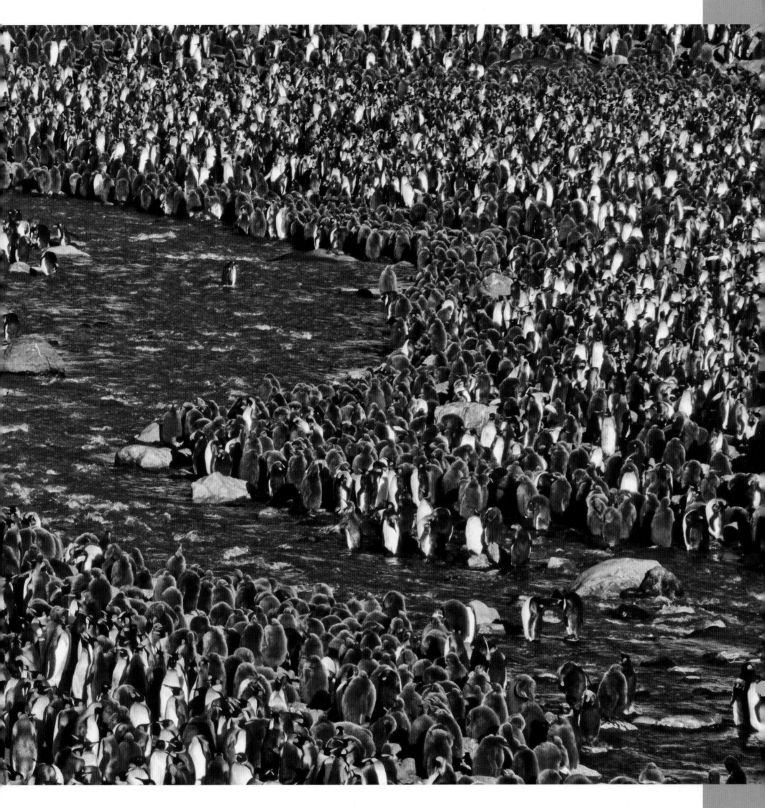

Above

An S curve is always a
compelling compositional
device, even when it's made
of a massive colony of king
penguin adults and chicks.

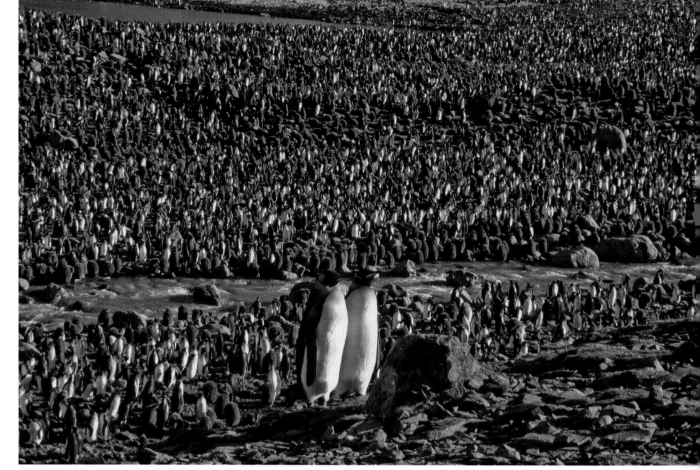

Canon EOS-1N, EF 28-135mm lens

Above

Two king penguin adults on the outer edge of the colony offer a perspective on their relationship to the colony behind them.

Opposite

These two adults fearlessly approached me as I lay on the ground. While I photographed them, they watched and seemed to try to communicate. Take me to your captain?

Their easy-going personalities make king penguins cooperative subjects for wildlife photographers, and the photographic opportunities of the Salisbury Plain are seemingly endless. Time is limited by the schedule of the ship that brought you, but it's hard to know where to start. It would be easy to walk among the penguins, but it's much safer for the birds if you work around the outer edges of the colonies and let them come to you. I've spent a lovely afternoon lying in penguin poop, photographing curious king penguins with a 17mm lens. And I've used the same lens to take in the entire colony in all its dramatic scale. All the while, brooding, hunting, feeding, nurturing, and courtship behaviors are happening all around you. You can't get it all, but you want to.

IF YOU DON'T KNOW WHERE TO START, REMEMBER THE OLD MOVIE ADAGE: SHOOT A LONG SHOT, A MEDIUM SHOT, AND A CLOSE-UP. THEN, FILL IN THE SPACES BETWEEN THEM.

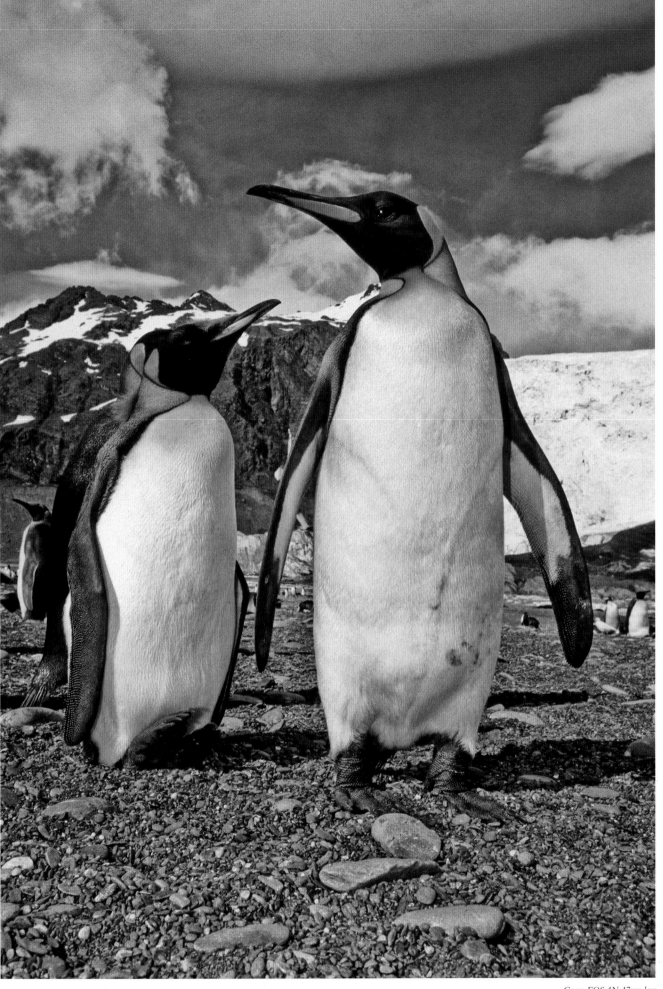

Canon EOS-1N, 17mm lens

A TALE OF TWO ROOKERIES

A century ago, the great egret, then known as the great white heron, was hunted nearly to extinction. Its plumes were all the rage for ladies' hats. As protections were enforced, the population rebounded to abundance throughout the world. Now, it is the draining of wetlands that threatens this species and others who share the egret's habitat.

I've photographed great egrets all over the world, but two places in the United States have been my favorites. They represent two very different approaches to photographing water birds at the nest with minimal disturbance. The first location, alas, is just a memory. On a small, grassy island in Southern Louisiana's Calcasieu Lake, I photographed egrets, roseate spoonbills, herons, and rails from seasonal blinds placed by our guide within the nesting area to facilitate photography. For several days in succession, we arrived by boat at sunrise, approached the rookery with extreme care, photographed from the blinds all day in extreme heat and 90% humidity, got great photographs, and caused no discernable stress to the nesting birds. But, it turned out that Mother Nature had bigger challenges in store for this rookery: It was wiped out by Hurricane Rita in 2005.

There's another easy location to photograph great egrets, great blue herons, and cormorants in their best plumage. In the early 1980s, the quintessential bird artist Roger Tory Peterson told me about the Venice Rookery, which was a local secret for many years. Sequestered near the busy civic center of Venice, Florida, the rookery is located on a small, lovely lake that hosts a productive and photographer-friendly (except for the 'gators) environment. This wonderful resource for wildlife photographers is managed by the Venice Area Audubon Society, which staffs a Welcome Center nearby. It's an interesting place to photograph year-round, but it's especially fruitful during the courtship and nesting period, from January through March. The rookery is a busy, sociable place. Photographers, sight-seers, and joggers come and go; people talk and laugh and make noise with their vehicles, and the birds, protected by an alligator-filled pond, seem oblivious to it all. There's no need for a boat, a guide, or a blind; you just need a long lens to get you across that moat.

SPLENDOR IN THE GRASS

I photographed this great egret in breeding plumage from a hot, humid blind located amidst an island rookery on Calcasieu Lake, Louisiana.

BIRD PHOTOGRAPHY DOESN'T ALWAYS HAVE TO BE HARD. MANY SPECIES ARE HIGHLY ADAPTABLE, SO BE READY TO ADJUST YOUR APPROACH AND YOUR EXPECTATIONS TO MATCH YOUR SUBJECT'S LOCATION AND ENVIRONMENT.

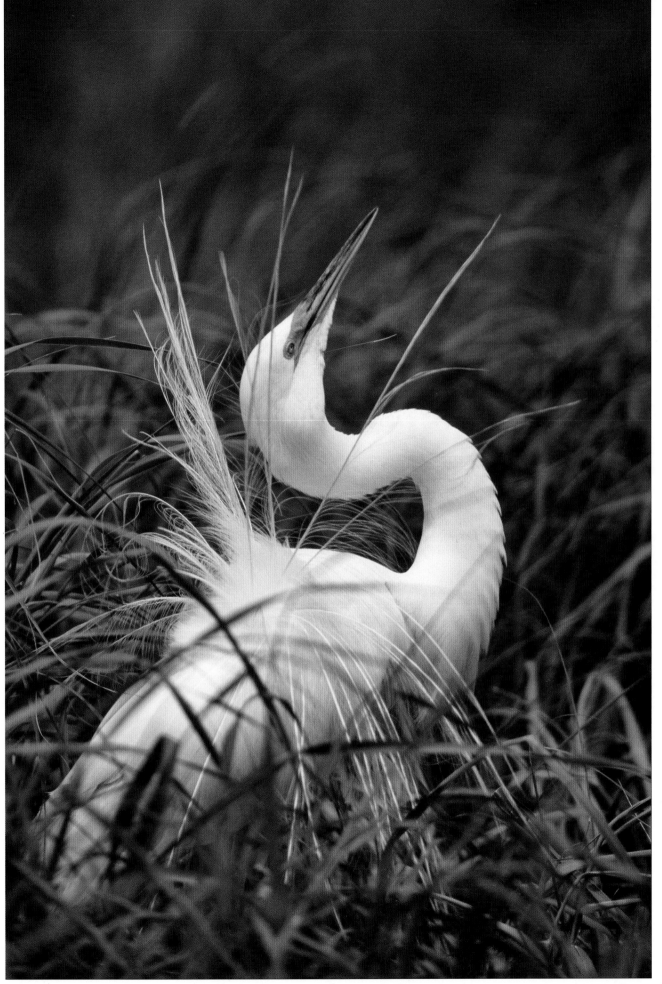

Canon EOS-1N, 600mm f/4L lens

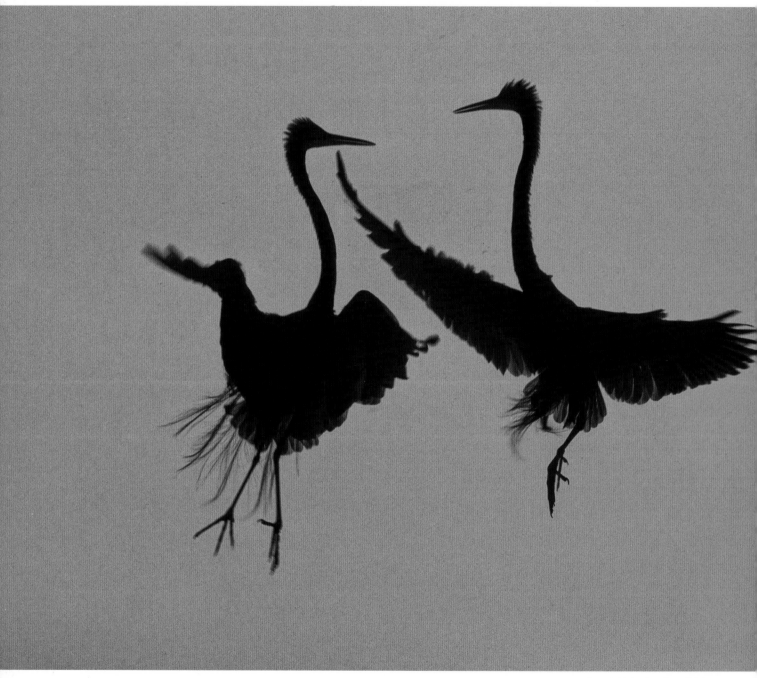

Canon EOS-1N, EF 500mm f/4L lens

Above

These great egrets are in courtship or territorial display—love or war. The other photographers at the Venice Rookery that afternoon had packed up and were getting ready to leave while I watched for silhouettes against the sunset-orange sky and was rewarded with this photographic opportunity.

IT'S HARD TO IMAGINE MORE BEAUTIFUL BIRDS THAN GREAT EGRETS IN BREEDING DISPLAY. THEIR GRACEFUL FORMS, SNOW-WHITE FEATHERS, EMERALD GREEN MASKS, AND LACY PLUMES REMIND ME OF PERFECT BALLERINAS. WHEN A MATING PAIR DANCES TOGETHER IN THE AIR, IT'S MAGICAL.

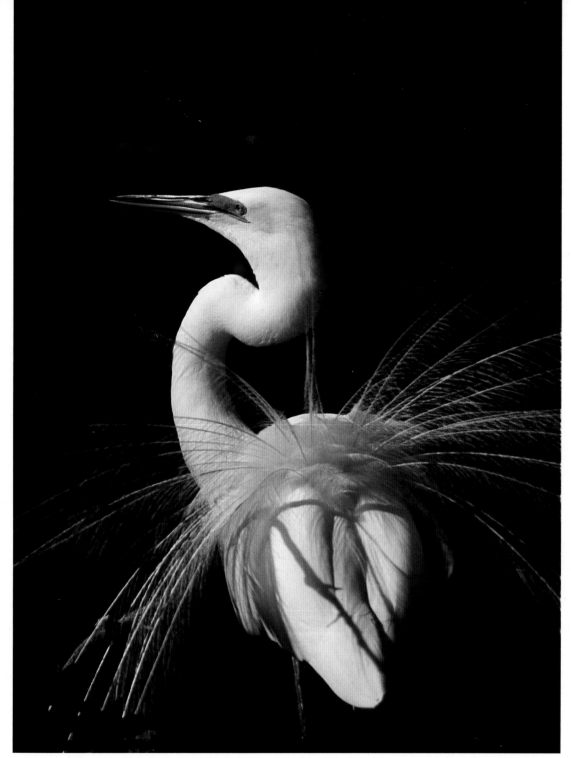

Canon EOS-1, EF 500mm f/4L IS lens with 1.4x tele-extender (700mm)

Above

This photograph was relatively easy to capture at the Venice Rookery in Florida. Exposing for the full-white bird in the sun rendered the shady area behind it pure black. We chose this image as the cover of our 1993 book, *Beyond the Basics.*

Canon EOS-1V, EF 100-400mm f/4.5-5.6L IS lens

A PERFECT PAIR

Two white mute swans glide into the image I imagined and framed.

EXPECTING THE UNEXPECTED

I love to photograph the bulb demonstration exhibitions at Keukenhof Gardens in The Netherlands. Each April, the gardens and greenhouses explode with muscari, narcissus, and a huge variety of tulips. The gardeners have designed and planted the displays the previous fall, and in April it all comes together in almost overwhelming swathes of color and design. I've photographed those flowers, and most especially the tulips, from every perspective I could think of, from multiple-image composite panoramas to intimate macro views.

When I have the chance to visit Keukenhof, I schedule at least ten days there to be sure that I can photograph the succession of blooms when each is at its peak quality. It's a very intense experience. One year,

however, I was distracted from my project by the mute swans gliding gracefully through the garden ponds and streams. The beautiful, elegant birds moved along the cool green waterways edged by bright flowers and scattered with white tree blossoms.

I saw two swans moving towards me in the water, and I anticipated that they would swim underneath a flowering tree. I set up my tripod near the place I hoped they would be, and as they moved into the position I had envisioned, I took several photographs. Sometimes there's only one shot, but it's always a good idea to bracket your composition as well as your exposure. The resulting image is one of my very favorites of two subjects I really love: swans and flower gardens.

IN A HEARTBEAT, MY MIND SWITCHED GEARS COMPLETELY FROM FLOWER PHOTOGRAPHY TO BIRD PHOTOGRAPHY—THAT IS, BIRDS IN A BEAUTIFUL FLORAL ENVIRONMENT.

Canon EOS-1V, EF 28-135mm f/3.5-4.5 lens

ANTICIPATION PAYS OFF; WHEN YOU'RE READY FOR THE PHOTOGRAPH YOU HOPE WILL HAPPEN, YOU'VE GOT A BETTER CHANCE OF SUCCESS. NOTE, HOWEVER, THAT WILDLIFE SUBJECTS HAVE THEIR OWN PLANS, SO YOU MIGHT BE THWARTED, NO MATTER HOW READY YOU ARE FOR THE PERFECT PICTURE.

While it's great to go eye to eye with a wild creature, it's better to watch some of them through the window of a blind, without their knowledge. This is especially true with some waterfowl and many nesting birds. You may be able to identify a location to which the birds will return repeatedly and predictably, such as a grit site or a nest, but your presence there would disrupt the birds' activity. This is where a blind comes into play. Your patience and sensitivity to your subjects' routines and needs will yield great photography.

A blind is useless unless properly positioned, so before you place it, you need to do some research. If possible, observe the site from a safe distance, paying attention to the birds' activity patterns, bright and shadowy locations, wind direction, and the movement of the sun over the site. With nesting birds, it's important to identify their flying lanes and their circuits through the trees and foliage as they approach and leave their nests. Be sure you don't interfere with these routes, because keeping adults from their nest can lead to its destruction. With waterfowl that are taking off and landing at a particular site repeatedly, position the blind in front of the flight pattern so you can capture the birds head-on; if you're behind them, you'll only get bird butts.

Birds will eventually accept just about any nonthreatening blind. A neutral or camouflage-patterned blind is ideal, but it really could be sky-blue pink with yellow polka dots and the birds would eventually ignore it if it stayed in place and didn't do anything more frightening than display bad taste. For shorter sessions, a hat blind can be useful; sit on a portable stool and wear a hard hat with camouflage material suspended from it. It flows over your body and conceals your form, but not your movement, so it doesn't work with highly sensitive birds.

Below

From a portable blind, I captured this male (right) and female mountain bluebird pair at the entrance to their nest hole in an aspen snag in the mountains above Mono Lake, California.

Canon EOS-1N, EF 500mm f/4L IS lens

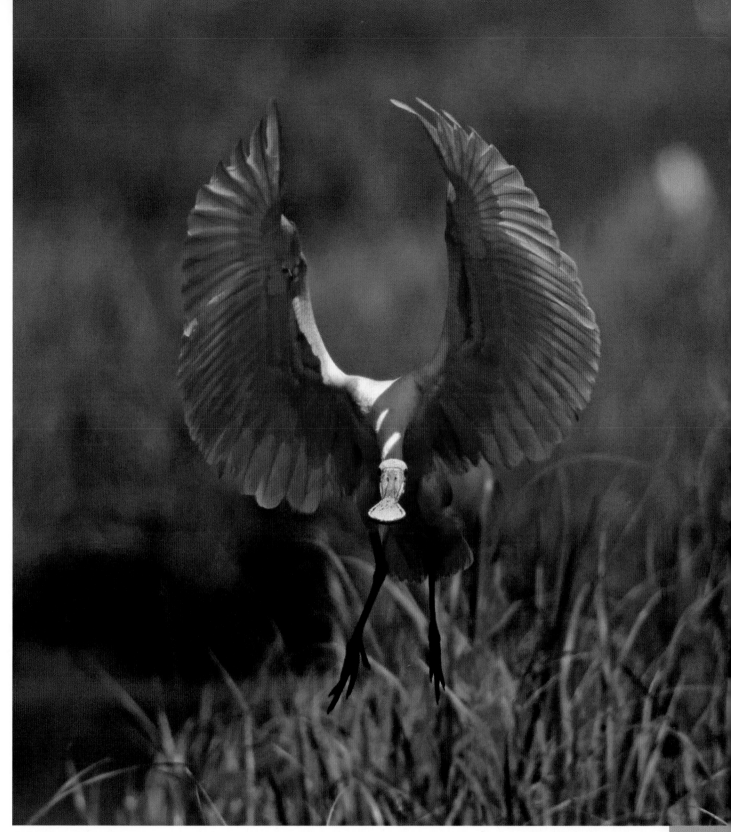

Canon EOS-1N, EF 600mm f/4L lens

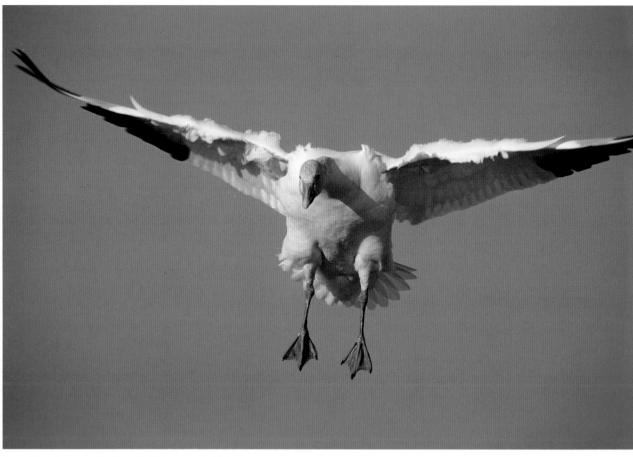

Canon EOS-1, EF 300mm f/2.8L lens with EF 2x tele-extender (600mm)

Above

A snow goose lands into the wind at a grit site in Southern Louisiana, photographed from a portable blind.

A blind may have you covered, but it's up to you to keep the noise down. Birds don't care what you smell like, which is a good thing, since sometimes you can get pretty ripe photographing from an airless blind in hot, humid weather. Keep in mind, though, that a blind doesn't make you invisible to mammals and reptiles; be aware of what kinds of other critters are likely to be in the area and interested in checking you out. It's hard to out-run a bear when you're wearing blinders.

GREAT NATURAL SCIENCE PHOTOGRAPHY OFTEN REQUIRES PLANNING, PATIENCE, AND AN ALMOST CREEPY, VOYEURISTIC ABILITY TO WATCH WHILE REMAINING UNSEEN.

PADDLE SOFTLY... AND CARRY A BIG LENS

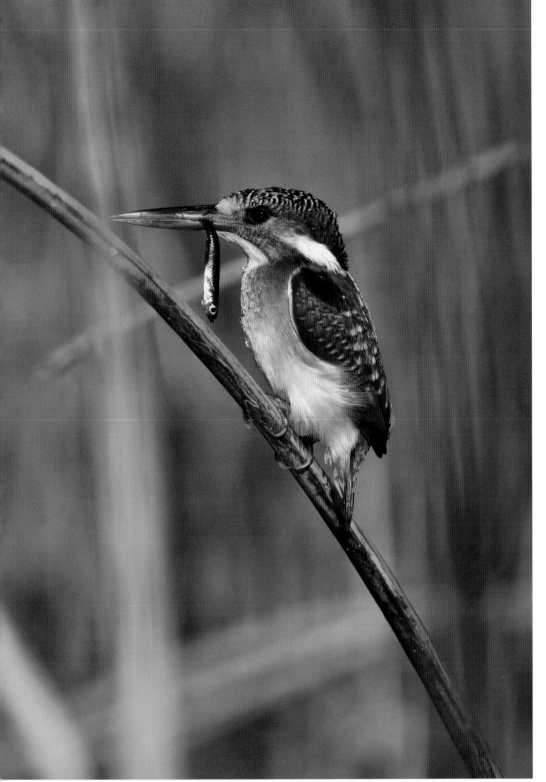

Canon EOS-1Ds Mark III, EF 100-400mm f/4.5-5.6L IS lens at 400mm, exposure of 1/500 second at f/11, ISO 200

This page

THE AFRICAN PRIZE

A 21-megapixel, full-frame camera gave me the detail needed to emphasize this subject: the tiny, elusive malachite kingfisher, with a miniscule fish. This image is cropped to about 65% of the original capture, and still prints beautifully at 40 x 60 inches (about 102 x 152 cm).

While wildlife photographers in Africa still want to capture the Big Five (elephant, lion, rhino, leopard, and Cape buffalo), there are other elusive prizes to seek. Chief among these is the Little One—the malachite kingfisher. It's not that the bird is hard to find; it's quite common in reedy areas near water and ponds. But it's tiny at only 4-5 inches tall (10.2-12.7 cm), it's busy, moving over the water in quick bursts, and it's shy. The photographer's only real hope is to approach quietly by water and capture the bird before it bolts. That means carrying a lot of pixels and a lot of glass.

ONE HOT AFTERNOON, I SET OFF WITH A SKILLED GUIDE, A 21-MEGAPIXEL FULL-FRAME D-SLR AND MY FAVORITE ALL-PURPOSE 100-400MM ZOOM LENS. AND A HAT. AND A SNACK. WE WERE READY FOR ANYTHING.

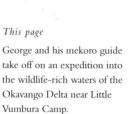

Little Vumbura Camp in Botswana is an elegant establishment of six luxurious tents situated on a small island under a mature forest canopy. It's surrounded by the floodplain of the Okavango Delta, and deep, clear channels of slow-flowing water. Willing staff will pole you through the water in your own native craft, called a mekoro. How does it sound so far? Too perfect? Well, there are also crocs and hippos in the water.

Shooting from a mekoro is challenging in some respects. It's similar to a kayak in that you're sitting down in the water and must mitigate the movement of the unstable platform. But there's another person standing in the craft—the guide—who is making unpredictable movements of his own. Still, there are advantages; the guide has a good vantage point and can stop the movement of the mekoro on a dime by planting his pole in the riverbed.

We'd seen two malachite kingfishers on an earlier foray in a small motorboat, but they were not stopping for us to take their picture. In the mekoro, you can approach more stealthily, but it's still tough to capture a kingfisher. Even when you spot one, it's likely to be obscured by the rushes and reeds.

But I got lucky. I spotted a beautiful adult kingfisher just six feet away (less than two meters). We stopped. I took some shots. It stayed. We moved forward a bit. It stayed. The bird had just caught a tiny fish and was busy manipulating it to get it into the right position to be swallowed, head first. Sometimes, kingfishers even flip the fish in the air to reposition it, but I wasn't *that* lucky. Still, the bird's preoccupation and my 21-megapixel camera made the shot possible at 400mm. Cropped and printed at 40 x 60 inches (102 x 152 cm) on our breakfast room wall, that little bird stands tall, his tiny minnow is a nice-sized trout, and you can see every brilliant feather and scale in sharp detail.

This page

George and his mekoro guide take off on an expedition into the wildlife-rich waters of the Okavango Delta near Little Vumbura Camp.

Canon EOS 5D, EF 28-135mm f/3.5-5.6 IS lens

©*Kathryn Vincent Lepp*

BIRDS

152

GEORGE AND KATHRYN LEPP

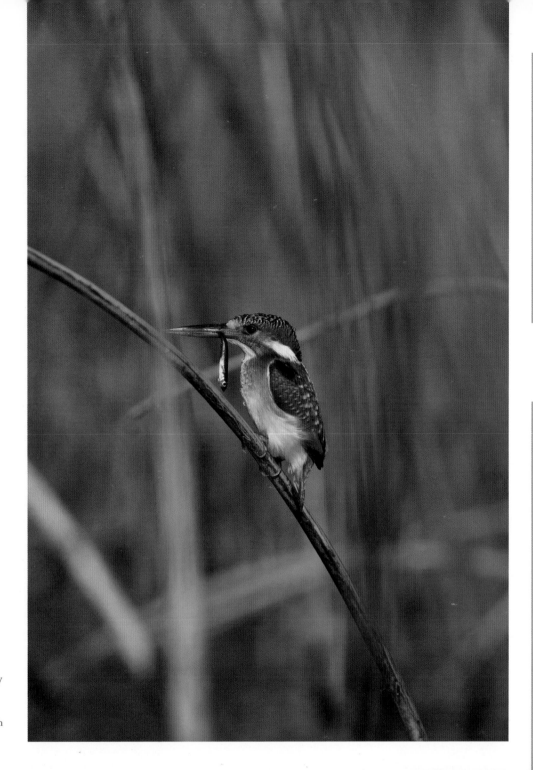

Right

The original capture of the tiny kingfisher isn't bad, it's just not the composition I wanted: too much environment, not enough feathers and scales.

THERE'S NO SUCH THING AS TOO MANY PIXELS. AS A COMPOSITIONAL TOOL, A FINELY DETAILED CAPTURE GIVES YOU THE POWER TO CROP SO YOU CAN REALIZE IN THE FINAL IMAGE THE MAGNIFICATION YOU WANTED, BUT COULD NOT ACHIEVE, IN THE FIELD.

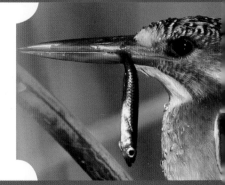

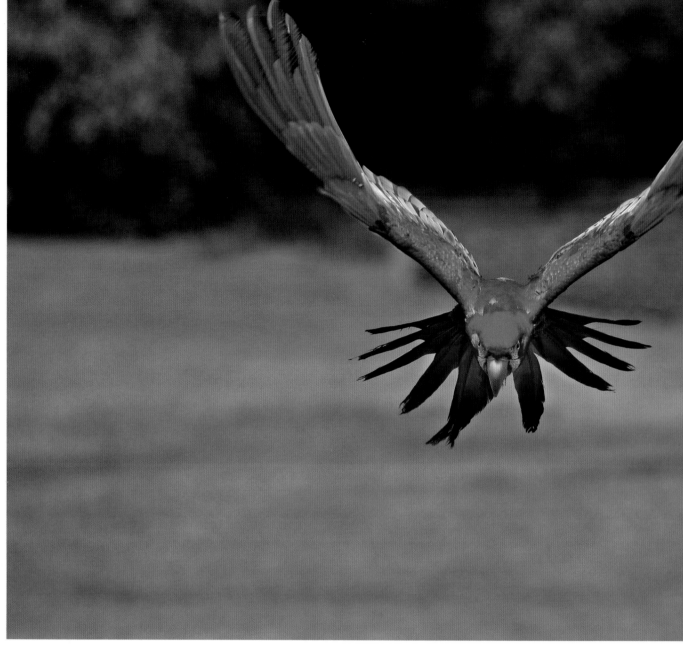

Canon EOS 20D, EF 100-400mm f/4.5-5.6L IS lens at 400mm, exposure of 1/1000 second at f/8, ISO 200

A PARROT READY FOR PRIME TIME

Above

COMING AT YOU

A scarlet macaw flies directly at the camera to land on the arm of its favorite trainer directly above my head while I lay on the ground. Canon featured this photograph in the Canon EOS 20D camera brochure.

This project started with another one of those great phone calls from the folks at Canon. They wanted photographs that would demonstrate the faster autofocus capabilities of the fourth generation of a consumer digital camera, the EOS 20D. When I think autofocus, I think flying birds, so I suggested we strut the new camera's stuff with a bright parrot flying right into the lens. They gave the go-ahead, and I was on it.

I lived in southern California at the time, and I knew there were trained birds nearby at various zoos and aquaria. But as I contacted the trainers at one location after another, I was told the birds were not immediately available; they were all overweight, and unable to work before a two- to three-week program of exercise to get them back in flying condition.

I finally found a scarlet macaw at Universal Studios, fit and ready to fly repeatedly from point A to point B. I got permission from the Los Angeles Botanical Garden to use some of the facility's open areas for the shoot, and made a deal with the macaw's two trainers to fly it from nine to noon one morning.

We met at the garden and, against a neutral treed background, one trainer repeatedly released the bird to the other as I photographed it from every possible perspective. The best results were achieved when I stretched out on the ground with the receiving trainer standing right behind me, a setup that put the bird on a trajectory right into my lens. As promised, that bird flew again and again all morning long, until just before noon, when it punched the clock. Canon loved the resulting images, and that beautiful bird looked great flying right at you out of the EOS 20D brochure.

Below

The macaw comes in for a landing, spread wings and tail forming a beautiful red starburst.

155

SOMETIMES THE PHOTOGRAPHY IS JUST HALF THE STORY; IT CAN TAKE LONGER TO SET UP THE ELEMENTS OF A SHOOT THAN IT DOES TO TAKE THE PHOTOGRAPHS.

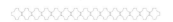

I NEEDED A PARROT RIGHT NOW, AND I WASN'T WILLING TO WAIT FOR ONE TO FINISH A SEASON OF *THE BIGGEST LOSER.*

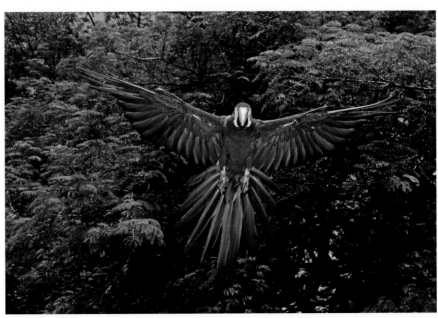

Canon EOS 20D, EF 28-35mm f/3.5-4.5 IS lens at 35mm, exposure of 1/750 second at f/1, ISO 200

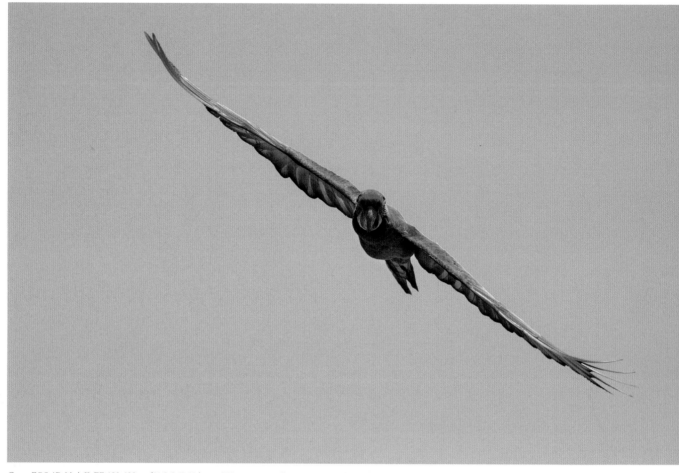

Canon EOS-1D Mark II, EF 100-400mm f/4.5-5.6L IS lens at 250mm, exposure of 1/1500 second at f/8, ISO 200

PREDICTABLE PRACTICE MAKES PERFECT

When I was teaching field workshops regularly on California's central coast, I often took my classes to a nearby animal rehabilitation facility to practice wildlife photography approaches and techniques. The nonprofit operation received injured wildlife, rehabilitated them when possible, and maintained those that could not be released back into the wild. It was a great resource for local educational programs because those animals and birds that could handle the environment were regularly taken on school visits. I particularly enjoyed photographing a beautiful military macaw that was a resident in the facility for several years. He was a cooperative subject for headshots and feather details. When I discovered that the macaw could fly, it added a new dimension to our workshops.

It's difficult to photograph flying birds; framing, focusing, and the position of the light are constantly changing as you follow a bird flying at close range. This macaw did circles, however, which gave the students a way to anticipate his direction and distance. The predictability of the bird's flight allowed us to practice photography of flying birds with a subject that repeatedly performed the same maneuver.

PHOTOGRAPHING THE MACAW WAS AN "AHA!" MOMENT FOR MANY STUDENTS AS THEY WERE FINALLY ABLE TO MASTER THE FRAMING AND FOCUS OF A SUBJECT IN CONSTANT MOTION.

Canon EOS-1D Mark II, EF 100-400mm f/4.5-5.6L IS lens at 160mm, exposure of 1/1500 second at f/8, ISO 200

Above

A Canon EOS-1D Mark II body enabled a capture speed of eight frames per second, maximizing the opportunity to get the perfect placement of wings and head against the sky.

Opposite

I've sold this shot of a colorful, graceful military macaw many times. Practice, and a predictable subject, allowed me to place the bird with precise symmetry within the frame.

SEEK OUT OPPORTUNITIES TO PRACTICE NEW WILDLIFE PHOTOGRAPHY TECHNIQUES WITH A PREDICTABLE AND CONSISTENT SUBJECT. YOU'LL LEARN INVALUABLE LESSONS ABOUT HOW TO SET UP YOUR SHOT AND YOUR CAMERA SYSTEM, AND YOU CAN APPLY THESE LATER IN DIFFICULT FIELD SITUATIONS.

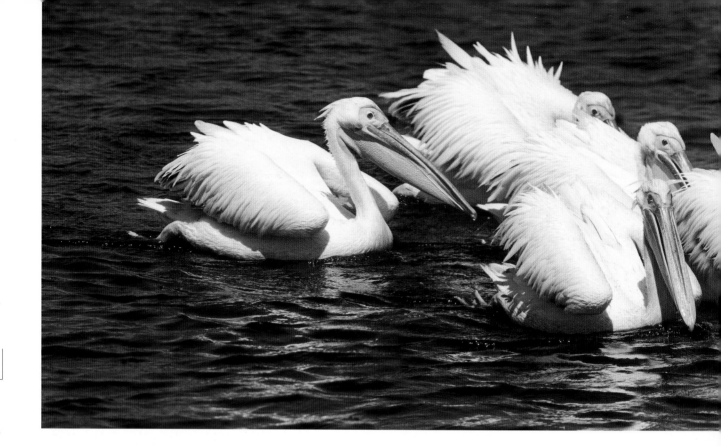

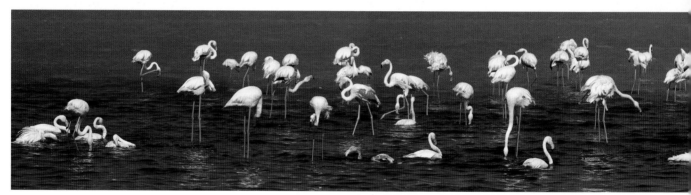

Canon EOS-1V, EF 100-400mm f/4.5-5.6L IS lens

BIRD PANORAMAS: TAKE A STEP BACK

Tanzania's Ngorongoro Crater is Eden for wildlife photographers. It's the largest intact volcanic caldera in the world, and its forests, grasslands, springs, and lake support an amazing and diverse concentration of wildlife. As in many other African reserves, human visitors to the Crater are confined to vehicles and established roads. To overcome these restrictions, a photographer must employ a versatile approach to subjects.

While photographing flamingos and pelicans in a pond, I needed my 500mm lens to fill the frame with the large birds. But I also wanted to capture the full story: the entire group of birds, not just one. My options were to change to a wide-angle lens or ask the driver to back off. In either case, the composition of the group would have changed by the time I took my photograph. And, as for using a wide-angle lens, a wide shot from a distance would have included much more of the sky and foreground than I wanted in the picture. Once those elements were cropped to concentrate on the bird formation, the quality of the image would have been insufficient to be printed at a size that would do the composition justice.

The answer was the panoramic technique I love to use and to teach. In this situation, it was the perfect solution. It was the only way to capture the composition from the place our vehicle was standing, and with the lens I had on the camera, but it was also the best way to portray the whole story before me: the number of beautiful birds and the compelling arrangement of their forms.

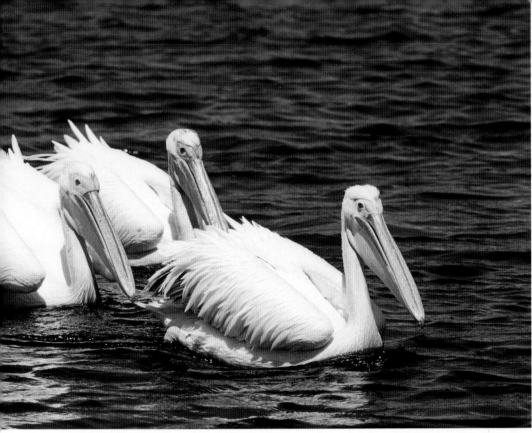

With birds, you're usually
using a lot of glass, and
my 500mm lens filled the
frame with just one of these
big white pelicans. When
the group moved into a
pleasing composition, I used
the panorama technique
to capture the entire scene
before it dissolved.

Canon EOS-1V, EF 500mm f/4L IS lens

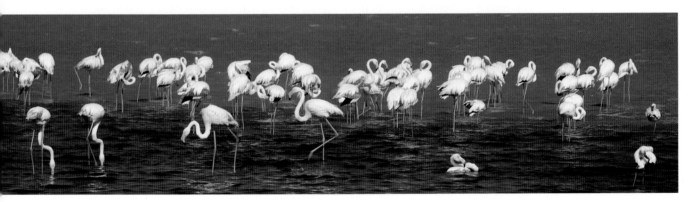

Above

If one flamingo is interesting, an entire group is fascinating—
and the latter composition tells the real story. The photograph
you need to take is a long, narrow band of birds, but you need
a lot of pixels to get enough quality to print that image at a
size that does justice to the beautiful forms and feathers of the
flamingos. The answer is a panorama that moves over the group,
bird by bird, like a video pan compressed into one moment.

THINK BEYOND ONE FRAME, AND TURN A CONSTRAINT
INTO A CREATIVE TOOL.

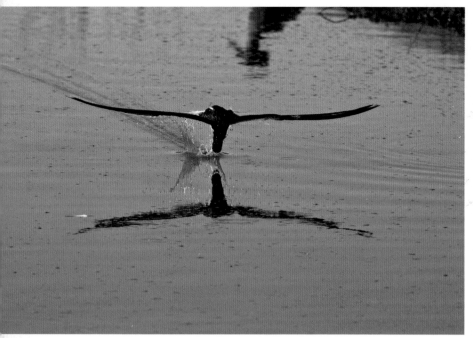 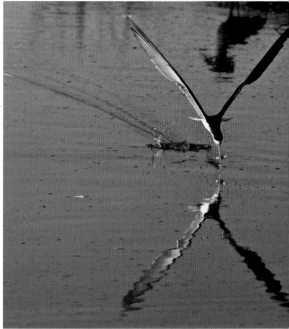

THE SKIMMER AND THE FISH: MYSTERY SOLVED

For years, in the "ethics" section of my seminars, I've used a photograph of a black skimmer taken in a Texas estuary. The bird skims above the brackish water, its lower mandible slicing the surface in hopes of trapping a fish. I'd watched and photographed skimmers performing this maneuver for many an hour, and all I'd ever gotten was this rather incomplete picture, as the bird tries and tries again, but does not succeed. In my attempt to illustrate inappropriate alteration of digital images of wildlife, I've asserted that it would be wrong to position a fish moving up into the skimmer's mouth, because it would be representing that something happened that, in fact, did not. We don't really know, I said, how the fish enters the bird's mouth. But now we do.

In November 2007, I photographed African skimmers fishing a pond at Duba Plains on the Okavango Delta of Botswana. I was carrying a new camera, the Canon 1D Mark III, which has superb autofocus capabilities and a capture rate of 10 frames per second. Even better, the camera performed well at expanded ISOs, meaning that action-stopping shutter speeds were possible without flash. These advantages of top-of-the-line digital systems all came together as I followed a skimmer that shot right at me over the pond. I held down the shutter button and fired off a long series of shots, and while I knew I had the bird in place, I didn't know if we had a fish.

That night I looked at the series on my laptop computer, and carefully examined each one. The skimmer slices through the water with its lower mandible leading; suddenly, its head tucks under its body down into the water; then it rises off the water with a small fish caught crosswise in its beak. At first I thought I'd missed, somehow, the critical moment where the fish was caught, but then I saw it clearly reflected in the water below the tucked head. And that's when I really knew how a skimmer catches a fish.

 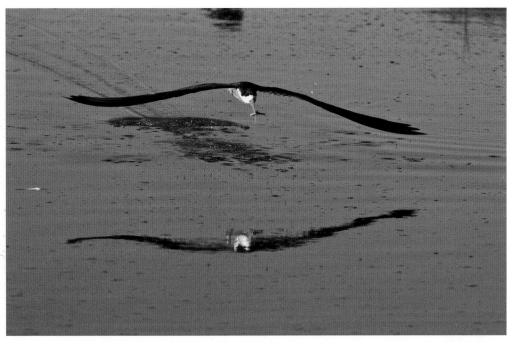

Canon 1D Mark III, EF 500mm f/4 L IS lens (equivalent 650mm with 1.3x APS-H sensor), exposure of 1/3000 second at f/9.5, ISO 800

NOW I USE THE PHOTOGRAPH OF THE AFRICAN SKIMMER IN MY SEMINARS TO ILLUSTRATE THE MOMENT I KNEW FOR SURE THAT THE CAPABILITIES OF DIGITAL CAPTURE HAD COMPLETELY SURPASSED FILM.

PEOPLE LIKE TO SAY, "IT'S NOT THE TECHNOLOGY THAT MAKES A SIGNIFICANT PHOTOGRAPH, IT'S THE PHOTOGRAPHER," BUT I THINK IT'S BOTH. TECHNOLOGICAL ADVANCES CAN ENABLE US TO CAPTURE IMPORTANT IMAGES THAT ONCE WERE IMPOSSIBLE TO ACHIEVE.

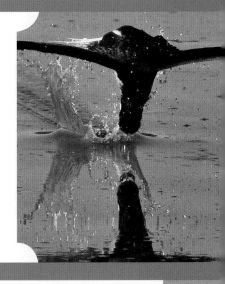

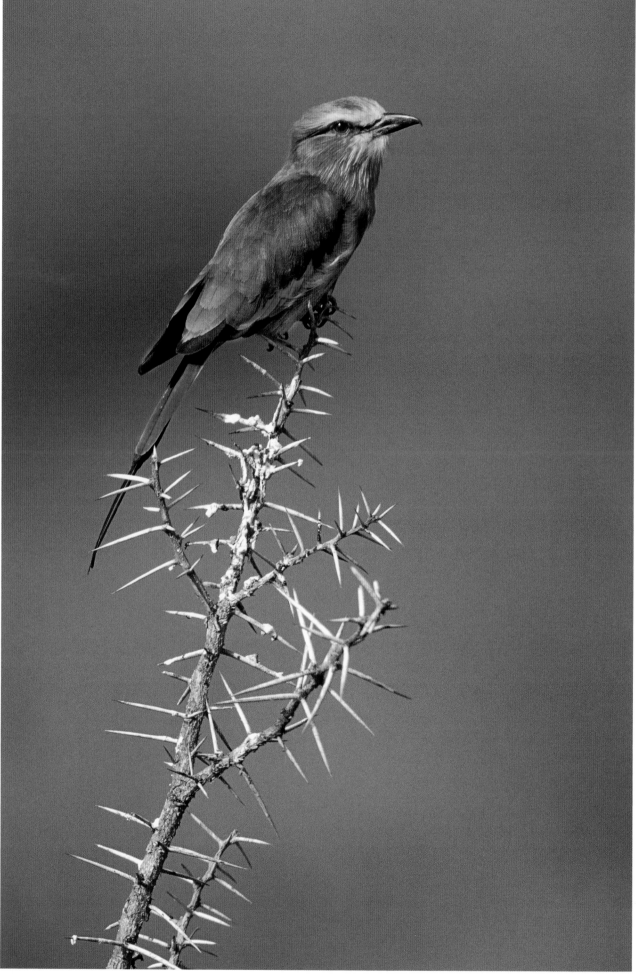

Canon EOS-1V, EF 500mm f/4L IS lens

In southern Africa, avid bird-lovers on safari are usually eager to photograph three beautiful, elusive species: the malachite kingfisher, the African bee-eater, and the lilac breasted roller. Of the three, the roller is the largest, the most common, and by far the most aggravating.

Members of the roller family are known for their long, shallow dives and thrilling, full-body rolls. The lilac-breasted variety found in eastern and southern Africa is commonly seen in relatively barren expanses punctuated by occasional acacia or other trees. Actively territorial, lilac-breasted rollers tend to make themselves known when a group of photographers passes through. They'll perch invitingly on that tree branch hanging over the road, just ahead. "Stop!" you cry to the driver. He does. As you focus your lens on the lovely bird, it winks at you and flies to the next perch, out of range. Well, okay, the bird doesn't really wink. But the lilac-breasted rollers I've encountered were so coy, alternately teasing and evasive, that they reminded me of saucy little fairies that would entice you so far into the haunted forest you'd never find your way out again.

I just couldn't stop chasing every lilac-breasted roller I encountered in ten days on the Okavango Delta. And in the end, one bird let me have just enough time to photograph it with my long lens, giving me a good close look at its lovely painted body and haughty expression—staying for awhile, but only just long enough to make me want more.

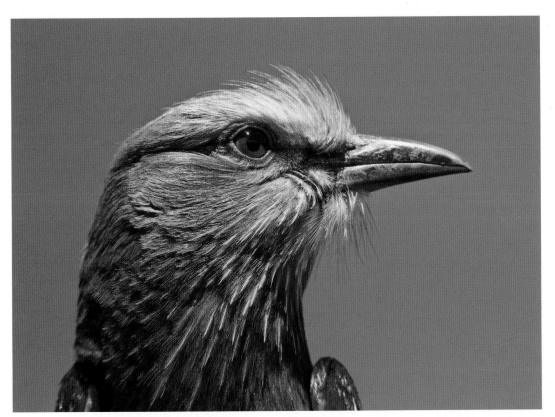

Canon EOS-1D Mark III, EF 500mm f/4L IS lens with EF 1.4x tele-extender and 25mm extension tube (910 mm), exposure of 1/350 second at f/11, ISO 400

Left
Sometimes, perseverance is rewarded with a bird that waits. This lilac-breasted roller on the Okavango Delta came almost too close, but gave me time to add an extension tube to my lens combination to shorten the focusing distance.

Opposite
THE PAINTED LADY
Lilac-breasted rollers seem to love to tease photographers into the chase, but this one perched on a thorny acacia in Tanzania just long enough for me to capture it.

LET YOURSELF BE MESMERIZED BY A FLIGHTY SUBJECT. INFATUATION CAN LEAD YOU TO A GREAT SHOT.

OUR LADY OF THE WEEDS: A LESSON IN APPROACH

Every book on wildlife photography (including this one) will advise you to approach your subject carefully, and stop before signs of stress, aggression, or fear are displayed. This is especially important in the case of nesting birds, where a photographer can be the direct cause of a nest's destruction or abandonment by cutting off the parents' access to the young and forcing the babies to fledge before they are ready, or inadvertently exposing the nest to predators. But within a species, individuals display a wide range of tolerance of photographic intrusion.

Two years running, this Anna's hummingbird nested just three feet (less than one meter) off the ground in the same batch of bushes in the woods near Morro Bay, California. In early spring, the brush was really not much more than dried leaves and seedpods left from the previous summer. The bird's fearless disposition no doubt contributed to her seemingly risky choice of nesting site. For my purposes, however, it couldn't have been a better setup for safely documenting the nesting cycle. Apparently, it worked out for the hummingbird as well; the young from both nests fledged successfully.

Canon EOS-1, 100mm macro lens, fill flash

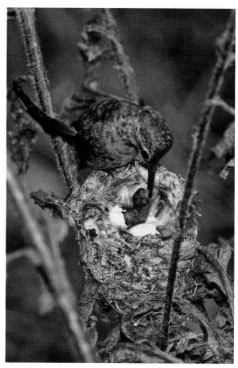

Canon EOS-1, 100mm macro lens, fill flash

Left

It pays to be first-born. You get all the attention, and all the food, at least for a day or two.

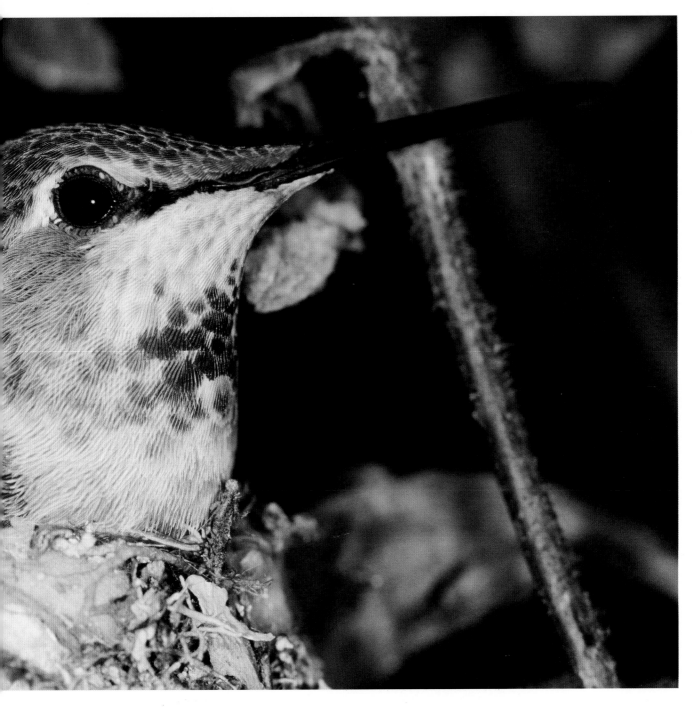

Above

OUR LADY OF THE WEEDS

We gave this patient, female Anna's hummingbird a saint's name because she was so amenable to photography.

THROUGHOUT TWO SEASONS OF PHOTOGRAPHY, "OUR LADY OF THE WEEDS" MET MY LENS (EVEN MY 100MM MACRO LENS) WITH THE DIGNITY AND GENEROSITY OF A SAINT. IN ALL MY YEARS CHASING HUMMINGBIRDS, I'VE NEVER ENCOUNTERED ANOTHER ONE LIKE HER.

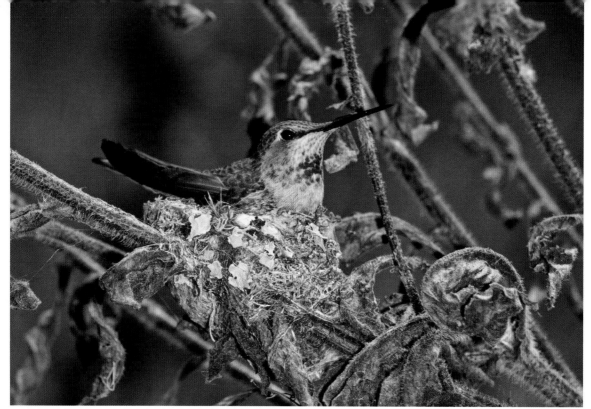

Canon EOS-1, 100mm macro lens, fill flash

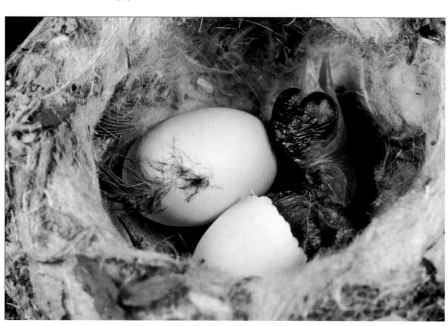

Canon EOS-1, 100mm macro lens, two small TTL flashes

Above

For two years in a row, this hummingbird built her nest near the ground in a dried-out bush.

Left

A quarter would cover this tiny nest containing a day-old hatchling and its about-to-appear sibling.

IT'S ALWAYS IMPORTANT TO GIVE WILDLIFE SUBJECTS THE OPPORTUNITY TO "JUST SAY NO" TO PHOTOGRAPHY. BUT WHEN THEY SAY YES, MAKE THE MOST OF IT.

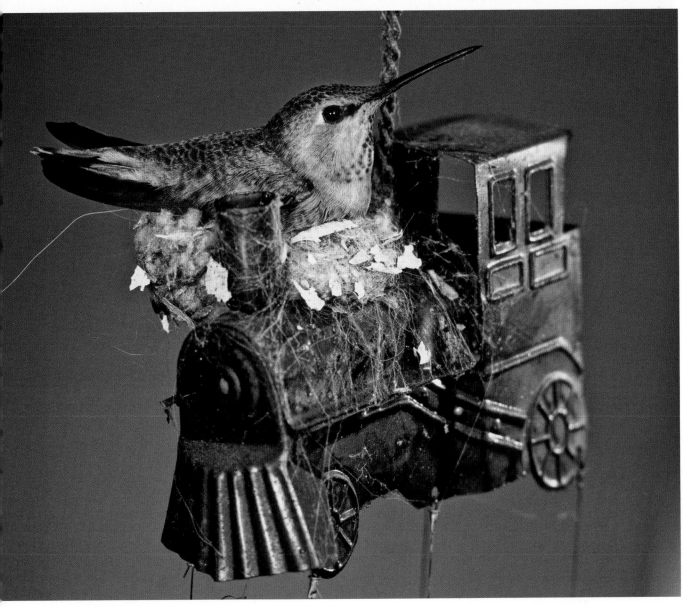

Canon EOS-1N, EF 300mm f/2.8 L lens, two flashes

IN PASSIONATE PURSUIT OF HUMMINGBIRDS

Female hummingbirds do their nest building and brooding alone. They'll typically choose a location with water, insects, and nectar available nearby. They may look for a site protected from jays, magpies, and other predator birds, but they often seem unconcerned about humans.

For several years, I spent a lot of time photographing hummingbirds, a passion to which I was introduced by Kathy's dad, David Thomas, an avid bird photographer. While I was still in photography school, Dave and I would drive all over Southern California to preserves and parks that harbored hummers, and we spent many

Above
**MOTHER HUMMINGBIRD
IN TRAINING**

I love everything about this stoic little bird and her choice of platform for her nest. In this photograph, it's easy to see how she relies on spider webs to secure the nest to its unusual base.

HUMMINGBIRDS ARE LOVELY AND FASCINATING, BUT WHEN IT COMES TO NEST BUILDING, THEY SOMETIMES SEEM LIKE THEY'RE NOT QUITE BRIGHT—OR MAYBE HUMMINGBIRD MOMS JUST HAVE A GREAT SENSE OF HUMOR AND STYLE.

GEORGE AND KATHRYN LEPP

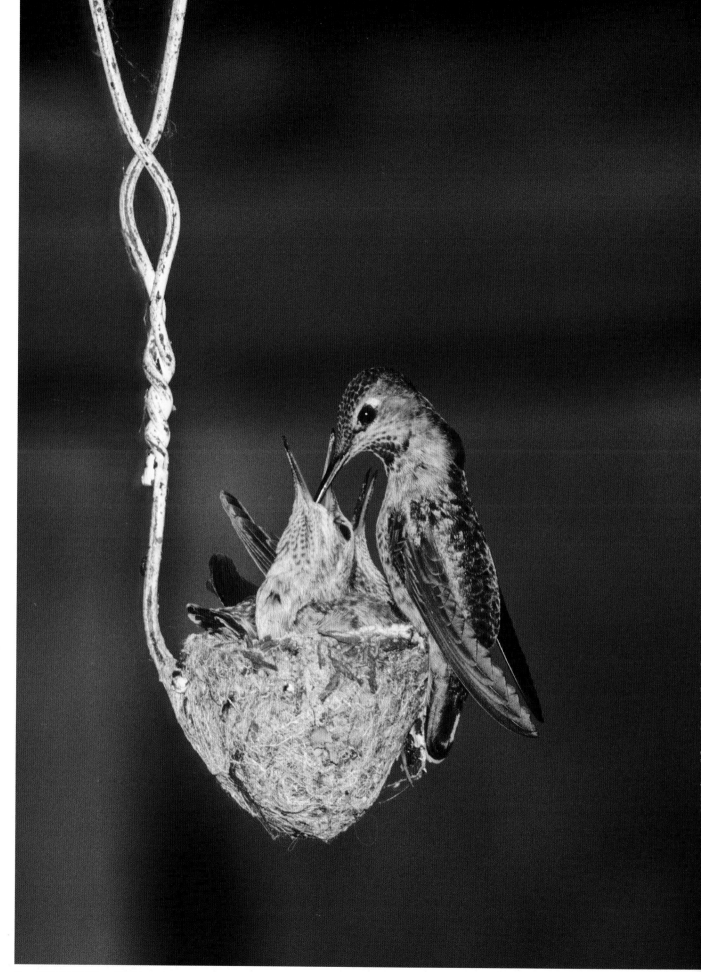

Canon EOS-1N, EF 300mm f/2.8 L lens with EF 2x tele-extender (600mm), flash

an hour setting up flash systems on deep-throated flowers, trying to stop a hummingbird's wings, or better yet, both stop them and suggest their motion on the same piece of film. As people learned of my hummingbird obsession, they'd call to tell me about an unusual nest they'd found, and sometimes I'd travel a good distance to photograph it. Today, I guess we'd all just blog about the nests and post our photographs and videos of the hatchlings and fledglings on the Internet. But thirty years ago, we called, drove, photographed, made prints, mailed them out, wrote it up for the newspaper…

Spider webs are the glue that holds hummingbird nests together, enabling them to attach to branches in fields or forests.

Webs also secure the nests to some extremely unlikely base structures in the thick of human activity. I've seen many nests built in decorative pots on porches, in hanging flower baskets outside kitchen windows, and in low bushes right by a busy pedestrian corridor. At the Santa Barbara Natural History Museum, an exhibit on hummingbirds included a nest built on top of an orange still attached to the tree, and a nest incorporated into the loop of a knotted rope. The most unusual nest I've photographed, and my favorite, was positioned atop a miniature locomotive on the base of a wind chime. The female Anna's hummingbird did not budge while I photographed her and her unusual home; she just kept staring back at me with a look that said, "What?"

Left

This Anna's hummingbird chose the hook of a wire hanger as the cross beam to support her nest, and wrapped it all up in a complicated net of spider webs. She generously tolerated my photography throughout the nesting cycle in the carport she'd chosen to shelter her brood.

WHEN YOU CONSIDER HOW FREQUENTLY HUMMINGBIRDS BUILD THEIR NESTS ON SOMEBODY'S PATIO OR PORCH, YOU MIGHT CONCLUDE THAT THE BIRDS ARE INVITING US TO WATCH (AND PERHAPS PROTECT) THEM. AND WHEN A CREATURE THAT TINY, LOVELY, AND DELICATE PUTS ITS TRUST IN YOU, IT IS A SPECIAL HONOR, INDEED.

IF YOU'RE PASSIONATE ABOUT A PARTICULAR WILDLIFE SUBJECT, LET YOUR FRIENDS AND COLLEAGUES KNOW ABOUT IT SO THEY CAN ALERT YOU TO GREAT PHOTOGRAPHIC OPPORTUNITIES. PEOPLE LOVE TO SHARE A DELIGHTFUL FIND WITH OTHERS WHO WILL APPRECIATE IT.

G E O R G E A N D K A T H R Y N L E P P

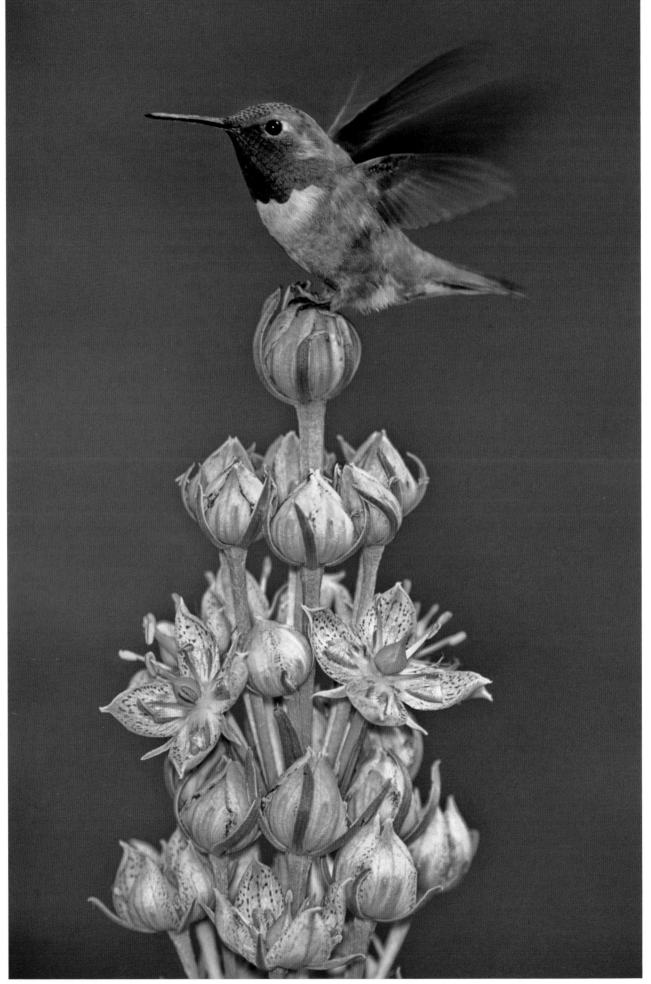

Canon EOS-1, 600mm f/4L lens, projected fill flash

One of the most delightful things about rufous hummingbirds is the beauty of their environment. What better combination of photographic subjects than prime wildflowers and jewel-like birds? Throw in the rufous's speed and determination, its feisty territorialism, and scolding chatter and you've got a near-perfect subject for challenging photography. Now imagine the whole package: magical copper-colored birds with attitude feeding on fields of purple larkspur and hot pink paintbrush in a basin 12,000 feet (about 3.7 kilometers) above sea level, rimmed by 14,000-foot (4.3-kilometer), snow-capped, granite peaks, and crowned by a sky of the color we call Colorado blue. You're in Yankee Boy Basin, hummingbird capital of the Rockies.

Photographing rufous hummers is not all that different from photographing big game on a safari in Africa. You need a hardy four-wheel-drive vehicle; you need a 500mm lens and a 1.4x tele-extender, or similar long-range combination; you need a projected flash, a sharp eye for focus, and a steady hand. And, you need patience.

Male rufous hummers are extremely territorial—to a fault, you might say. They expend so much energy in attack mode, protecting a food source, that it seems likely they use more calories in defense than they could ever get from feeding. They find a favorite perch—in a patch of willow or the spike of a monument plant—that gives them a good vantage point on their turf. Any intruder draws immediate pre-emptive action. It's this very predictable set of behaviors—feed, perch, attack—all within a small, defined territory, that makes it possible to photograph them.

My favorite way to photograph hummingbirds is to capture both their brilliant plumage and their whirring wings. You can do this by photographing in ambient light and projecting some quick, concentrated flash onto the subject at the same time. The bird will be sharply captured by the flash, but the longer exposure of the ambient light will allow the wing blur to record. The flash also adds a little catch-light into the bird's dark eye—a perfect look for such a mischievous animal. Shooting with a long telephoto adds another benefit. Depth of field is minimal, and the

Left

HUMMINGBIRD IN A CROW'S NEST

This rufous hummer returned repeatedly to a single tall monument plant to watch for intruders into his territory. You'll find monument plants in bloom only every few years in Colorado's San Juan Mountains; each plant blooms only once in its 20 to 80-year lifespan. The combination of elusive flora and fauna make this image one of my favorites.

❖❖❖❖❖❖❖❖❖❖❖❖❖❖❖❖❖❖❖❖❖❖

HUMMINGBIRDS ARE DRAWN TO FEEDERS AND NARROW-THROATED GARDEN FLOWERS IN YOUR OWN BACKYARD, AND THAT'S A GOOD PLACE TO PRACTICE YOUR HUMMER PHOTOGRAPHY BEFORE YOU INVEST THE TIME AND ENERGY TO GET CLOSE TO THE REALLY FEROCIOUS, BIG-GAME RUFOUS HUMMINGBIRDS YOU'LL FIND IN JULY AND AUGUST IN THE WILDS OF SOUTHWESTERN COLORADO'S SAN JUAN MOUNTAINS.

❖❖❖❖❖❖❖❖❖❖❖❖❖❖❖❖❖❖❖❖❖❖

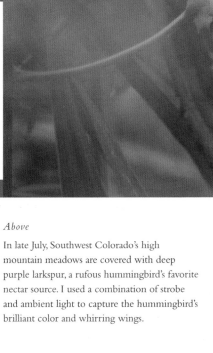

background and foreground can be nicely thrown out-of-focus around the bird. It isolates the action within the natural environment without the busy distraction of surrounding foliage, providing a colorful but neutral background or frame.

Autofocus is of little use here. The bird is tiny, active, far away, and moving through a forest of stems and flowers. In such conditions, your autofocus sensors will constantly get hung up on the wrong plane. But TTL flash capability and projected flash are essential. Set TTL flash with exposure compensation at 1 to 2 stops less than the ambient light. The projected flash attachment concentrates the light and extends the effective distance. In combination, the flash enhances the colors of the bird and fills in shadows, while the ambient light gives a natural, outdoor look to the entire scene. The flash duration is very quick (1/1000 second to 1/30,000 second, depending on the distance) to stop the action, while a slower shutter speed (from 1/60 second to 1/500 second) lends a nice blur to the fast-moving wings. (High-speed sync can also be useful.) The patient photographer puts his or her long telephoto lens on a sturdy tripod at the edge of the bird's territory, watches the action for awhile to get a sense of the places the bird is frequenting, sets the camera on manual focus, then shoots a lot of pixels. There will be many misses!

TAKE THE TIME TO PURSUE ELUSIVE SUBJECTS. WHILE THE ODDS FOR SUCCESS MAY BE LOW, THE EXPERIENCE AND THE OCCASIONAL GREAT SHOT MAKE IT ALL WORTHWHILE.

Above

In late July, Southwest Colorado's high mountain meadows are covered with deep purple larkspur, a rufous hummingbird's favorite nectar source. I used a combination of strobe and ambient light to capture the hummingbird's brilliant color and whirring wings.

172

BIRDS

GEORGE AND KATHRYN LEPP

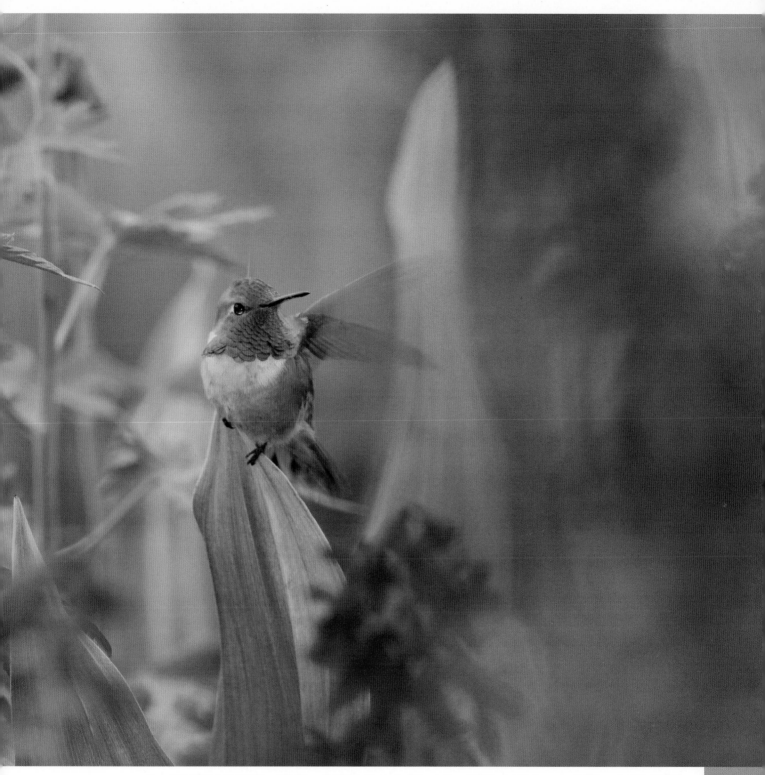

Canon EOS-1D Mark III, EF 500mm f/4L IS lens with EF 1.4x tele-extender (910 mm), Canon 580 EX projected flash, exposure of 1/200 second at f/11, ISO 800

THE TWO RUFOUS HUMMINGBIRDS FEATURED IN THIS STORY WERE PHOTOGRAPHED IN THE SAME LOCATION, FIFTEEN YEARS APART. ONE IS CAPTURED ON FILM, THE OTHER ON A DIGITAL SENSOR. OTHERWISE, THE TECHNIQUES WERE THE SAME, AND EACH REPRESENTS A MEMORABLE DAY OF SHOOTING AMONG THE WILDFLOWERS IN THE HIGH MOUNTAIN MEADOWS OF THE COLORADO ROCKIES, A RUFOUS HUMMER'S FAVORITE SUMMER LOCATION.

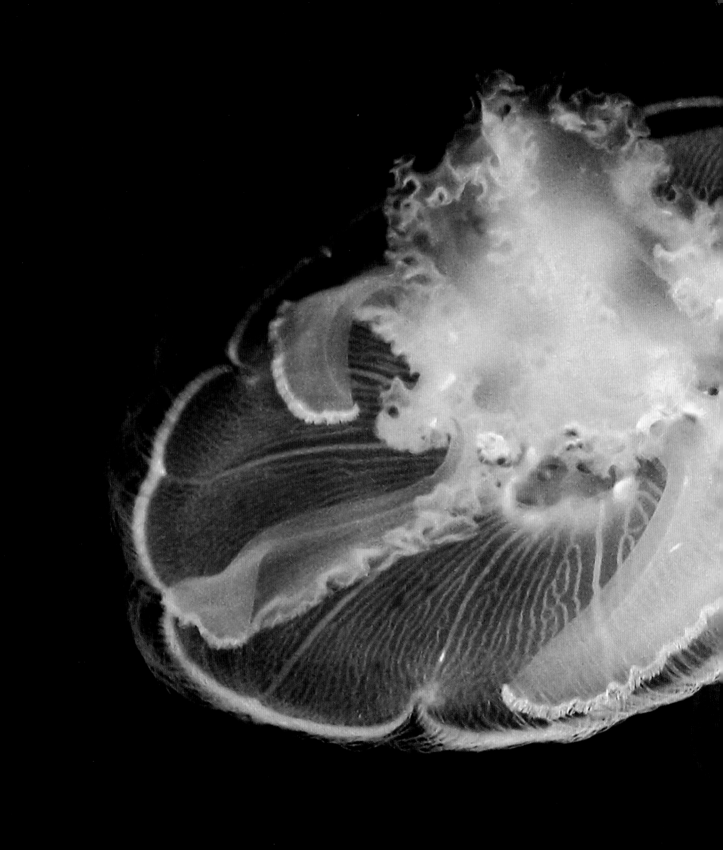

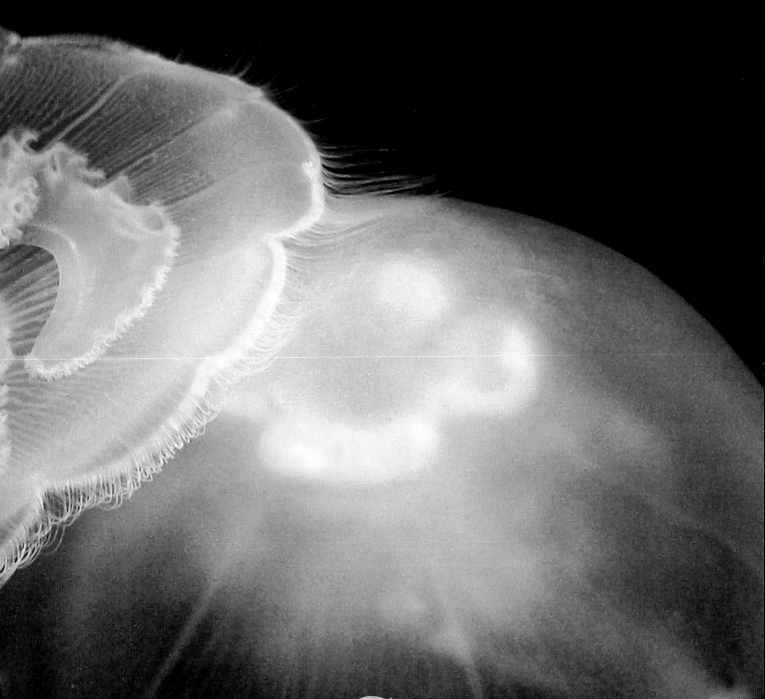

SMALL
CRITTERS

THE EIGHTH WONDER OF THE WORLD

Below

Masses of monarch butterflies cover the broad trunk of an oyamel fir tree in the forest of Chincua, Mexico, at 10,000 feet (3,048 meters) elevation. The area supports about 15 million butterflies each winter, less than 20% of the total migration to the central Mexican mountains.

The amazing story of the annual migration of monarch butterflies from eastern Canada to central Mexico is now well-known, but forty years ago, it was a mystery. Unraveling that mystery has been the life's work of two great entomologists, the Canadian Fred Urquhart and the American Lincoln Brower. Their story is a classic illustration of the way a few individuals can challenge the destructive course of mankind by understanding the complex course of nature.

At the far northern point of the circular migration of monarchs, imagine scientists in Toronto tagging tens of thousands of individual butterflies and organizing a network of volunteers to track them through their route, all before the

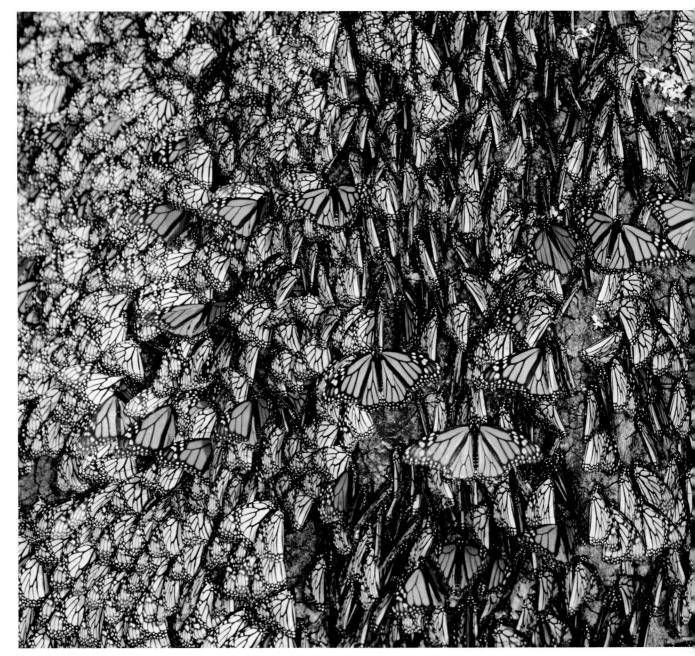

Nikon F2, 200mm macro lens, fill flash

days of the Internet. At the southern point, imagine isolated campesinos (subsistence farmers) for whom the annual fall arrival of the monarchs—and the blanketing of nearby forests by butterflies—is a part of local legend and culture: the return of the souls of their ancestors, coinciding approximately with the Dia de los Muertos (the Day of the Dead). Even Mexican naturalists were unaware of the butterflies' annual sojourn in the mountains of Michoacán until the Canadian researchers located the overwintering sites in 1975, following four decades of research. Readying the work for publication in *National Geographic*, they kept the locations secret.

Meanwhile, Brower had been working in Florida, studying the co-evolution of

177

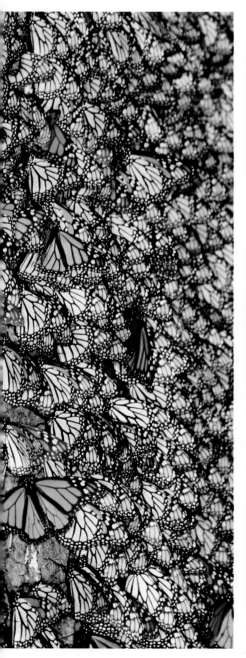
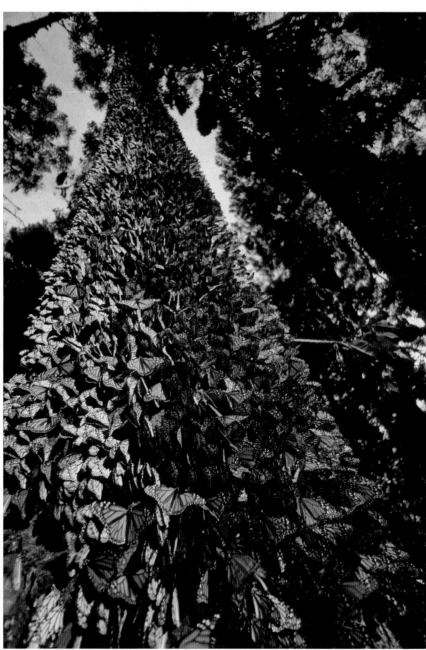

Below

Oyamel fir trees are some 80 feet (24 meters) tall, and when thousands of monarchs are climbing up them toward the sky, they seem to vibrate and shimmer with the shifting colors of butterfly wings.

Nikon F2, 17mm wide-angle lens

the monarchs and milkweed, the butterflies' primary food source and an essential element in both reproduction and migration. He and his collaborators deduced the location of potential overwintering sites and discovered the monarch's Chincua colony. In December 1976, I joined Brower as the photographer for his American team of researchers, and we drove into the mountains to the site, where Urquhart's team was tagging monarchs. The situation was a bit tense, and the encounter between the two scientists became a well-publicized international incident. I just wanted to take photographs, and from my perspective, there were plenty of monarchs for everyone.

There were, in fact, hundreds of millions of butterflies.

My first reaction was to simply sit and watch. The boughs of the giant oyamel fir trees sagged with the weight of the insects that clung to every centimeter of bark, every needle. When a cloud covered the sun, the monarchs clustered together, wings closed tightly, unmoving. When sunlight hit them, they became animated, swirling like bright leaves against the blue sky, and their scales fell like sequins through the air. I looked around in amazement, and wondered where to start my photography. It was an opportunity, and a responsibility, of enormous magnitude.

I made three trips to the monarch overwintering sites with Lincoln Brower and his colleague Bill Calvert in the late 1970s, and my photographs appeared in many scientific and popular publications, including the cover of *Natural History* magazine. In the early 80s, some of my monarch images were used to represent the University of California's bi-national institute for research on Mexico and the United States (UC MEXUS). The monarchs were seen as a natural treasure that both countries shared and an important opportunity for collaboration between U.S. and Mexican scientists. More important than those and subsequent publications was the fact that the images supported Brower's efforts over the next decades to protect the monarch forests from logging, a complex issue because the residents of the area depended on the trees for firewood and income. Eventually, the Mexican government extended protection to large portions of the forests by establishing the Monarch Butterfly Biosphere Reserve and encouraging ecotourism. But due to conflicts in land use priorities, some areas have been deforested nonetheless.

Mexico is not alone in its responsibility for the monarch migration, which Brower once named "The Eighth Wonder of the World." Brower has since identified the full circle of the monarchs' annual migratory pattern, which involves four generations of butterflies and spans three nations. He has also documented the need to maintain the milkweed populations required for food and reproduction throughout the spring and summer portion

Nikon F2, 200mm lens

of the cycle. In the United States and Canada, many natural stands of milkweed have been replaced by genetically engineered soybean and corn agriculture, restricting the monarchs' migration routes. Resolving the challenges affecting the ancient migration of the monarchs requires the commitment of all three of the countries involved.

In 2008, Mexico's Monarch Butterfly Biosphere Reserve—consisting of more than 56,000 hectares (138,379 acres) of the monarch overwintering area—was named a World Heritage site by the United Nations Educational, Scientific, and Cultural Organization. In its findings, UNESCO cited the concentration as "the most dramatic manifestation of the phenomenon of insect migration" in the world. Indeed, the whole world is watching as the monarchs' story continues to unfold.

Above

Warmed by the sun, the butterflies rise into the sky while their scales fall through the air like sequins.

APPROACH EVERY PHOTOGRAPHIC PROJECT AS IF IT MIGHT BE THE ONE THAT DEFINES YOU, OR THE ONE THAT MAY DEFINE A CRITICAL ENVIRONMENTAL ISSUE OF OUR TIME.

GEORGE AND KATHRYN LEPP

I'M ALWAYS CHASING BUTTERFLIES

While butterflies may be found in abundance in patches of wildflowers or cultivated garden flowers, their whimsical—dare we say flighty—approach to nectaring can frustrate even the most determined photographer. I am certainly determined, and I'm often successful at capturing butterfly subjects in the field, but just as often, I fail. Whether the outcome is good or bad, my wife maintains that it is quite amusing to watch me try. Picture this: The truck is parked off the road by a field of bee flowers, I'm chasing swallowtail butterflies from one plant to another in the hot August sun, and

Right

THE ESSENCE OF SUMMER

A two-tailed tiger swallowtail in prime condition nectars on bee flower near the entrance to Phantom Canyon in Colorado. The species is Arizona's state butterfly.

Opposite

A western tiger swallowtail nectars on a small columbine plant growing alongside Lee Vining Creek in California's Eastern Sierras.

Canon EOS-1Ds Mark II, EF 180mm f/3.5L macro lens, exposure of 1/350 second at f/11, fill flash

Kathy is sitting in the shade on the tailgate, calling, "to your left," or "right behind you," cheering me on and getting a good laugh.

Swallowtails, which are fairly easy to find in Colorado's middle elevations in summer, are among my favorite butterfly subjects. They are beautiful, they hang out in gorgeous environments, and they nectar at a flower just a little bit longer than most other species of butterflies do. Sometimes, there is enough time to get in position, frame the shot, throw a little fill flash on the composition, and get the photograph.

Successful butterfly capture requires advance preparation and practice. You need a long enough lens so that you don't have to be right on top of the butterfly to fill the frame. A telephoto macro lens satisfies this need and also gives you great working distance, allowing you to approach without disturbing the butterfly (sometimes). Most of the optional automatic functions on your camera are not useful for this type of photography; they give you too many choices and take too much time to work. Autofocus, especially, gets hung up on the flowers or foliage around the subject. Slightly expanded ISO, say 200-400, will give you the faster shutter speed required for a sharp handheld capture.

My strategy for butterfly photography is to set up my system on a test flower, using manual focus and an exposure that combines fill flash and ambient light so that I can capture successfully from any orientation to the sun. Set the focus at the ideal distance from the test subject. When you're photographing a butterfly, move the camera toward or away from it and fire when the image is sharp. It's hard to keep track of what's going on around you when you're looking at the world through a macro lens, however, so it helps to bring along an assistant who will keep an eye on the action and alert you to nearby subjects—that is, if you don't mind the laughter.

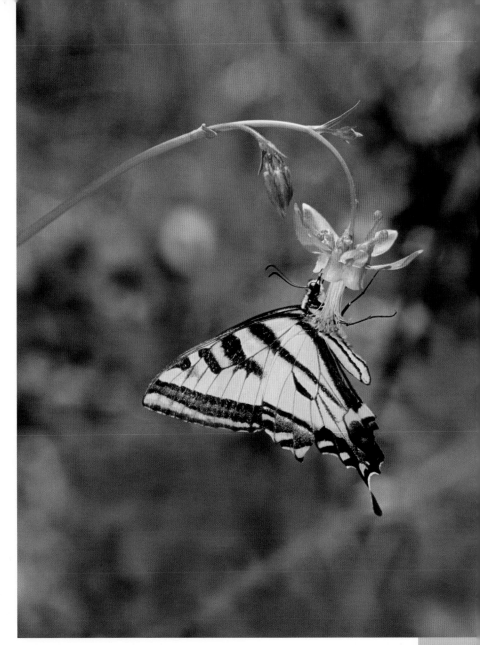

Canon EOS-1N, 180mm macro lens, flash

WITH BUTTERFLIES, IT'S ALL ABOUT MOVING—YOUR BODY AND THE CAMERA. WHILE YOU MIGHT THINK THAT AUTOMATIC FUNCTIONS WOULD BE HELPFUL WHEN CAPTURING SOMETHING AS TINY AND SPONTANEOUS AS A BUTTERFLY, THE OLD MANUAL TRICKS ACTUALLY WORK BETTER.

A DAY AT THE BUTTERFLY ZOO

A great butterfly aviary is a wonderful thing, and like most nature photographers, I have my favorites that I visit again and again. Well-designed and maintained aviaries have a good variety of butterflies in a healthy, appropriately landscaped and naturally lit environment, pathways and benches positioned to facilitate viewing and photography, a strong educational component, breeding facilities on site to renew butterfly populations without capturing in the wild, and a photographer-friendly atmosphere. (Be aware, though, that most aviaries don't allow tripods.) Aviaries that focus on tropical species and their environments provide compelling illustrations of the species we are in danger of losing as rainforests are decimated. Aviaries are also important reminders of the loss of butterfly habitat that is occurring virtually everywhere in the United States due to construction and pesticide contamination.

Since the lighting in an aviary is somewhat stable and the subjects are abundant, it's an excellent location for practicing

This page

I photographed this Julia butterfly at the Day Butterfly Center at Callaway Gardens in Pine Mountain, Georgia. The combination of a macro telephoto lens and fill flash rendered the background foliage a serene, natural green against which the butterfly nectared on a delicate purple flower.

Opposite

A male heliconius butterfly drops pheromones on the female below in a courtship display, photographed at Butterfly World, just north of Fort Lauderdale, Florida.

Canon EOS-1V, 180mm macro lens, fill flash

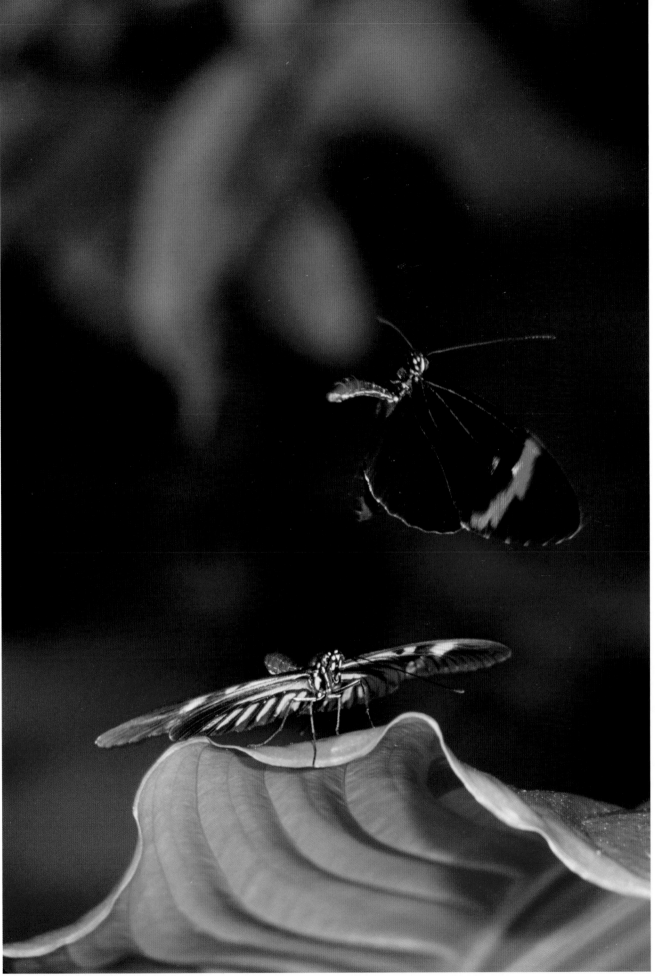

Canon EOS-3, 100-300mm zoom lens, exposure of 1/250 second at f/11, on-camera flash

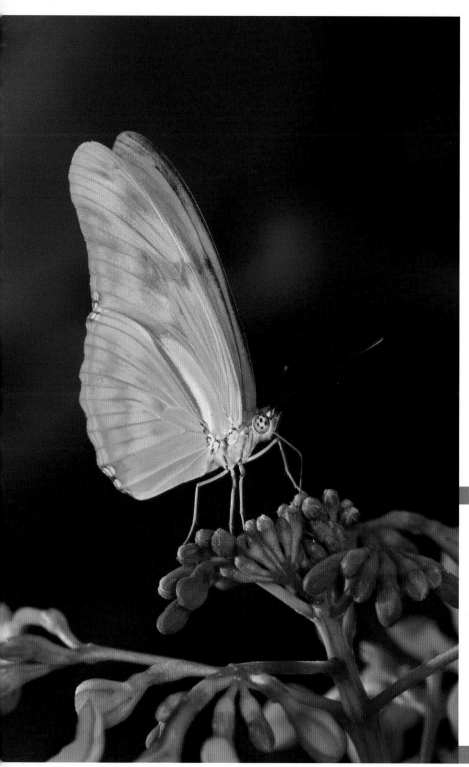

Canon EOS-1Ds Mark III, EF 180mm f/3.5L macro lens, exposure of 1/60 second at f/16, ISO 400

Above

This Julia butterfly and the flowers on which it is nectaring were illuminated by a Canon Macro Twin Lite MT 24-EX and backlit with a slaved wireless flash held by an assistant at the Niagara Parks Butterfly Conservatory in Niagara Falls, Canada.

your butterfly pursuit skills for later use in the wild. Spend some time observing your subject's behavior; if a butterfly goes to the same place twice, it most likely will return a third time. Position yourself at that location and be ready. Using a telephoto macro lens throws the background out of focus (which is especially helpful when fencing, water tubing, or other artificial looking structures fall within the frame), and it also gives you the working distance you need to keep from chasing the butterflies away. You will be handholding your camera/lens system, so use expanded ISO settings (i.e., 400-800) and flash fill to achieve a fast shutter speed. The combination of ambient light and added flash will give you a sharp subject and a natural-looking background, but sometimes full flash is necessary in darker locations. If you have a willing assistant and an off-camera flash, you can light the subject from behind to separate it from the background and emphasize the delicate details, such as the antennae and proboscis.

> YOU MIGHT LOSE TRACK OF AN ENTIRE DAY WHILE CHASING BUTTERFLIES AT AN AVIARY, BUT NOT TO WORRY! IT'S A NO-STRESS, ALL AROUND GOOD TIME PHOTOGRAPHIC PROJECT.

THE BLEEDING EDGE OF BUTTERFLY PHOTOGRAPHY

I've been fascinated by high-magnification, or macro, photography for decades. The perspective offers an intimate look at a flower or insect, revealing its secrets to the viewer, and turning a bee's eye or a flower's stamen into a finely detailed design element. It's an interesting way to photograph a butterfly's wing with its extravagant, complex patterns of tiny, brilliant scales. In years past, I accomplished high-magnification photography of butterfly wings with a complicated low-tech setup of an SLR body, macro lens, extension tubes, bellows mounted on a copy stand, and a couple of flashes. That setup yielded minimal depth of field at best; the band of sharpness could be measured in fractions of a millimeter.

Now I photograph butterfly wings at high magnification with a complicated high-tech setup that includes a Canon 21-megapixel full-frame D-SLR, an MP-E 65mm f/2.8 macro lens, and an MR-14 EX dual flash macro light, all mounted on a copy stand above a movable stage, which holds the subject. I might even add additional small flashes, controlled by TTL metering, to light the subject from the sides or below. My D-SLR is connected by a cable to my laptop computer, which displays a live view of the image as I adjust the position of the subject to achieve maximum sharpness.

Below

Photographed at five times life size, a butterfly's wing reveals that it is far from flat; there are ridges and indentations that challenge the photographer's ability to achieve sharpness. This image and the others featured in this vignette were photographed several times, capturing slices of sharp focus and compositing them into one completely sharp image using a software called Helicon Focus.

185

Canon EOS-1Ds Mark III, Canon MP-E 65mm f/2.8 macro lens, MT 24EX macro flash, six images, each with exposure of 1/8 second at f/11, ISO 200, composited using Helicon Focus software

Left

Adding some extension tubes behind the lens brings the magnification from 5x to 9x. At this magnification—and with the help of an image composite, resulting in extended depth of field—the full dimensions of each scale of the wing are revealed.

Below

This wing, photographed at 5x, reveals both structure and design elements. When you experience a magnified view of something this intricate, it takes you into another world.

Canon EOS-1Ds Mark III, Canon MP-E 65mm f/2.8 macro lens, MT 24EX macro flash, six images, each with exposure of 1/25 second at f/8, ISO 400 ISO, composited using Helicon Focus software

I can even move the area of sharp focus through the subject, from top to bottom, capturing a sequence of images that I later composite into one entirely sharp image. This process, which I call unlimited depth of field, is especially effective on butterfly wings because they are never completely flat; they have many different planes and ridges that are huge at high magnification. The resulting images are high-quality, crisp, detailed, and brilliantly colored. Printed sixty-inches wide (152.4 cm) on my large-format professional printer, they turn a butterfly wing into a wall-sized abstract creation that is all the more fascinating because it is actually a photograph of a real creature.

DANCING ON THE LEADING EDGE OF ANY TECHNOLOGY CAN BE RISKY, COSTLY, AND TIME-CONSUMING—AND YOU MIGHT EVEN CUT YOURSELF! STILL, IT'S WORTH-WHILE TO EXPLORE TECHNOLOGICAL ADVANCES WITH THE POTENTIAL TO INCREASE THE SCIENTIFIC RELEVANCE AND AESTHETIC RICHNESS OF YOUR PHOTOGRAPHY.

Canon EOS-1Ds Mark III, 65mm f/2.8 macro lens, MT 24EX macro light, four images, each with exposure of 1/250 second at f/11, ISO 200, composited using Helicon Focus software

TRY THIS AT HOME!

Sometimes you don't have to go far to get a significant photograph, or a profitable one. You can grow your own subjects at home! Unfortunately, some of my most popular home-based images feature pests or parasites, and the reason we have them is our own fault.

Take the cottony cushion scale (please). It's an agricultural pest that loves citrus. Since we live in Colorado, you'd think the cottony cushion scale would be completely irrelevant to our lives, but it's a major irritant. My wife Kathy never stops trying to grow the Meyer lemons she learned to love while living in Southern California. Every year she buys new trees loaded with scented blossoms and infant fruits. They thrive on the deck in the summer, and in the fall we bring them into a sunny location in the house, where they are lavished with attention. A reasonable crop of pungent sweet lemons is harvested around New Year's to serve as the significant ingredient in an incomparable lemon cream pie or two.

The next thing we know, the trees are dying; cottony cushion scale has invaded them and anything else growing in the same room. Ants love the sugary liquid the scale emits, and they quickly organize themselves to "farm" the scale insects, escalating the problem. As it turns out, the best way to control cottony cushion scale is to import Vidalia beetles (an Australian ladybug), a classic instrument of biological control.

In the end, we throw the trees away and start over with new ones. I figure that each lemon costs about $10, but I don't think

Canon EOS-1Ds Mark III, MP-E 65mm f/2.8 macro lens, MT-24EX macro twin light flash, five exposures of 1/180 second at f/16, ISO 200, composited using Helicon Focus software

Left

The infamous cottony cushion scale is the scourge of citrus groves and my wife's decorative dwarf lemon trees. The egg sack contains from 600 to 800 eggs, which may explain why it is so difficult to eradicate this pest.

Right, top

Don't kill this one! I stalked this praying mantis in the back yard, using a flash on the camera and a telephoto macro to capture the insect in its environment. The mantis eats other insects, so if you have lots of bugs, you're likely to have these beneficial critters also.

Right, bottom

My dog had fleas. So I photographed them at 6x with a portable, handheld setup that included a camera with a special 19mm macro lens, extension tubes, and a rig to hold two small TTL flashes—an accessory called the Macro Bracket, which I invented. The most difficult aspect of working at a magnification of 6x is that the subject seems to move within the viewfinder at light speed! Even slight movements by the photographer, the subject, or the subject's host are exaggerated at high magnification.

> **INSECT PESTS** ARE GREAT PHOTOGRAPHIC SUBJECTS, AND YOU'VE GOT THEM RIGHT AT HOME! BEFORE YOU KILL 'EM, SHOOT 'EM. OR BETTER YET, BRING IN MORE BUGS TO EAT THE ONES YOU'VE GOT, AND YOU'LL NEVER RUN OUT OF OPTIONS.

Kathy is going to give up on this project anytime soon. So, I really need to make some money on my photographs of this truly awful insect pest.

I've made a pretty good profit on my photograph of a flea in its natural environment—the fur of a poodle. I photographed the flea and several of its brethren when I lived on the California coast, a notoriously comfortable location for fleas. The strategy for photographing the flea was complex. The poodle could be relied upon to roll over on his back and reveal his flea-ridden belly when my highly trained assistant (my son Torrey) indicated a willingness to give him a good tummy rub. While the dog was in a blissful, scratch-induced coma, I chased the flea around with a macro setup that included two flashes. From there, I took the pictures straight to the bank.

Nikon F2

FRAGILE: HANDLE WITH CARE

Below

The opalescent nudibranch's beautiful colors warn predators that it's not good to eat; the tips of the nudibranch's cerata host stinging cells. I moved this 1.5-inch specimen (37 mm) into a shallow area of its tide pool to photograph it, where a dark substrata emphasized the animal's glowing opacity. Once photographed, I returned the nudibranch to its original place in the pool at Montaña de Oro State Park in California.

Few natural subjects require more special attention than the residents of tide pools. Most people probably think these creatures are pretty indestructible considering their tough bodies, their ability to withstand pounding waves, and their adaptation to ever-changing environments. And it's true; within their environment, tide pool animals are strong, but they are desperately vulnerable outside of it.

I've photographed in tide pools in many places around the world, but most extensively along the central California coast. I monitored the tide pool colonies there over a period of twenty-five years. At first, the pools were rich environments, and wonderful sources of great photographs. They were so interesting that they came to be viewed as resources for enhancement of natural science education in the local schools. Over the years, hundreds of busloads of kids and adults descended on these rocky coves. Ironically, the more that people experienced and learned about the fragile marine ecosystems, the less there was to see; overexposure to human curiosity has noticeably diminished the population and diversity of species in the more accessible sites. As with so many natural phenomena, some tide pools have been loved to death.

Canon EOS-1N, 100mm macro lens, two TTL flashes mounted on a Macro Bracket

Less accessible tide pools are still rewarding places to photograph, but you must be a basic biologist to do so without causing harm to your subjects. Consider each pool as its own ecosystem, and each crab, anemone, sea star, or sea slug within it as a member of an interdependent community. Most tide pool denizens aren't able to control their movements very well. They've established themselves within their environment so as to maximize their ability to thrive and reproduce. If you uproot a sea star to photograph it, then toss it back in another pool some distance away, it may not survive.

The first basic rule of tide pools is to treat animals with care and respect while you observe and photograph them. Properly handled and protected, tide pool subjects can be repositioned for photography, but they must always be returned to their exact original location. An excellent strategy is to relocate the subject for a short time into a shallow area of an accessible pool, or you can place it in a shallow aquarium filled with water from the pool. (Be sure to sneak up on sea stars and snatch them up quickly before they get a good defensive grip; do not try to pry them loose, or they could be damaged.) When tide pool residents

Below

When you examine most tide pool residents closely, many complicated, fascinating details are revealed, such as the tiny white pincers seen here in this close-up detail of the back of a sunflower starfish—a large, many-pointed sea star—photographed at Pismo Beach, California.

Canon EOS-1N, 100mm macro lens, two TTL flashes mounted on a Macro Bracket

Above

Striped shore crabs move fast. They are small—only about 3 inches (7.62 cm)
in diameter—and they like to hide in crevices and under rocks in tide pools.
To photograph this one in shallow water, I used a telephoto macro lens, which
allowed enough working distance to keep the subject comfortable and in place.
The whole session was accomplished in the crab's own environment, and that's
the best way to work.

are out of the water, they lose their form, and reflections off of their wet surfaces are a problem. Photographing them just beneath the surface of the water keeps them comfortable and allows you to control reflections, yielding the true colors of the animal to your lens. Ask a friend to hold a black umbrella over your subject, or cast a shadow on it, to improve the clarity of your capture. If you use a flash, shoot it at a bit of an angle to keep your light source from being reflected in the photograph. Work quickly, and return your tide-pool subject to the place you found it as soon as possible to minimize exposure to changes in water temperature and chemistry.

DO YOUR HOMEWORK BEFORE YOU PHOTOGRAPH IN TIDE POOLS SO YOU CAN BE PREPARED TO PROPERLY HANDLE AND IDENTIFY THE SUBJECTS YOU'LL FIND THERE. AND WHENEVER YOU CAN, LINK THE MESSAGE OF CONSERVATION TO YOUR TIDE-POOL IMAGES.

Canon EOS-1V, 180mm macro lens, two TTL flashes mounted on a Macro Bracket

FOUND TREASURES

When you consider the fact that seashells are skeletons, it's interesting that we are always looking for them along the beach and consider them to be treasures worth keeping. Indeed, most public beaches are kept clear of shells; the minute one hits the beach, someone collects it. It makes the beach more comfortable for bare-footed visitors, but you have to wonder if there is a natural purpose to the buildup of shells on beaches that is somehow being thwarted by the way we sweep them clean.

Every shell was once part of a living thing: an integral piece, the exoskeleton, of an invertebrate creature. If you collected shells from coral reefs and rocky sea bottoms, you'd likely be harvesting live animals. Some shells are recycled after their original owner is finished; hermit crabs use found shells to protect their soft abdomens and hide from predators, but as the crab grows, it must find larger and larger shells to house itself.

There is another kind of found beach treasure that is not technically a shell. The sea urchin known as the sand dollar leaves a dry, flat disc when it dies. This collectible is actually the sand dollar's endoskeleton, an internal support that was covered with skin and spines when the animal was alive.

Occasionally I have access to beaches that haven't experienced much human intervention, and the sheer abundance of shells can be startling. I found the shell concentrations pictured on page 197 on a beach near San Ignacio Lagoon, a nursery and breeding site for gray whales on the Pacific coast of Baja California, Mexico. The beach is accessible only by boat and is protected by law, so the shells have been accumulating there for a long time. I like that idea.

Right

Some shells have important uses. This hermit crab, photographed near Morro Bay, California, carries a small turban shell on his back for camouflage and protection. As the crab grows, it will abandon this shell and choose a larger one.

ONE MAN'S TRASH IS ANOTHER MAN'S TREASURE. JUST ASK ANY HERMIT CRAB.

Canon EOS-3, 180mm macro lens, two TTL flashes mounted on a Macro Bracket

GEORGE AND KATHRYN LEPP

Canon EOS-3, Canon TS-E 90mm f/2.8 tilt-shift lens, exposure of 1/125 second at f/22

Left

I found this sand dollar (the endoskeleton of a type of sea urchin) on a protected beach near San Ignacio Lagoon in Baja California, Mexico. I photographed it with an emphasis on the reflective wet surface of the sand and water.

Right

Everything on this Mexican beach is protected by law, and it can be reached only by small boat, so shells have accumulated in large patches. To exaggerate the impact, I framed the picture to suggest that the beach was carpeted with shells as far as the eye could see.

WHEN I CAPTURE AN IMAGE OF A STRETCH OF SAND PILED WITH SHELLS, IT'S LIKE GIVING A KIND OF GIFT TO THE VIEWER, A TREASURE CHEST FOUND IN AN ISO-LATED COVE FAR, FAR AWAY.

Canon EOS-3, Canon TS-E 90mm f/2.8 tilt-shift lens, exposure of 1/125 second at f/16

MYSTERIES OF THE DEEP REVEALED

The mysteries of the aquatic world call to many of us; the deeper the water, the more fascinating we find its creatures. Relatively few people ever have the opportunity to photograph, Cousteau-like, in the depths of the sea. But in aquariums, the diverse, beautiful, and sometimes bizarre residents of underwater environments meet us eye to eye.

I am delighted by the growing number of excellent aquariums in North America, and as I travel around presenting seminars and workshops, I try to make time to spend a few hours with the local marine life. In the past few years, I've discovered new aquariums in cities as diverse as Denver, Chattanooga, and Atlanta. Alert readers may note that these cities are far from the sea—all the more reason to locate a zoo for marine animals in the cultural hearts of their communities! Some aquariums feature both freshwater and ocean environments, and include exhibits of complete ecological communities, such as a wetlands with fish, small mammals, and birds. The displays may be regional, or entirely exotic, like a recreated Antarctic ice field, complete with penguins. Aquariums allow you to view sharks and sea turtles swimming around, above, and below you in huge tanks that are open to the sky, and you've got

tiny sea horses glowing under spotlights, showcased like gems in a jewelry store. Some facilities even have the equivalent of a petting zoo; our grandchildren love to touch and feed the stingrays at the Denver Aquarium.

A day at the aquarium feeds all my photographic senses. There's unusual light, color, design, action, and lots of challenges that can be solved with high-tech, expensive equipment—my favorite! When Kathy and I make a serious photography trip to an aquarium, I take along a high-resolution D-SLR, three lenses (17-40mm, 24-105mm, and a 100mm macro lens), extension tubes, and two off-camera strobes. Kathy holds a third, wireless flash to give dimension to the subject, or to light the background. This system works extremely well for photographing small subjects in dimly lit tanks. A tripod is usually a hazard in close, dark quarters (and many aquariums don't allow them), but this handheld capture system allows me to put enough light into the tanks so that fast shutter speeds are possible. It doesn't have to be that complicated, though. Work on subjects that are close to you; place your lens right up against the glass without scratching it (a rubber lens hood is useful), and if you can take the flash off-camera, direct it into the tank at an angle to reduce reflections.

This page

The reflective surface of the scales on these mackerel gives the image an ocean ambience. The long exposure necessary to record the color showed only streaks of the moving subjects, but firing two off-camera flashes at the end of the exposure allowed the fish to be sharply recorded as well.

Opposite: **SEA NETTLES**

These stunning jellyfish are displayed in a large tank fitted with lighting and background colors that emphasize the animals' beauty. To capture the color and mood, I used only ambient light, but a long exposure would have blurred the slowly drifting jellies, and the camera had to be handheld. To shorten the shutter speed in the low-light conditions, I used ISO 800.

Canon EOS-1V, 50mm macro lens, two flashes on a Macro Bracket

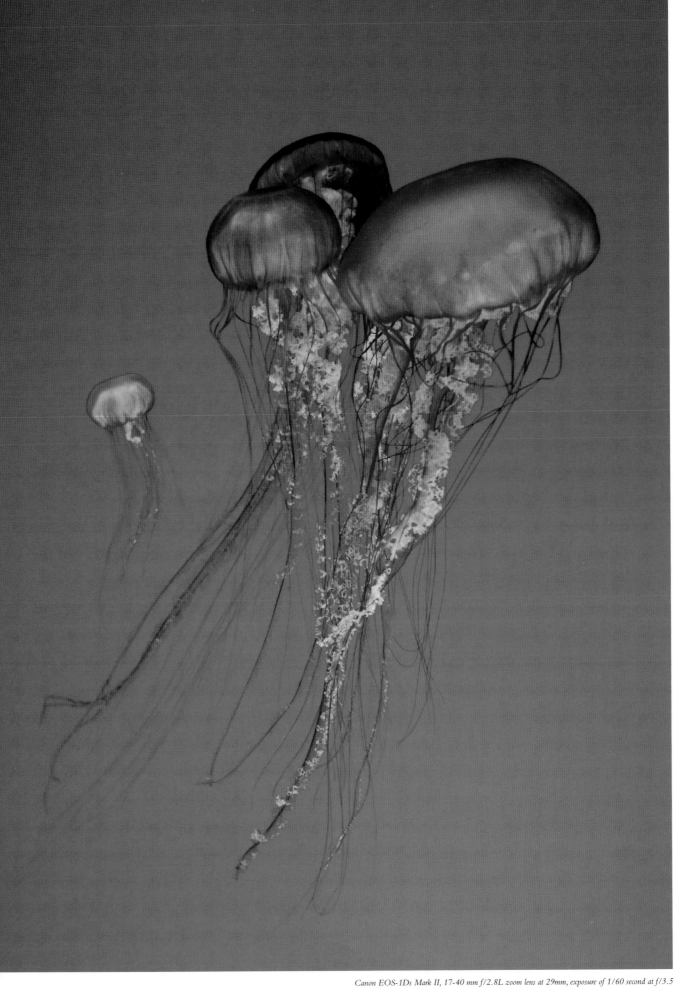

Canon EOS-1Ds Mark II, 17-40 mm f/2.8L zoom lens at 29mm, exposure of 1/60 second at f/3.5

Canon EOS-1Ds Mark II, 15mm f/2.8 fisheye lens, exposure of 1/30 second at f/5.6, ISO 800

Above

The California coastal environment is depicted in this huge tank at the Monterrey Bay Aquarium. The tank is open to the sky, providing enough ambient light for photography. I captured this natural-looking scene by placing a 15mm fisheye (it figures) against the acrylic viewing portal.

AQUARIUMS GIVE PEOPLE THE OPPORTUNITY TO APPRECIATE MARINE WILDLIFE THEY WILL NEVER SEE IN A NATURAL ENVIRONMENT, AND THEY'RE WONDERFUL FACILITIES FOR ACCOMPLISHING PHOTOGRAPHY THAT IS BOTH SIGNIFICANT AND CREATIVE.

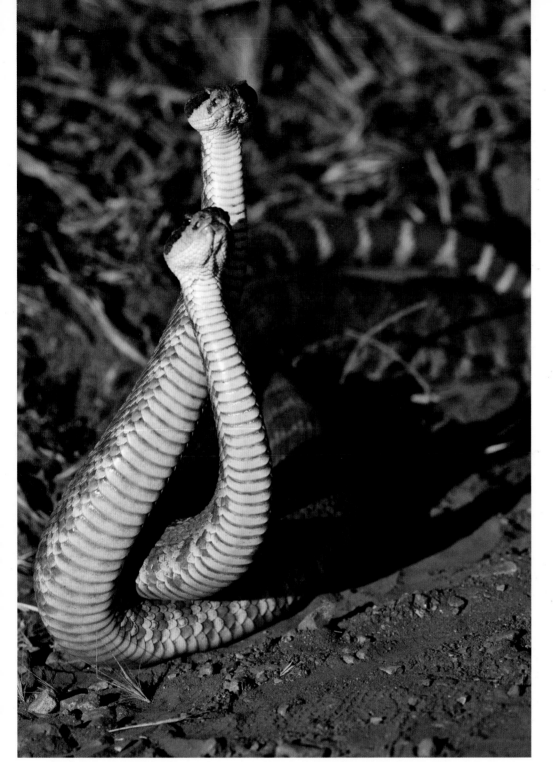

Canon EOS-1Ds, EF 500mm f/4L lens, exposure of 1/350 second at f/11, ISO 200

One fine spring day, my friend Rich Hansen and I walked along the cliffs of Montaña de Oro State Park in California; we were planning to photograph pelicans as they soared on wind currents above the waves. We had our cameras and long lenses on tripods slung over our shoulders when we came upon two rattlesnakes entwined in a silent, sinuous mating dance.

The snakes engaged in a beautiful, bizarre ritual that reminded me simultaneously of a cobra for its elegance and the Kama Sutra for the diversity of its positions. From time to time they paused together in a classically choreographed pose. We photographed them with the ultra-long lenses we'd intended for the pelicans. And we were glad we hadn't started the day looking for macro subjects.

Above

DO YOU MIND?

Rattlesnakes can engage in mating behavior for several hours, even days, and these two were not deterred by the presence of two photographers. A long lens kept me at a comfortable distance.

Canon EOS-1Ds, EF 500mm f/4L lens, exposure of 1/350 second at f/11, ISO 200

Rattles were not a factor in this silent mating dance. The male keeps at it until he pins the female with his body in a position that allows insemination to occur. She will carry the eggs until the young are viable. Once they are born, they're on their own.

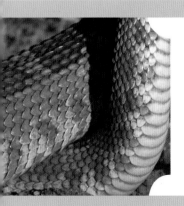

WHEN YOU'VE GOT THE RIGHT EQUIPMENT AND THE RIGHT LIGHT AND YOU COME UNEXPECTEDLY UPON THE RIGHT SUBJECT, SAY, "THANKS, MOTHER NATURE," AND MAKE THE MOST OF IT.

WORKING TO SAVE THE YOSEMITE TOAD

Once my work in support of natural science research began to be published, more opportunities to photograph threatened species came my way. One of the most memorable of these subjects was the colorful Yosemite toad, now listed as an endangered species by the International Union for the Conservation of Nature (IUCN).

Biologist Cynthia Kagarise Sherman was one of the first to document the severe decline of Yosemite toad populations in their only environment, the wet mountain meadows of the high Sierra Nevada Mountains. The toad is active in the late spring and summer, and at high elevations, these are two very short seasons. During that four-to-five month period, the toad reproduces at the shallow edges of ponds formed by melting snow and fortifies itself for the winter to come. For the other seven to eight months of the year, it hibernates in burrows under the snow.

In the early summer of 1978, I was assigned by *Natural History* magazine to work with Kagarise Sherman while she completed her dissertation research on the toads in the Tioga Pass area. We observed and photographed the toads as they made their way from one pool to another, sometimes traveling across broad expanses of snow in their determination to reproduce. It was my job to document a complete life history of the toad—over a two-week period!

Below

Eggs spill around a pair of Yosemite toads in amplexus in a shallow pond. The Yosemite toad population has collapsed in the Sierra Nevada Mountains, its only habitat, and the species is internationally known to be endangered. As of this writing, the U.S. government has not acted to protect the toad under the Endangered Species Act.

203

Nikon F2, 200mm macro lens

Kagarise Sherman, dedicated in her efforts to unravel the mystery of the toad's diminishing populations, continued her research and publications on the Yosemite toad for more than twenty years until her death in 2002. Citing her work and others', the IUCN listed the toad as endangered in 1996. Nonetheless, the precise cause of the decimation of the species is still not known. Even in protected, pristine areas such as Yosemite National Park, entire populations have collapsed. Hypotheses for the declines include disease, livestock grazing, drought, and predation from introduced trout.

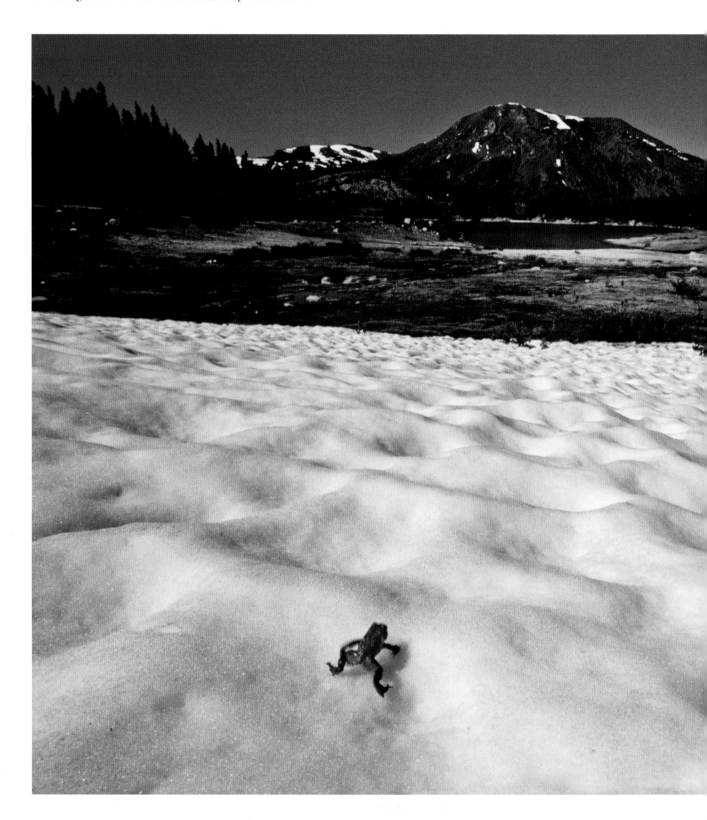

UNFORTUNATELY, THE U.S. FISH AND WILDLIFE SERVICE HAS NOT YET ACTED TO PROTECT THE SPECIES, DESPITE CONTINUING LEGAL CHALLENGES FROM ENVIRONMENTAL AND CONSERVATION ADVOCATES.

Left
Set against the vastness of the high Sierras, a male toad moves across a snow bank in search of a mate.

WHEN YOU HAVE THE OPPORTUNITY TO WORK WITH SCIENTISTS, HOWEVER BRIEFLY, THEY ARE SHARING THEIR LIFE'S WORK WITH YOU AND TRUSTING YOU TO PORTRAY IT ACCURATELY. IN THE PRESENCE OF SUCH COMMITMENT, THE SUBJECT BECOMES A PART OF YOUR LIFE'S WORK AS WELL.

Nikon F2, 17mm wide-angle lens

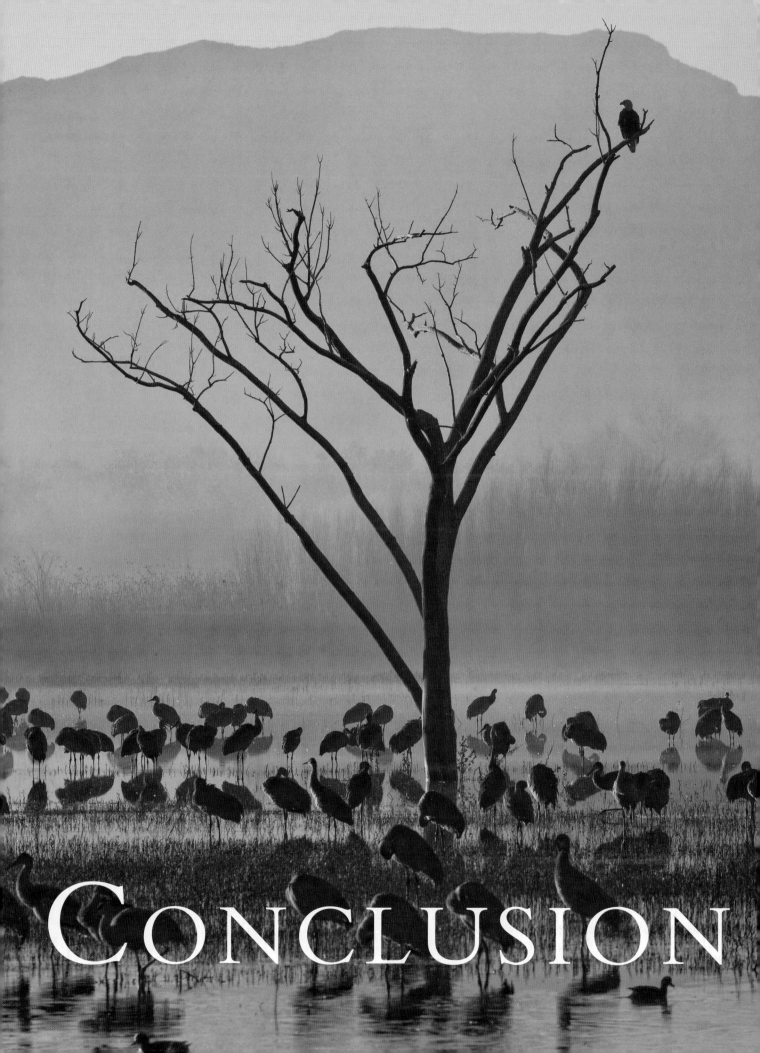

CONCLUSION

Between the moment I first imagined this book and the moment Kathy and I completed it, some eighteen months have passed. I knew from the outset that I needed to put my stories to my pictures for other photographers to see and to understand. I wanted to give my readers an opportunity to stand beside me at my window to the natural world, to share my perspective, to go where I've gone, to experience the locations and the wildlife subjects I've known. For this volume, I chose images that, for me, are the most representative of my work. Now, as I look back over this survey of my wildlife photography, I feel both fulfillment and dissatisfaction. This is the way, I imagine, that most artists feel as they reflect upon what they've achieved and what they have left to do before they can define their work on any subject as complete. I hope I never reach the moment where I think I'm done with the subject of wildlife.

Throughout this book I've mentioned some of the uses to which others have put my images. Beyond commercial endeavors and art venues, my photographs have appeared in textbooks, illustrated doctoral dissertations, and documented scientific papers; they've been donated to raise money for environmental programs, scholarships for students, and community causes; they've served as symbols to raise awareness of threatened places and animals. In these ways, I feel my work has a life beyond my own.

Your own wildlife photography can matter in these same ways. From the start, it will make you a more sensitive and knowledgeable person. Photography inspires people to look closely, stay longer, become more aware, and drives them to understand and explain the phenomena of the wilderness. Photography is a medium for your message that is powerful, lasting, and universally understood because it speaks in images. Wildlife photography makes us better stewards and better citizens of the natural world, and it gives us a place to stand between Nature and those who disdain her. And if your photography calls you to activism on Nature's behalf, all the better.

Through my seminars and workshops I've spent time with many thousands of photographers, and the quality that unites them all is delight—the sheer ability to be surprised and pleased—in the wildlife they encounter. They are driven to document it. They are determined to photograph it in a way that captures the special qualities of their subjects, large or small, and conveys them to others: the beauty, the meaning, the wonder, that we find in the natural world, if we're open to it. It is in this same spirit that Kathy and I have shared these photographs and their stories with you.

PHOTOGRAPHY INSPIRES PEOPLE TO LOOK CLOSELY, STAY LONGER, AND BECOME MORE AWARE.